FREDERIC REMINGTON
THE MASTERWORKS

FREDERIC

REMINGTON
THE MASTERWORKS

THE SAINT LOUIS ART MUSEUM

in conjunction with the

BUFFALO BILL HISTORICAL CENTER, CODY

HARRY N. ABRAMS, INC., PUBLISHERS, NEW YORK

MICHAEL EDWARD SHAPIRO

PETER H. HASSRICK

With essays by

DAVID McCULLOUGH

DOREEN BOLGER BURKE

JOHN SEELYE

Project Director: Margaret L. Kaplan
Editor: Ellyn Childs Allison
Designer: Bob McKee

This exhibition has been made possible by a
generous grant from Merrill Lynch & Co., Inc.
The Henry Luce Foundation has provided funds for the
research and publication of the catalogue

Library of Congress Cataloging-in-Publication Data
Shapiro, Michael Edward.
 Frederic Remington: the masterworks/Michael Edward Shapiro,
Peter H. Hassrick; with essays by David G. McCullough, Doreen
Bolger Burke, John Seelye.
 p. cm.
 "The Saint Louis Art Museum in conjunction with the Buffalo Bill
Historical Center, Cody."
 Includes index.
 ISBN 0–8109–1595–2. ISBN 0–89178–032–7 (pbk.)
 1. Remington, Frederic, 1861–1909—Criticism and interpretation.
I. Title.
N6537.R4A4 1988
709′.2′4—dc19 87–23167
 CIP

Pages 2–3: Detail of *The Intruders*, 1900 (Plate 19)
Pages 4–5: Detail of *Polo*, 1904 (Plate 58)
Pages 6–7: *The Quest (The Advance)*, 1901 (Plate 25)
Pages 8–9: Detail of *Cow-boys Coming to Town for
 Christmas*, 1889 (Figure 43)
Pages 10–11: Detail of *The Wounded Bunkie*, 1896 (Plate 50)

CONTENTS

Remington

ACKNOWLEDGMENTS

It is a pleasure to identify the individuals and institutions whose contributions to the creation of this book have been most notable. First and foremost, The Henry Luce Foundation and its program officer, Mary Jane Hickey, supported the research for the project with a substantial grant. For their good faith and generosity we are sincerely grateful. Lowell McAllister, director of the Frederic Remington Art Museum in Ogdensburg, New York, and his board and staff made available the museum's relatively untapped archives and were also unfailingly generous with their time. Also at the Remington Museum, Melodie Ward, former administrative aide, and Bruce Eldredge, former executive director, were enthusiastic supporters of the project during its long period of gestation. Staff members Beverly Walker, Ruth Hunter, and Mark Van Ben-Schoten assisted the authors in their archival research. Allen P. Splete made available to the essayists his compilation of Remington's letters.

Each of the four museums participating in the exhibition on which this book is based contributed significantly to its success. At The Saint Louis Art Museum, Director James D. Burke endorsed the project in 1984. Mary Ann Steiner, director of publications, guided the book from its infancy to its maturity, ably assisted by Suzanne G. Tyler and Pat Woods. The manuscript was typed by Debbie Blumenthal, Debbie Boyer, and Libby Martin. Curatorial coordination was supervised by Sidney M. Goldstein, admirably assisted by Marie Louise Kane. As registrars, Helene Rundell and Nick Ohlman shared considerable responsibilities. Administrative coordination was managed by Rick Simoncelli; development efforts were directed by Kathryn J. Rybolt; and Marge Lee handled public relations.

At the Buffalo Bill Historical Center, the institution collaborating with The Saint Louis Art Museum in this project, curators Sarah E. Boehme and Paul Fees, registrar Joanne Kudla, research assistant Melissa Webster, and Teresa Robertson were all exceedingly helpful.

The American art department at The Metropolitan Museum of Art consistently backed the undertaking from its inception to its conclusion. We particularly thank John K. Howat, Lewis I. Sharp, and Doreen Bolger Burke for their supportive roles. Emily K. Rafferty was instrumental in securing the corporate sponsorship by Merrill Lynch that made possible the national tour of the exhibition. At The Museum of Fine Arts, Houston, Peter C. Marzio and David B. Warren were enthusiastic supporters of the exhibition from the first.

One of the most significant features of this book—photographs of Remington's finest bronze sculptures made from a single consistent intellectual and artistic standpoint—would not have been possible without the vision and talents of Jerry L. Thompson.

Several dealers in American art—Russell E. Burke III, Michael Frost, James Graham, Rudolf G. Wunderlich, and Gerold Wunderlich—graciously assisted with information and photographs. The American art departments at Sotheby's, under Peter Rathbone, and at Christie's, under Jay Cantor, were always helpful, as was Christie's energetic sculpture department, under Alice L. Duncan.

The lenders to the exhibition were most generous in agreeing to part with their works of art for an extended period of time. We would like to thank: at the Addison Gallery of American Art, Nicki Thiras; at the Amon Carter Museum, Jan Muhlert, Rick Stewart, Linda Ayres, and Anne Adams; at the Anschutz Corporation, Philip S. Anschutz and Elizabeth Cunningham; at The Art Institute of Chicago, James N. Wood, Katharine Lee, Neal Benezra, and Milo M. Naeve; at The Brooklyn Museum,

Robert L. Buck, Linda Ferber, and Barbara Gallati; at Choate Rosemary Hall, Diane C. Langlois; at the Sterling and Francine Clark Art Institute, David S. Brooke and Martha Asher; at the Denver Art Museum, Richard S. Teitz and David Curry; at The Thomas Gilcrease Institute of American History and Art, Fred A. Myers and Jeanne King; Mr. and Mrs. William D. Hewit; William Koch and his curator Joseph Keiffer; at The Lyndon Baines Johnson Library and Museum, Gary A. Yarrington; The Metropolitan Museum of Art; The Museum of Fine Arts, Houston; at the Museum of Western Art, Denver, William C. Foxley; at the National Cowboy Hall of Fame, Ed Muno; at the National Museum of American Art, Smithsonian Institution, Charles C. Eldredge, William Truettner, and George Gurney; at the North American Life and Casualty Company, Howard E. Barnhill and William B. Watkin; at the Gerald Peters Gallery, Gerald Peters and Julie Schimmel; Laurance S. Rockefeller and the staff of The Art Museum, Princeton University, Allen Rosenbaum, Betsy Rosas-

co, and Robert Lafond; the Frederic Remington Art Museum; Larry Sheerin; at The Shelburne Museum, Benjamin L. Mason and Celia Oliver; at The Toledo Museum of Art, Roger Mandle and Pat Whiteside; at The Virginia Museum of Fine Arts, Paul Perrot; Mr. and Mrs. Robert White II; at the Yale University Art Gallery, Helen Cooper; and six anonymous private collectors.

Several additional people assisted in the negotiations for the loan of works of art: David B. Findlay, Jr., Mrs. Margaret M. Frank, Samuel Sachs II, Nancy R. Shaw, Samuel J. and Joseph E. Tilden, Evan H. Turner, and R. Frederick Woolworth. Finally, the five essayists each contributed to the form this book has taken. We are most grateful to them all.

Michael Edward Shapiro
Chief Curator
The Saint Louis Art Museum

Peter H. Hassrick
Director
Buffalo Bill Historical Center
Cody, Wyoming

FOREWORD

Frederic Remington, the well-known artist of the American West, has never been the subject of a major traveling exhibition. Earlier retrospectives, organized by the Amon Carter Museum in Fort Worth, Texas, and the Buffalo Bill Historical Center in Cody, Wyoming, presented a selection of the artist's work, but these exhibitions did not travel, nor did they offer the multiple viewpoints of the present exhibition.

Had *Frederic Remington: The Masterworks* been undertaken merely out of a sense of timeliness, the title would have been very different, as would the works of art selected and the topics discussed in the catalogue. The extensive research on which the exhibition and this book are based and, more important, a willingness to relook, rethink, and reevaluate the artist's oeuvre have resulted in the conclusion that Remington belongs not just in the forefront of artists of the American West but in the ranks of the best artists that America has produced.

Peter H. Hassrick, an established author of books on Remington's paintings, and Michael Edward Shapiro, a scholar of American bronze sculpture, began discussing this exhibition and catalogue more than five years ago. Enthusiastic commitment to the project on the part of The Saint Louis Art Museum and the Buffalo Bill Historical Center gave it impetus and direction. The unflagging cooperation of the Frederic Remington Art Museum and interested support from The Metropolitan Museum of Art provided an environment in which its quality and scope could grow.

We are grateful to The Henry Luce Foundation, whose generous grant supported the publication of this book. The grant allowed the researchers and writers to explore the archival holdings of the Frederic Remington Art Museum and to examine the many Remington paintings, drawings, and sculptures in private and public collections. We especially thank Mary Jane Hickey, program officer for the Luce Foundation, for her continuing supportive interest.

Merrill Lynch & Co., Inc., has generously sponsored the entire national tour of these works by this great American artist. The company's generous sponsorship has ensured that the exhibition will be seen by museum visitors in St. Louis, Cody, Houston, and New York.

Without the cooperation of the lenders, both institutional and private, we would not have been able to present an exhibition of such quality and breadth. We especially appreciate the generous participation of the Amon Carter Museum, Fort Worth, and The Thomas Gilcrease Institute of American History and Art, Tulsa. Those lenders who allowed their objects to be rephotographed for this book deserve special thanks.

Doreen Bolger Burke, Peter H. Hassrick, David McCullough, John Seelye, and Michael Edward Shapiro not only endorsed the concept of this exhibition but expanded it uniquely in their respective essays. We thank them for their insights into the artist and his work.

Frederic Remington: The Masterworks, exhibition and book, reflects the most recent scholarship of the community of American art historians. We hope that our efforts have opened new avenues of interpretation and visual experience. We are delighted to thank all those who have assisted us in celebrating, for the first time across the nation, the artistic accomplishments of a great American artist who died nearly eighty years ago.

James D. Burke
The Saint Louis
Art Museum

Peter H. Hassrick
Buffalo Bill
Historical Center

Peter C. Marzio
The Museum of
Fine Arts, Houston

Philippe de Montebello
The Metropolitan
Museum of Art

PREFACE

This book and the exhibition it accompanies assert that the art of Frederic Remington is in need of serious reevaluation and that his epic and highly distilled vision of the American West entitles him to a place in the pantheon of our most distinguished painters and sculptors. We hope that by gathering a highly selective body of Remington's finest paintings, sculptures, and drawings in a book that provides a clear view of the present state of Remington studies we will stimulate a higher level of critical discourse on this artist than has previously existed.

To call for a reassessment of an artist whose name is as widely known as Remington's may seem paradoxical; however, the popular success of some artists, particularly if they work in a realistic vein, occasionally is in inverse proportion to their critical esteem. Thus, Remington, long a popular favorite, has remained what we must call a critical failure. A range of circumstances has prevented a considered reflection on his work and its place in the art of the period.

During his lifetime, Remington never received a museum exhibition of any kind, nor was he accorded a retrospective after his untimely death in 1909. Perhaps his career had not been long enough or—a more damaging supposition—perhaps his works of art were not considered sufficiently significant. A felicitous aspect of the itinerary of this exhibition is that it includes The Metropolitan Museum of Art, the museum Remington most admired and one of the three institutions that acquired the artist's works during his lifetime.

The literature that forms the basis for our understanding of Remington's achievement has not, in general, been on the same level as the works of art in question, nor has it convincingly interpreted them. The first monograph on Remington, written by Harold McCracken and published nearly half a century after the artist's death, presented important information gleaned from archival and other primary sources in the straightforward, rather folksy manner that has characterized Remington scholarship until recent years.

Other factors—such as the considerable distance of many of the artist's key works from major cities, the widely held opinion that cowboys and Indians are subjects of little artistic substance, and the perception of western art as a category isolated from American art in other styles—all have combined to blur Remington's stylistic achievements, his relations with other artists, and the distinctive sense of closure, decline, and nostalgia in his paintings and sculptures. One other factor, the direct result of Remington's popular appeal, explains our difficulty in properly assessing his

sculptural innovations: the vast and unceasing production of recasts of his images, cranked out like paperweights, has deadened our understanding of the aesthetic and technical accomplishments that distinguished the original casts. But the tastes of cultural establishments are changing, and this book is a testament to that fact. It is unlikely that any museum would now deaccession Remington's paintings, as was done in the 1940s.

We now state with confidence that Remington was an artist of considerable versatility. His work includes not only the dynamic scenes of action for which he is best known but pictures of great melancholy and loneliness, such as *Coming to the Call* and *The Fall of the Cowboy*. He explored Impressionist sunlight (*Pete's Shanty, Ingleneuk*), Post-Impressionist abstractness (*Indians Simulating Buffalo*), and Symbolist inwardness (*The Outlier*), and his bronze sculptures have an equally wide formal range. Moving between smooth-surfaced but highly active and iconic images whose forms have been etched into the consciousness of our culture (*The Bronco Buster*) and utterly still and deeply textured bronzes (*The Norther*), Remington became one of the most innovative sculptors of his generation, defying the weighty nature of metal with a freedom that comes close to reckless abandon. If we invoke his gifts both as an illustrator and as a writer of fiction, we quickly see that he was enormously talented.

Remington had a powerful and complex personality. His Rabelaisian girth, his swaggering and expansive language, his narrow views, his friendships with such notable figures of the age as Theodore Roosevelt and Owen Wister, and with hunters, cowboys, and soldiers buttress our belief that he embodied many of the engaging as well as some of the unappealing aspects of turn-of-the-century America.

Our hope is that this book, written nearly eighty years after his death, may be seen as a turning point in the historiography of the art of Frederic Remington. A revisionist spirit in the scholarship of American art, coincidental with changing tastes in American cultural institutions, has made this an auspicious moment to assert the importance of his achievements. If occasionally a plaintive tone can be heard in our essays or if we seem to be trying too hard to prove our point, it is because we strongly believe we are righting an art-historical wrong, an error that has skewed our perception of Remington's life and work and the role they played in a complex era. In light of the varying interpretations of realism in contemporary art today, Remington's heroes and victims now appear uncannily modern.

Michael Edward Shapiro

Peter H. Hassrick

REMINGTON
THE MAN
By David McCullough

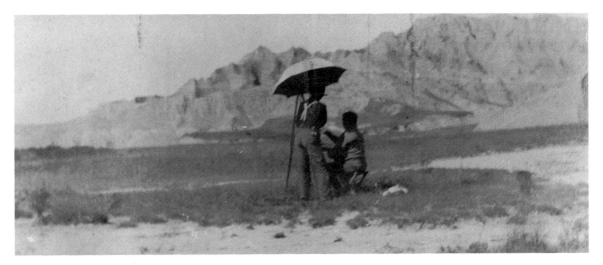

FIGURE 1. Remington painting in the Badlands. Frederic
Remington Art Museum, Ogdensburg, New York

He was never idle.
—Washington Post, 1909

The story is that young Fred Remington was standing at the corner of Ninth and Main
in Kansas City one summer day in 1885 when he saw a man he knew, a house painter
named Shorty Reeson, coming along in a spring wagon pulled by an ill-kept mare
that Remington liked the looks of. Remington was then twenty-four and down on his
luck. He had come west to make his fortune and in two years had succeeded in losing

a sizable inheritance, about $9,000, roughly half of what it had taken his late father a lifetime to accumulate. The young man's first western venture was a sheep ranch in central Kansas. When that failed, he saw his future in "hardware or whiskey—or anything else," as he said at the time. With the money left, he bought into a Kansas City saloon as a silent partner, but within a year it too had failed. In the meantime, his new wife had left him. She was Eva Caten from back home in upstate New York, where they had been married the previous October. After three short months in Kansas City, she packed her things and headed home—once she found that Remington was not a successful iron broker, as he had led her to believe, but the keeper of a low saloon. The one note of promise since her departure was the sale, through a local art dealer, of some western scenes he had painted.

Was the mare for sale? Remington called to Shorty Reeson, according to an old account in the *Kansas City Star*. She was not, Reeson said (he "being wise in the ways of horse trading"). Was she good under saddle? Remington asked. Best see for himself, Reeson said. So at the busiest intersection in Kansas City, in front of the Grand Junction Hotel, they unhitched the wagon and borrowed a saddle, and Remington swung up to give the horse a try. Satisfied, he agreed to a price of $50. And thus the next morning, sometime in August 1885, Remington left Kansas City behind him, heading west.

The scene could hardly be more appropriate—the lone figure of a man on the move, heading into an uncertain, possibly perilous, future in the prime of youth. The background is the Old West, but the man is of greater interest than the background. And of course there is the horse. For Remington there was always the horse. If he could have but one thing written on his tombstone, he once told a drinking companion, it would be "He knew the horse."

Besides, he had an audience for this turning point in his life, a vital element not overlooked in the old account. "They warned him of the perils. He smiled," it says. "They coaxed him, he went." His popularity as a "good fellow" was firmly established. Long afterward, the cashier of a billiard parlor spoke of him lovingly as "One Grand Fred." Recalling the time, Remington said, "Now that I was poor I could gratify my inclination for an artist's career."

He was born on October 1, 1861, in a big frame house that still stands on Court Street in Canton, New York, on the northwest watershed of the Adirondacks, which is

15

about as far north in New York State as it is possible to be without crossing into Canada (Fig. 2). His full name was Frederic Sackrider Remington. His father, Seth Pierre Remington, was the proprietor of a local newspaper, a lean, active man, ardent horseman and ardent Republican, who distinguished himself as a Union cavalry officer in the Civil War. His mother was Clara Bascomb Sackrider, whose family had a hardware business in Canton. An only child, little Freddie had the run of the town, his love for which was to be lifelong, as indeed it was for all of New York's North Country, as it is called. In 1873 the family resettled in nearby Ogdensburg, overlooking Canada on the St. Lawrence River. Seth Remington, "the Colonel," had been made Collector of the Port at Ogdensburg. He sold his newspaper and for both pleasure and profit began raising and racing trotting horses.

In a photograph taken at Canton shortly before the move, eleven-year-old Freddie, dressed in the visored cap and miniature uniform of a volunteer fire fighter, poses with the "heroes" of Engine Company One (Fig. 5). Twice in consecutive years Canton's business district—and the Colonel's printing plant—had been destroyed by fire. The Colonel rallied the town to establish three new fire companies, and Freddie was made an official mascot. On the Fourth of July he marched with his father and the other men of Engine Company One at the head of the parade. Full-grown, he stood five feet nine and weighed upward of two hundred pounds. He exuded physical power. An old Kansas City saloonkeeper who had seen plenty of rough men in his time described him as "a bull for size and strength," and said Remington could have been a prizefighter had he chosen. A Kansas City matron called him a Greek god who fairly "shone with the light of youth." Even as a schoolboy he cut an impressive figure. At sixteen, in a letter written from the Highland Military Academy in Worcester, Massachusetts, he portrayed himself as follows:

> I don't amount to anything in particular. I can spoil an immense amount of grub
> at any time in the day...I go a good man on muscle. My hair is short and stiff, and
> I am about five feet eight inches and weigh one hundred and eighty pounds.
> There is nothing poetical about me....They all say I am handsome. (I don't think so.)

He had been sent to another military school, the Vermont Episcopal Institute at Burlington, where he had his first formal art lessons, then to Highland Academy, where his pen drawings of soldiers and battles were considered a wonder by his

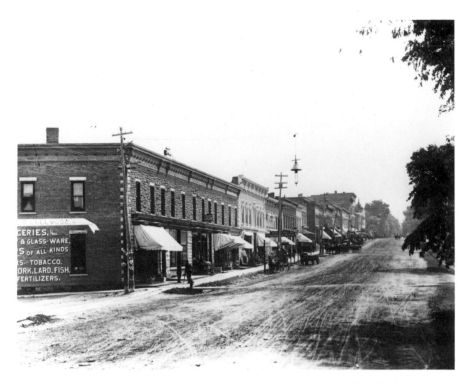

FIGURE 2. View of Canton, New York, in the 1870s. Frederic
Remington Art Museum, Ogdensburg, New York

classmates. He had no aspiration to any wealth or fame that called for excessive
effort, he wrote in bantering spirit to one of his Sackrider uncles. "I mean to study for
an artist." More often, he talked of pursuing a career in journalism like his father,
who was now in failing health and a worry. "Do you miss my 'gab' on martial sub-
jects?" the boy wrote after a visit to Canton. "Guess if I hadn't come home you would
have died."

At Yale he enrolled in the School of Fine Arts and played football, making a name
for himself as a first-string forward, or rusher, on the Yale team of 1879 (Fig. 3), the
last of the fifteen-man teams, whose captain was the famous Walter Camp, the "Fa-
ther of Football." The program at the School of Fine Arts was under the direction of
John Ferguson Weir, an accomplished, European-trained painter known for his dra-
matic portrayals of heavy industry. Instructions in drawing were under John Henry
Niemeyer, "the German," who held to the classic drill of drawing only from plaster
casts and who inscribed on the blackboard a maxim of Ingres's: Drawing is the Probi-

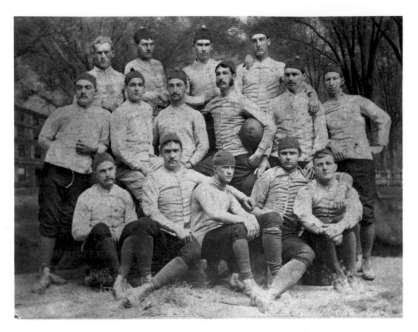

FIGURE 3. The Yale football team in 1879 (Remington in front row, far right). Frederic Remington Art Museum, Ogdensburg, New York

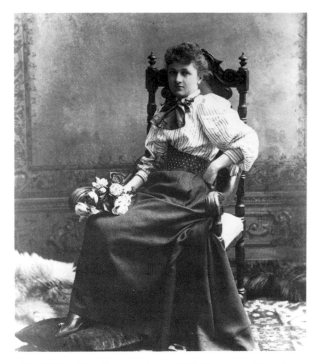

FIGURE 4. Eva Remington. 1884. Frederic Remington Art Museum, Ogdensburg, New York

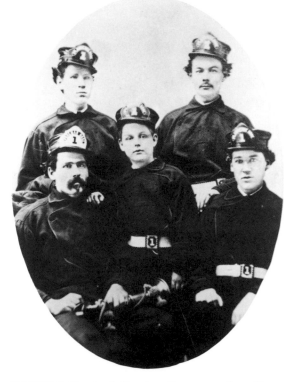

FIGURE 5. Canton's Engine Company One (Remington at center). 1872. Frederic Remington Art Museum, Ogdensburg, New York

ty of Art. When asked for guidance by an aspiring young artist long afterward, Remington said his advice was never to take anyone's advice, but then added, "Study good pictures and above all draw—draw—draw—and always from nature."

Repeatedly over the years, he would portray himself as self-taught, and in the main this was so. Nevertheless, his Yale training, brief as it was, served him well and in some of his mannerisms—figures of speech, the clothes he wore—he was to remain unmistakably a product of Yale, more Yale than cowboy, ever after. Friends were addressed as "old boy" or "old chap," words like "bully" became habitual. Traveling to and from the West by train, he was frequently mistaken for an Englishman.

On the death of his father, in 1880, Remington dropped out of Yale after only a year and a half. He tried different jobs in Ogdensburg and Albany, stuck to none, worried about his future, proposed to Eva Caten and was turned down by her father, went west briefly—to Montana Territory and principally for the fun of it—came home with some sketches and a pale blond mustache. Again he tried a clerk's life in Albany, disliking every moment. On coming into his inheritance at twenty-one, he took off immediately for Kansas, the sheep farm, and his string of misadventures.

Neither his mother nor Eva Caten took an interest in his artistic efforts or held any hopes for him in that line. Only one member of the family, William Remington, a favorite uncle who owned a Canton dry-goods store, remained convinced that the boy's future was in art. Had anyone else who knew his story been in Kansas City to see him ride away that summer of 1885, they could not possibly have envisioned all that happened so soon after.

His success was sudden and extraordinary. He became focused as he had never been. His capacity for concentrated effort, his energy and productivity were all at once boundless. In little more than a year, back from his wanderings through New Mexico and Arizona, reunited with Eva (Fig. 4), his bank account nicely enhanced by his Uncle Bill, he had established himself as a magazine illustrator in New York. He had an apartment in Brooklyn and an entree at *Harper's Weekly*, the country's leading magazine, where he made his first call dressed in full cowboy regalia. In short order he was discovered by *St. Nicholas* and *Outing* magazines. In 1887 *Harper's Weekly* alone carried thirty-nine of his sketches and drawings. He received a commission from *Century Illustrated Magazine* to illustrate a new series of articles by young Theodore Roosevelt, articles that would later appear as a book, *Ranch Life*

and the Hunting Trail. The next year more than seventy Remington drawings and sketches appeared in *Harper's Weekly*. His income was a princely $8,000. He was working now in pen and ink, oil, and watercolor. In 1889, the year of his enormous oil *A Dash for the Timber* (Plate 1), he and Eva bought a large house on a hill in suburban New Rochelle, New York, with stables and a sweeping lawn. By 1890, only five years after being down and out in Kansas City, he was one of the best known artists in America, a full-blown celebrity at the age of twenty-eight. In 1890 *Harper's Weekly* ran more than a hundred of his illustrations, seven as double-page spreads. Furthermore, he was now writing as well as illustrating. He painted *A Cavalryman's Breakfast on the Plains* (Plate 6), *Cabin in the Woods* (Plate 2), *Aiding a Comrade* (Plate 7), and *The Scout* (Plate 5). He had his first one-man show. Eva described him as working as if he had forty children to support. For a new illustrated edition of Longfellow's *Song of Hiawatha*, the largest commission he had yet received, Remington would produce twenty-two full-page plates and nearly four hundred drawings.

The improvement in his work, meantime, was astonishing. The first drawings for *Harper's Weekly* had, as editor Henry Harper said, "all the ring of new and live material," but they were "very crude" in execution and had to be redrawn by staff artists. The early oil *Signaling the Main Command* (Fig. 6), painted in 1886, is so stiff, so awkwardly handled overall, that one wonders how possibly it could have been done by the same artist who painted *A Dash for the Timber* just three years later.

In *Signaling the Main Command* everything is at a standstill, everyone rooted to the ground. Horses and men are like cutouts pasted down on a drab backdrop and on each other. There is no air between them, no life in any gesture. By contrast, *A Dash for the Timber* is everything suggested by its inspired title (Remington was good at titles). The excitement is terrific. The massed riders charge pell-mell, nearly head on at the viewer. Their horses are flying—hardly a hoof touches the ground—and the dead weight of the one rider who has been hit makes the action of the others, and of the pursuing Indians, all the more alive. The dust flies, guns blaze away, the wind whips the big hat brims. There is no time for second thoughts. It is big action in big space. The painting is nearly the size of a mural, measuring four by seven feet. It drew immediate attention when accepted for exhibition at the National Academy of Design and remains one of the masterpieces of American painting, let alone western art.

Some of Remington's subject matter, like *Hiawatha*, had nothing to do with the West. On occasion, the magazines commissioned sporting sketches, for example. *Cabin in the Woods* was a North Country scene, and there were to be more as time went on. It was the West, however, that the editors and his public wanted most, the Wild West—cowboys, horses, soldiers, renegade Indians, and action, lots of action— and at intervals during all the work, he kept going back and forth to the West to gather material. He became known as the expert on the subject. The widespread impression was that Remington's West must be authentic, the *real* West, and this accounted in no small measure for his popularity. The editor of *Century*, the highly cultivated Richard Watson Gilder, is said to have offered Remington a box of cigars and said: "Tell me about the West." "He draws what he knows and he knows what he draws," the readers of *Harper's Weekly* were informed in a biographical essay on the artist.

It was said repeatedly—and usually with Remington's encouragement—that he had been a cowpuncher himself, that he had seen action with the troops, when in truth he had never done either. He had experienced a lot of hard riding with the cavalry in New Mexico and Arizona, in Montana and the Dakota Territory. He had known and observed countless cowboys and Mexican vaqueros, Cheyenne, Apache, Sioux, and Crow Indians. He had seen nearly all the West in every season and made friends everywhere he went sketching and painting or simply using his eyes. "Without knowing exactly how to do it, I began to try to record some facts around me," he later explained, "and the more I looked the more the panorama unfolded. Youth is never appalled by the insistent demands of a great profession."

Like so many before him and since, he found the West physically and emotionally invigorating—therapeutic. He loved the air, the dazzling light, the freedom he felt in such "grand, silent country." But it was there also that he had staked his claim professionally—"Cowboys are cash," he told a friend—and rather than trying to dress the part, to play cowboy or soldier, he seems to have gone out of his way to be conspicuously the observer only, to be nobody but Frederic Remington. On one grueling cavalry exercise in the heat and dust of June in Arizona, an expedition that seems to have been designed in part to test his endurance, he measured up well enough to be elected an honorary member of the troop—he was made the mascot again by his uniformed heroes—but he went wearing an English safari helmet.

On another of his forays, in Montana in 1890, he arrived at an Eighth Cavalry encampment on the Tongue River sitting astride a tall horse and wearing a huge brown canvas hunting coat swelling with pockets, yellow English riding breeches, and fancy Prussian boots set off by long-shanked English spurs. It was a memorable spectacle. On his head this time was a tiny, soft-brimmed hat, which in combination with the canvas coat made him look bigger even than he was. A man of phenomenal appetite for good food and drink, Remington had become by then "a huge specimen of humanity," weighing perhaps 250 pounds. When he dismounted, it is said, the horse appeared glad to be rid of him. A young officer who was present on that Montana trip, Lieutenant Alvin H. Sydenham, himself an amateur artist, described Remington as a "big, good-natured, overgrown boy" and left this intriguing account of Remington's working methods in the field:

> I watched this fat artist very closely to see "how he did it." My stock of artistic information was as great when he went away as it was before he arrived. There was no technique, no "shop," about anything he did. No pencils, no notebooks, no "kodak"—nothing, indeed, but his big blue eyes rolling around at everything and into all sorts of queer places. Now and then an orderly would ride by, or a scout dash up in front of the commanding officer's tent. Then I would see him look intently for a moment with his eyes half closed—only a moment, and it gave me the impression that perhaps he was a trifle nearsighted.

One morning before dawn, Sydenham was awakened by a prolonged scratching at the flap of his tent. It was Remington asking for a "cavalryman's breakfast." Sydenham didn't know the expression. "A drink of whiskey and a cigarette," Remington said. The story quickly made the rounds, to the advantage of Remington's already considerable popularity with the men.

To Sydenham, Remington was "a fellow you could not fail to like the first time you saw him," and others would later say much the same. Though never a cowboy or soldier, never a good shot, often bothered by the sight of blood, he relished the comradeship of "hard-sided," plainspoken men, "men with the bark on," who loved the outdoors as he did and welcomed his high spirits and his fund of stories. Nothing gave him such pleasure, he said, as sitting about with good companions "talking through my hat." He was always just arrived from somewhere far, always on his way somewhere else interesting. In the words of a lifelong friend, an Adirondack hunter and guide named Has Rasbeck, "Remington never stays put for long in any one place, but

there's an awful lot of him while he's around."

He called the soldiers of the Indian-fighting army "my tribe," and they, more even than the cowboys and ranchers, were the "real West," both in what he painted and what he wrote. It was a highly selective reality, to be sure, as he knew perfectly well. The real West of the sod-house homesteader, of crops and families, of small towns and railroads had no appeal for him. He never responded to any of that as did such chroniclers as Willa Cather or his friend Hamlin Garland, for whom, like Cather, the West was native ground. Remington's westerner is a horseman, the wild-riding soldier or cowboy, and Remington's West is a place of endless conflict, his horsemen ever battling with the elements or the Indian, another horseman, who to Remington is a true savage and so joined with the elements. Nature in his West is never benign or sustaining. It is remorseless, a killer—and thus antithetical to civilization—to any but the brave and uncomplaining. Indeed, it was the very advance of "the derby hat, the smoking chimneys, the cordless binder" that impelled him, he later said. "I knew the wild riders and the vacant land were about to vanish." The whole picturesque way of life of his tribe was as doomed as that of their Indian foe.

While the rest of the country spoke of the advance of the frontier, the "taming" of the West, as a positive force in the building of American civilization, to Remington the frontier was receding and, in the end, a tragic loss. He went west to chase a disappearing past, not to find the future. To him the West was more a place in time than any part of the map or something to own. His paintings and drawings, the things he wrote, had nothing to do with dreams of a home in the West. He bought no land there and wanted none. He never lived there, never stayed more than a month or two at a time. Some of it he thought ugly and depressing, like the Dakota Badlands that so entranced Theodore Roosevelt. What mattered were those wild riders; they were the "living breathing end" of a time that must not go unrecorded or uncelebrated.

Roosevelt, too, in books and articles, was trying to capture the open-range West before it was gone. So also was their mutual friend the writer Owen Wister, whose articles Remington illustrated. The three saw themselves joined in common cause. They encouraged, advised, and complimented one another. "It seems to me that you in your line, and Wister in his, are doing the best work in America today," Roosevelt wrote to Remington. He considered Remington the country's greatest living painter and was hardly less enthusiastic about Remington's writing. "Are you aware...that

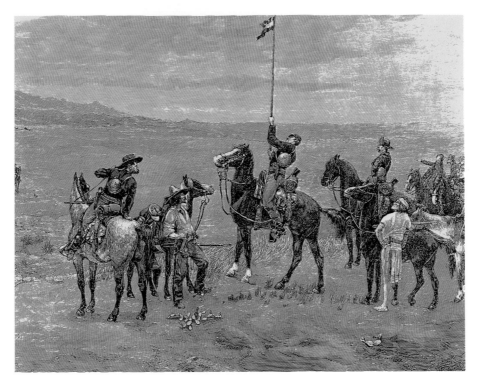

FIGURE 6. Frederic Remington. *SIGNALING THE MAIN COMMAND.*
1886. Engraving of an oil painting reproduced in *American Heritage,* April
1975, p. 11. Frederic Remington Art Museum, Ogdensburg, New York

aside from what you do with the pencil, you come closer to the real thing with the pen than any other man in the western business?" Roosevelt asked Remington in 1897, by which time Remington had published more than sixty articles. "I don't know how you do it," Roosevelt continued, "anymore than I know how Kipling does it."

Wister was a Philadelphian, a Harvard graduate like Roosevelt, wealthy, citified, a little finicky, anything but a westerner. Kidding him with advice on how to do a proper western story, Remington wrote, "Put every person on horseback and let the blood be half a foot deep. Be very profane and have plenty of shooting. No episodes must occur in the dark." Wister privately thought of Remington as a "rollicking animal" and "the most uneven artist I know," as he confided to his mother, but he provided a glowing introduction for a portfolio-sized book of Remington drawings called *Done in the Open.* Remington, he said, was more than an artist, he was a national treasure. It was out of the creative production of Roosevelt, Wister, and Remington—three easterners—that a heroic vision of the Wild West emerged to claim the popular

imagination just as the nineteenth century was about to end, a vision that persists undiminished at the close of our own century; and it was in the East, in comfortable surroundings, that their important work was done. Roosevelt wrote his spirited accounts of roundups and bucking horses at a desk at Sagamore Hill, his twenty-two-room house overlooking Long Island Sound at Oyster Bay. Wister "pegged away" at the first true Western in American literature, *The Virginian*, while escaping a Philadelphia winter in Charleston, South Carolina. Remington produced the great body of his work in a "Czar-sized" (as he said) studio built to order on his hill at New Rochelle, from where he, too, could catch a glimpse of Long Island Sound.

But of the three Remington had, as Roosevelt admitted, the greatest talent and the greatest influence. He produced much, much more, in print and on canvas, and with greater feeling. However selective or romanticized his West may be, he loved it with a passion. His work, as he said, was always more a matter of heart than head.

His pleasures were simple. He loved horses, dogs, good cigars, snowstorms, and moonlit nights; fresh vegetables, pancakes, spareribs, pigs' knuckles, salt pork and milk gravy, roast beef—nearly everything ever put on his plate but spinach and Virginia ham, which he thought tasted like stove wood. ("How that man would eat," recalled a waitress at an Adirondacks hotel. "My, my, my, how that man would eat!") When he was drinking, which was often, he preferred Scotch or martinis, and apparently he could drink just about anyone under the table. According to his biographers Peggy and Harold Samuels, he could drink a quart of liquor in an evening.

He was a warm friend, by all accounts, a generous host, and a faithful correspondent who enlivened his letters with delightful little drawings, often as a way of poking fun at himself. His spelling was atrocious. (He spelled *whom* with an *e* on the end, *humor* was *humer*. He even had trouble getting the names of his best friends right.) Dressed for one of his expeditions into New York, he wore a silk hat, kid gloves, and patent-leather shoes, and carried a walking stick with an elk-horn handle. Otherwise he was without pretense and considered the best of company by many of the prominent figures of the day. He counted among his friends General Leonard Wood, dramatist Augustus Thomas, architect Cass Gilbert, the painters Childe Hassam and John Twachtman, and his fellow illustrator Howard Pyle.

He and Eva had no children, nor does he seem ever to have shown the least interest in children. His life was his work, his travels, his friends, his lunches in town at the

Players' club, an occasional black-tie dinner, and Eva, for whom, it is said, he had an abiding devotion. She was small and dark-haired, with large wistful eyes. He called her "kid," because she was three years older. In one letter she refers to him as "my massive husband," and in old photographs and drawings of the two together, she looks about one-third his volume (Fig. 9).

He named their house at New Rochelle "Endion," an Algonquin Indian word meaning "the place where I live" (Fig. 10). At first he worked in the attic, then downstairs in the library. Later, he built a studio twenty-four by forty feet and twenty feet high, with a stone floor, brick fireplace, and a big skylight such as he had never had before. He filled it with his treasured props—old rifles, revolvers, an 1840s cavalry saber, a pair of snowshoes, riding paraphernalia. There was an immense moose head over the fireplace, a human skull on the mantelpiece, Indian rugs on the floor, Indian pots and baskets scattered about—drums, tomahawks, any number of beaded shirts and moccasins hanging on the walls. It was all just as he wanted, the place where he liked most to receive friends or to be photographed. The double doors at one end were high and wide enough for him to bring a mounted horse in and out.

On a typical day he worked from eight in the morning until three in the afternoon, preferably sitting down in a broad, low-slung rocking chair, so that he could tilt back to appraise his progress without getting up (Fig. 11). He worked fast, totally absorbed and whistling some tune over and over until it drove anyone else present to distraction. After three, he went for a ride or a long walk, though as time went on and his weight increased, the walks became less appealing. Dinner finished, if there was company he would hold forth in the studio again, in a big leather chair, "talking half the night." One year he went to Europe on assignment with Poultney Bigelow, a magazine writer and editor whom he had known at Yale. Another year, he made a hurried visit to North Africa, again with Bigelow. Summers, he headed home to the North Country, often to Cranberry Lake, his favorite lake in the Adirondacks, where he would sit in the shade of the hotel porch sketching or trying to hit a loon with his rifle. (He said he shot a ton of lead into the lake and never killed a bird.) With his Adirondack hunting companion Has Rasbeck, he made a canoe trip down the Oswegatchie River, from Cranberry Lake to where the Oswegatchie empties into the St. Lawrence, descending 1,100 feet in about fifty-one miles, an adventure he described in his favorite of all the articles he wrote, "Black Water and Shallows." "The zest of

The following pages contain
people who know us.

Yours faithfully
Frederic Remington.

(above left) FIGURE 7. Photograph of Remington. 1909. Frederic Remington Art Museum, Ogdensburg, New York

(above) FIGURE 8. Eva listening to Theodore Roosevelt giving a speech about her husband at Cheyenne, Wyoming, on August 28, 1910. "The Indian is civilized, the cowboy is passing, the cattle are taming; even the cayuse is passing into history," Roosevelt said. "One man's work, however, will preserve them for all time in pictures and in bronze…this man was Remington." Frederic Remington Art Museum, Ogdensburg, New York

(left) FIGURE 9. Frederic Remington. Cartoon of Remington and Eva. n.d. Pen and ink on paper, 9¼ × 7¾ in. (23.5 × 19.7 cm.). Frederic Remington Art Museum, Ogdensburg, New York

the whole thing," he said, "lies in not knowing the difficulties beforehand."

In 1895, one of the most important years of his working life, his first book was published, a collection of fifteen magazine pieces that he called *Pony Tracks*. He painted *The Fall of the Cowboy* (Plate 10) and was now working in "mud," as he said, sculpting, and beside himself with pleasure, despite the difficulties of the unfamiliar medium. He had found the recipe for being "Great," he notified Wister. The result was his first bronze, *The Bronco Buster* (Plate 47), or "Broncho Buster," as he spelled it. ("Is there anything that man can't do?" an artist friend exclaimed, on hearing of Remington's latest efforts.) Remington was sure his sculpture would make him immortal. "My oils will all get old and watery—that is they will look like *stale molasses* in time—but I am to endure in bronze....I am going to rattle down through all the ages." He had only been fooling away his time until now, he felt certain. "Well—come on, let's go to Florida," he urged Wister, "you don't have to think there. We will fish."

Yet, for all this, the exhilaration of the work, the pleasures of home, friends, the voluminous, convivial style of the man, he was churning with anger and distress, anguish over his weight and his drinking. He was beset with fears of getting old. He abhorred the times he was living in, the "enfeebling" present. The country was going to hell and he seethed with indignation over the ineptitude of the "peak-headed, pigeonbrained men in public life." Europe was nothing but a "ten-cent sideshow," literary critics were "library upholstery."

In one of his stories in *Pony Tracks*, he observed that the cowmen of the West were good friends and virulent haters. Certainly he was too, whether by nature or imitation. When his mother was remarried to a man of whom he did not approve (and for no apparent reason, save possibly that he was a mere hotelkeeper), Remington refused to speak to her ever again.

He despised much of mankind—Italians, Jews, "stinking" Russians, "Polacks," Hungarians—virtually every one of the new Americans pouring into the country through Ellis Island. They were the rubbish of Europe, said this most American of American artists. He once said he liked writing for the magazines because it gave him a chance to use his right, that is, as a boxer does, to hit hardest. In one article, "Chicago Under the Mob," an account of the Pullman Strike riots of 1894, during which twelve men were killed, he made pointed contrast between the soldiers, his favorite

Tenth Cavalry, all "tall, bronzed athletes," and the "malodorous crowd of anarchistic foreign trash" they had to face down (Fig. 12). But this was mild compared to the outbursts in his private correspondence and some of his diary entries, which went beyond any visceral response to a crisis like the Pullman riots, or the kind of offhand slurs and bigotry common in that day.

"Never will be able to sell a picture to a Jew again," he told Poultney Bigelow, "did sell one once. You can't glorify a Jew...nasty humans."

> I've got some Winchesters [the letter continued] and when the massacring begins which you speak of, I can get my share of 'em and what's more I will. Jews— injuns—Chinamen—Italians—Huns, the rubbish of the earth I hate.

The country was flooding with trash; it was no longer the America of "our traditions," he remarked in another letter to Bigelow who, as has been said, seemed to bring out the worst in him.

He longed for "a real blood letting," a war. He started harping on it as early as 1891. When revolution broke out in Cuba and it looked as though the United States and Spain might go to war over Cuban freedom, he wrote to Wister as excited as a twelve-year-old. "Say old man there is bound to be a lovely scrap around Havana—a big murdering—sure." It was his ambition, he said, "to see men do the greatest thing which men are called upon to do." His one regret was that so many Americans would have to be killed just "to free a lot of d—— niggers who are better off under the yoke." The only combat he had ever experienced firsthand was on the Yale football field.

On assignment from William Randolph Hearst, owner of the *New York Journal,* he and Richard Harding Davis, the era's most glamorous correspondent, sailed for Cuba to cover the uprising waged by the rebels, if the rebels could be found. Remington and Davis reached the island in January 1897. Reportedly, Remington soon cabled Hearst: "Everything is quiet. There is no trouble. There will be no war. I wish to return." To which Hearst is supposed to have replied: "Please remain. You furnish the pictures and I'll furnish the war." Hearst later denied the story. In any event, Remington came home empty-handed and sorely disappointed. But when Davis sent a dispatch about an incident in which a refined young Cuban woman, Clemencia Arango, was stripped and searched by Spanish officials on board an American ship in Havana because she was thought to be a courier for the rebels, Remington was called

in immediately to do a drawing for the *Journal* (Fig. 13). It ran five columns wide, its dramatic effect expertly handled by Remington, who contrasted the pale skin of the naked young woman with three hovering, heavily shadowed Spaniards who have not had the courtesy even to remove their hats. With only the Davis dispatch to go by, he had understandably assumed the Spanish officials were men. It was one of the few times Remington ever rendered the female form. "I don't understand them, I can't paint them," he once said of women. But the drawing caused a sensation. That edition of the *Journal* sold nearly a million copies, a record number. Seeing the story and drawing for the first time, Señorita Arango was mortified. The one Spanish official who had searched her was a woman, she said. The atrocity was a fake.

The war with Cuba, when it came, was the most wrenching, disillusioning experience of Remington's life. It was nothing like what he had expected; it bore no resemblance whatever to the high drama and heroics he had been painting and writing about for so long. There were no horses this time, no grand, silent country for background. There was smothering heat instead, mud, rain, yellow fever, dysentery, atrocious food or none at all, the strange jungle pressing in all around. He knew he had made a mistake in returning almost from the time he arrived. "The men were on half-rations, were out of tobacco, and it rained, rained, rained. We were very miserable," he reported in *Harper's Monthly*, writing now with no romantic illusions concerning the glories of war, writing, as it happens, one of the best accounts to come of the brief, ten-week conflict in Cuba. Nor was he anything but honest about his own behavior under fire: "A ball struck in front of me, and filled my hair and face with sand, some of which I did not get out for days. It jolted my glass [field glasses] and my nerves and I beat a masterly retreat, crawling rapidly backwards, for a reason which I will let you guess." He saw face wounds for the first time and trenches full of Spanish dead. "Their set teeth shone through their parted lips, and they were horrible." It was all horrible. "All the broken spirits, bloody bodies, hopeless, helpless suffering which drags its weary length to the rear, are so much more appalling than anything else in the world that words won't mean anything to one who has not seen it." Worst was the specter of white bodies lying in the moonlight, with dark spots on them. According to Remington, it took him a year to get over Cuba.

Meantime, he painted *Charge of the Rough Riders at San Juan Hill* (Plate 16), which makes the war look more like a football game than what he had written about, and

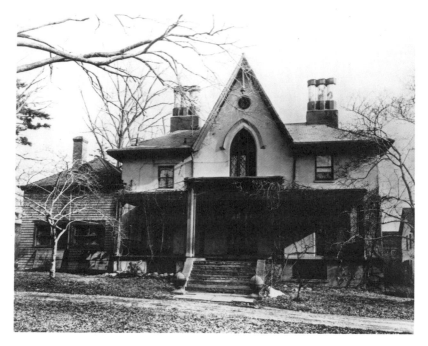

FIGURE 10. Remington's house in New Rochelle,
New York. Frederic Remington Art Museum,
Ogdensburg, New York

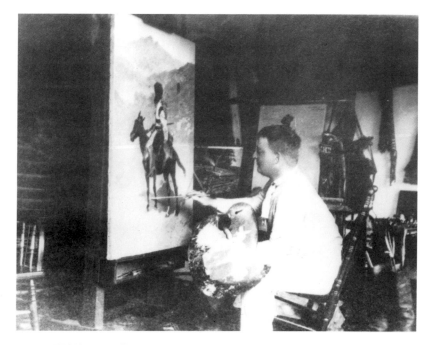

FIGURE 11. Remington painting *AN INDIAN TRAPPER*. 1889.
Frederic Remington Art Museum, Ogdensburg, New York

Missing (Plate 20), in which he returned to "my war," to give gallantry its due again: a stalwart cavalryman, his arms bound, a rope about his neck, walks stoically to his fate at the hands of his Indian captors, a good soldier to the last.

"I have spread myself out too thin," Remington told Wister as the new century began. He was overworked, "crazy with work." He vowed to do no more writing. (After 1905, having published more than a hundred magazine articles and two novels, he abandoned writing altogether.) If the fellows who sold groceries could take vacations, he mused, why couldn't he?

He bought a small island, Ingleneuk, in the St. Lawrence River upstream from Ogdensburg, at Chippewa Bay. He and Eva spruced up the house on the property, built a studio and a boathouse and put in a tennis court. Nothing he had ever owned, no place he had ever seen pleased him more. All his life he had needed the outdoors, as a release and a restorative. That had been chief among the attractions of the West. But here he was home in his own part of the world (Fig. 15). He could swim, fish, grow vegetables, or, having eased his immense bulk slowly into place, go paddling off in one of his beautiful cedar canoes built in Canton by his old friend J. Henry Rushton, who is still remembered as the Stradivarius of canoemakers (Fig. 14). He could climb about the rocks along the shore on moonlit nights. Some nights were so clear and still he could hear a dog bark over in Canada. It was also an excellent place for him to go on the water wagon, as he said, since Eva allowed no liquor on the island, which in all comprised about five acres (Fig. 16).

The best part of it for Remington was that he could work there as nowhere else, "away from publishers' telephones," as he said, "trolleys—fuss that makes life down in the big clearing—which I hate." He was fed up with "progress," now more than ever. In 1885, when he set off for the West on Shorty Reeson's horse, electric trolleys were still a thing of the future in Kansas City, telephones few, long-distance calls made possible only that same summer. The years since had seen the advent of the skyscraper, the automobile, the phonograph, and the adding machine, as well as the discovery of the X ray and the cause of yellow fever—advances in science and technology that brought unprecedented change on all sides and seemed to nearly everyone else entirely welcome, even thrilling. This, after all, was the *twentieth* century. Remington's friend Theodore Roosevelt, now the president of the United States, was

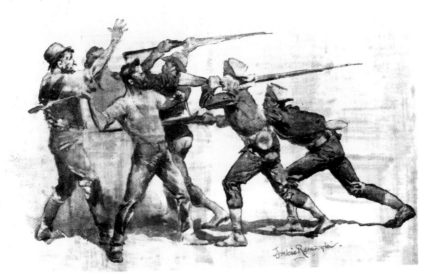

FIGURE 12. Frederic Remington. *GIVING THE BUTT*.
Pen and ink on paper. Reproduced in "Chicago Under
the Mob," *Harper's Weekly*, July 21, 1894. Frederic
Remington Art Museum, Ogdensburg, New York

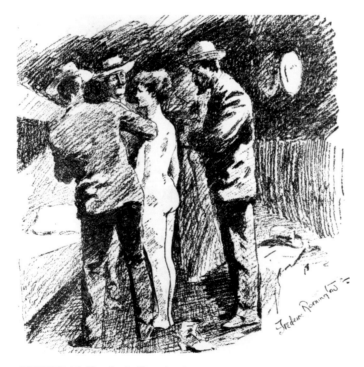

FIGURE 13. Frederic Remington. *SPANIARDS SEARCH
WOMEN ON AMERICAN STEAMERS*. 1897. Pen and ink on paper.
Reproduced in *New York Journal*, February 12, 1897

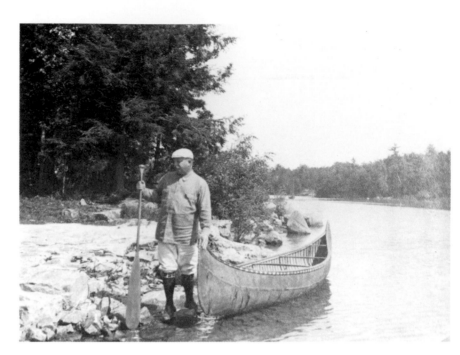

FIGURE 14. Remington at Ingleneuk. Frederic
Remington Art Museum, Ogdensburg, New York

building the Panama Canal. Magazine publishing had been revolutionized by the
invention of photogravure printing, which for Remington meant his work could now
be reproduced in color. He signed an exclusive contract with *Collier's* to do six paint-
ings a year, the subjects entirely of his choosing, for $6,000, and he maintained the
rights to the paintings. So because of the new technology he could paint as he
pleased, knowing his work would reach an audience of a size never before granted
an artist.

 Still, he claimed no use or affection for modern times. He was sour on all cities. He
refused to own an automobile. To any who thought differently, he said: "Go to your
microbes, your statistics, your volts, and your bicycles, and leave me the truth of
other days." His terrible problem was that the adored other days of the West were to
be found no more, though he kept trying. "Shall never come west again," he wrote to
Eva during one trip. "It is all brick buildings—derby hats and blue overalls—it spoils
my early illusions." On a later expedition, a wilderness camping trip near "Buffalo
Bill" Cody's ranch in Wyoming, he barely survived a blizzard, too much whiskey, and

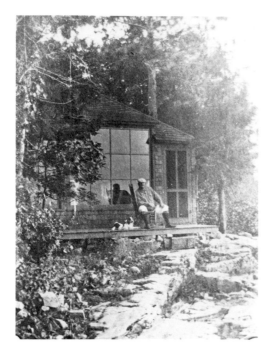

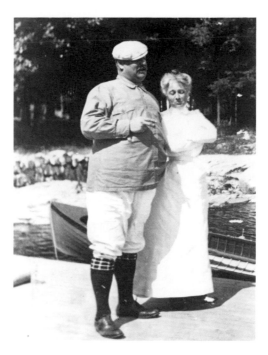

FIGURE 15. Remington on the porch of his studio at Ingleneuk. Frederic Remington Art Museum, Ogdensburg, New York

FIGURE 16. "Ingleneuk Indians" (Fred and Eva Remington). Frederic Remington Art Museum, Ogdensburg, New York

a "d—— old bed which made pictures all over me." He couldn't wait to get home. "Cowboys! There are no cowboys anymore!" he exclaimed.

In the big studio at New Rochelle in 1905, he had begun his most ambitious project yet, an enormous statue of a cowboy on horseback for Fairmont Park in Philadelphia. It was to absorb him for several years. But at Ingleneuk he concentrated strictly on his painting.

A change had come over his painting. The brushstrokes were looser and the light in his pictures was more diffused. He concentrated more on color than on line. He was painting pure landscapes, with none of the "story" quality obligatory in so much of the illustration he had done since the beginning. He was bound and determined to be accepted as an artist, not "just" an illustrator. Mostly, he was painting to please himself and painting the North Country with a zest.

Remington's magnificent *Evening on a Canadian Lake* (Plate 28), among the most evocative of all his works, is of two friends in one of his Rushton canoes. Other paintings from these last summers of his life are *Pete's Shanty, Ingleneuk* (Plate 40), *Chip-*

pewa Bay (Plate 35), and several oil sketches titled *Pontiac Club, Canada* (Plate 45). They were nearly as much a departure from his previous work as was his first venture in sculpture.

His western scenes, too, had a different quality. More and more of them were nocturnes like *Night Halt of the Cavalry* (Plate 37). "No episodes must occur in the dark," he had told Wister. Now he was absorbed in painting moonlight.

It was as if he wished to start all over. On Friday, February 8, 1907, he had carried seventy-five of his old western scenes outside at New Rochelle and burned them. A year later, on January 25, 1908, "a fine winter day," he did it again, building a big bonfire in the snow behind the house. This time he destroyed sixteen, including two of his best-known cowboy paintings, *Bringing Home the New Cook* (1907) and *Drifting Before the Storm* (1904). "They will never confront me in the future," he noted with satisfaction. His father, too, had once stood and watched his work go up in flames.

Remington at forty-six, the age his father had been when he died, thought about death a great deal. His father, dying of tuberculosis, had wasted away to almost nothing. Remington by 1908 weighed nearly three hundred pounds.

His diary from Ingleneuk, however, is filled with exhilaration in the new work, his unabashed happiness with the life there.

> May 26 . . . am getting on famously with my paintings.
> May 28 Worked to good purpose—made a success of *Pony Herds* which had got away from me.
> May 30 . . . I am doing great work. A man to work should not have anything else happening.
> June 5 Beautiful day—worked all morning—have 5 pictures done . . . am learning to use Prussian [blue] and Ultramarine in proper way.
> June 22 . . . I have now discovered for the first time how to do the *silver sheen* on moonlight.
> June 26 . . . made sketch [of] Pete's cabin—a nice impressional use of the vivid greens of summer. . . . Having bully swims these days and feeling fine.

That fall he would write, "I have always wanted to be able to paint running horses so you would feel the details and not *see* them. I am getting so I can stagger at it." He had arrived at an outlook not unlike that described by Delacroix in his journals:

"What I require is accuracy for the sake of imagination." Remington was then at work on his *Cavalry Charge on the Southern Plains in 1860* (Plate 30), a painting in concept not unlike *A Dash for the Timber*, but very different in execution. He was progressing with "quite good results," Remington thought, "better tone—looser."

With the new work under way, he craved new surroundings. For some years he and Eva had talked of building a house of their own design in the country. They found land in Ridgefield, Connecticut, and began construction. Everything was to be bigger than at New Rochelle. In May 1909 they moved in, and for all there was to do, Remington managed to keep painting. "I am performing miracles," he wrote at the end of a particularly good workday in June. He was bothered by stomach troubles—he thought maybe potatoes were his problem—but in one of the last of the diary entries, on October 9, he writes that he had not been so happy or felt so well in many years. One of his western nocturnes, *Fired On* (Plate 32), had been purchased for the National Gallery in Washington.

He died in the house at Ridgefield on the morning of December 26, 1909. He had complained of intense stomach pains a few days before when he and Eva were in New York. They made it home that night, but the following day an emergency appendectomy was performed on the kitchen table. It was to no avail. The doctors found that the appendix had ruptured and peritonitis had set in. For about forty-eight hours it seemed to others that the operation had been successful. Christmas Day there was a snowstorm of the kind Remington loved. He seemed to be comfortable through the morning, even optimistic, as the family exchanged presents. But the doctors knew there was no hope, and in the afternoon Remington went into a coma from which he never recovered. He was forty-eight years old.

On the first day of that year, New Year's Day, 1909, the man who in his lifetime had produced more than three thousand works of art wrote in his diary: "Here we go again...embarked on the uncertain career of a painter."

REMINGTON
IN THE CONTEXT
OF HIS ARTISTIC
GENERATION

By Doreen Bolger Burke

FIGURE 17. Frederic Remington. *RETURN OF THE BLACKFOOT WAR PARTY*. 1888. Reproduced in George William Sheldon, *Recent Ideals of American Art* (New York: D. Appleton & Co., 1888–89). Photograph courtesy of The Metropolitan Museum of Art, New York

In an era when European styles, subjects, and training held sway, Frederic Remington stands out as an American-trained artist who devoted himself to the most American of subjects—the West—painted, drawn, and sculpted with a vitality and vigor we like to consider national traits. Shortly after the artist's death, Theodore Roosevelt praised his work as embracing "all the most vivid and characteristic features of the Western pioneer life which is just closing."[1] This theme became the leitmotif of dis-

cussions of Remington's career. His art was initially appreciated by an audience drawn to western subjects. The first major monograph on his life and work, written by Harold McCracken, was published in the aftermath of World War II, when patriotic sentiments were strong. More recent scholars, most notably Peter H. Hassrick, Michael Shapiro, and Estelle Jussim, have given us a fuller picture of Remington the painter, sculptor, and illustrator. But Remington can also be studied as a member of his artistic generation. To make a simple analogy: If Remington's life were a play and this essay a review, I would mention the leading man in passing (that much is unavoidable) and would dwell on all that surrounded him—supporting actors, stage setting, even stage crew.

The elements of Remington's career to be considered are like those of any other artist of his period: How was he trained? What was the subject matter of his art? How did he fit or try to fit into the art establishment, both to achieve recognition and to sell his work? In what ways can his method and his style of painting and sculpting be related to the methods and styles of artists working at the same time? What were his connections with other artists, both European and American, and what did he have in common with them?

"I am going to do America"

French training and French art set the course for painting and sculpture in America for the duration of Remington's career. In an age when his contemporary William Merritt Chase proclaimed, "I'd rather go to Europe than go to heaven"[2] and when some of America's most accomplished artists, James McNeill Whistler, Mary Cassatt, and John Singer Sargent among them, settled permanently abroad, Remington remained a tenacious, vocal advocate of native art and artists. "No honey—I shall not try Europe again," he wrote to Poultney Bigelow in 1897. "I am not built right. I hate parks, collars, cuffs, foreign languages, cut and dried stuff. No Bigelow—Europe is all right for most everybody but me. I am going to do America—it's new—it's to my taste."[3] In a sense this rhetoric was self-justifying. Not only did Remington eschew foreign training but he also made only one quick trip to Europe, in 1892, and his purpose then was to prepare illustrations, not to study art. Among Americans who aspired to a career in the fine arts (as opposed to decorative work, engraving, or illustration), the pattern of Remington's career was unusual, if not exceptional. Even

the handful of late nineteenth-century painters who studied solely in America—Winslow Homer and Albert Pinkham Ryder are two important examples—for the most part made formative trips to Europe.

With respect to Remington's training and early career, however, it is essential to remember that he began as an illustrator, not as a painter or sculptor. Illustration did not become a part of the academic program in art schools until the 1890s, and illustrators tended to have less formal education and to learn on the job (the custom of having staff artists redraw an inexperienced illustrator's submitted sketch was a form of criticism not unlike that practiced by teachers in established academies). Illustrators also tended to work within a fairly limited range of subject matter, relying on their knowledge of costumes, customs, and accessories as much as on their skill as draftsmen. Remington was no exception. While learning the basics of his profession—mainly the drawing and painting of the human figure—he too selected a specialty, scenes of the American West, and began to gather sketches, photographs, costumes, and objects that would make him the acknowledged expert on his subject. Among the multitude of American illustrators who were Remington's contemporaries, Edwin A. Abbey did mainly Shakespearean subjects, Howard Pyle historical and literary subjects, and Edward Kemble scenes of black life in America (Fig. 18). For these illustrators, foreign training was not a necessity. Abbey spent most of his career in England, but that was hardly a surprising move, given his choice of subject. Pyle and Kemble worked in Europe only briefly, late in their careers. It is hardly surprising that Remington the illustrator never sought the European imprimatur so many of his artistic generation deemed essential.

Despite his pursuit of art training at home rather than abroad and his devotion to American subjects, Remington was aware of foreign art and art methods, particularly those of the French. John H. Niemeyer (1839–1902) and John F. Weir (1841–1926), his instructors at the Yale School of Fine Arts, were familiar with developments in Paris. Niemeyer, a German-born painter, had studied there for four years during the late 1860s—at the Ecole des Beaux-Arts under Jean-Léon Gérôme and Adolphe Yvon and in an independent class conducted by Louis-Marie-François Jacquesson de la Chevreuse, a follower of Ingres's. Weir, director of the School of Fine Arts, had studied with his father, Robert W. Weir, and perhaps at the National Academy of Design, in New York—but he, too, showed a keen interest in art education in the French capital. He closely followed his brother Julian's career as a student in Gérôme's stu-

FIGURE 18. Edward W. Kemble (American, 1861–1933). *THE PREACHER*. 1886. Pen and ink on paper, 13½ × 9 in. (34.3 × 22.9 cm.). The Metropolitan Museum of Art, New York. Gift of Spencer Bickerton, 1934

dio during the 1870s and from him obtained examples of figure studies executed by pupils at the Ecole, which he made available to his own pupils at Yale. Among these was *Nude Study of a Man* (Fig. 19), painted in 1875 by Pascal-Adolphe-Jean Dagnan-Bouveret, which would have been on view while Remington was a student in New Haven. It was the Parisian school and its rigorous academic program, centered on the study of the nude, that inspired the instruction at Yale. "I wish you would write me out the programme—in regular order—of your studies in the Beaux-Arts . . . as I want to model our plan upon it to some extent," Weir wrote to his brother in Paris in 1875,[4] and indeed the program offered at the School of Fine Arts in 1878–79 and 1879–80, the years Remington was there, seems to reflect the example of the Ecole.[5] Instruction was offered in drawing, first from the antique and then from the living model; advanced pupils studied painting under Weir much as they would have under Gé-

41

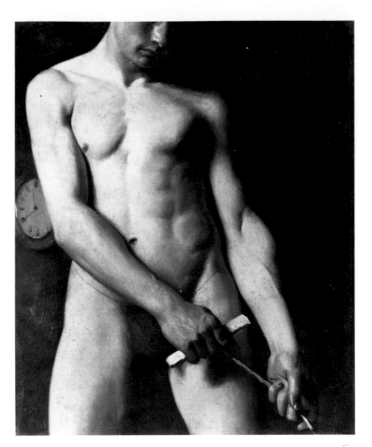

FIGURE 19. Pascal-Adolphe-Jean Dagnan-Bouveret (French, 1852–1929). *NUDE STUDY OF A MAN*. 1875. Oil on canvas, 16 × 13 in. (40.6 × 33 cm.). Yale University Art Gallery, New Haven, Connecticut. Gift of Julian Alden Weir

rôme or other instructors at the French school. As at the Ecole, additional lectures were offered on anatomy and perspective. In its aim "to furnish an acquaintance with all branches of learning relating to the History, Theory, and Practice of Art," the Yale program echoed the broad purpose of the instruction at Paris.[6] During the 1878–79 academic year, for example, there were lectures on etching by Charles C. Perkins; on architecture by William R. Ware; and on art in America by Clarence Cook.[7]

How much did Remington glean from his experience at the Yale art school? Much has been written about the inadequacies of the curriculum. Remington's fellow student Poultney Bigelow maintained that "no studio was better designed if its object was to damp the ardour of a budding Michael Angelo."[8] Little if any work done there by Remington survives. While Remington played down the importance of his formal

training, his wife, in response to an inquiry by Weir about her husband's tenure at Yale, asserted that "the instruction and inspiration which you gave him helped him through his entire art career."[9] Weir, whose experience of Europe was limited, may eventually have served as a role model for the young artist. Even during the 1880s, after traveling in Europe with his cosmopolitan brother Julian, Weir maintained that an art student could learn the essentials of his craft without studying abroad; later, Weir admitted, when the student had completed his formal training, foreign travel would enable him "to find more virile nourishment in the great world of nature and art." Weir even asserted that "artists of great merit, of exceptional genius"—a category in which Remington unquestionably placed himself—did not even need "systematic training such as the academy furnishes" because "their 'academy' was often comprised in the persistent preparation they themselves enforced."[10]

On a more practical level, Remington's method of utilizing sketches and photographs made on the scene in order to assemble elaborate compositions in the studio seems to reflect the example of such pictures by his mentor as *Forging the Shaft* (Fig. 20). Moreover, Weir's exploration of American subjects at a time when French subjects were attracting the interest of many American painters may have reinforced Remington's own inclinations. It was certainly the subject matter, not the style, of Weir's work that excited critical comment. "This artist has recognized that, after all, art is chiefly noble for that which it expresses," wrote Edmund C. Stedman of *Forging the Shaft*.[11] Remington may also owe a small debt to Weir for his taste for dramatic compositions and his careful drawing.

Niemeyer's impact on Remington is more difficult to evaluate, for much less is known about this teacher's life and work. Perhaps it is significant that Niemeyer was interested in sculpture and sculptors. While in Paris, he reportedly instructed Augustus Saint-Gaudens in the methods of Jacquesson; he must also have had some influence in the decision to add sculpture to Yale's curriculum in 1879–80, Remington's last year at the school; and later he actually worked as a sculptor.[12] Niemeyer's teacher Gérôme worked as both painter and sculptor and, following a reorganization in 1863, the Ecole des Beaux-Arts placed a greater emphasis on the unity of the fine as well as the decorative arts. By 1879 students at the Ecole were expected to work in painting, sculpture, and architecture, and four years later the trend was formalized in a class described as "cours simultané des trois arts."[13] Because so many Americans studied there during the second half of the nineteenth century, the school's

principles soon permeated American art education. Any number of Americans—Thomas Eakins, George de Forest Brush, and Frederick MacMonnies among them—worked both as painters and as sculptors. Yet no other American of the period seems to have mastered the technical and aesthetic possibilities of a second medium quite as completely as Remington. When he took up sculpture in 1894, he began to create pieces that can be related in subject and composition to his paintings, but they transcend the painted images in the originality of their conception and execution. While Remington's achievements as a sculptor remain to his credit alone, his attraction to sculpture may well date to his student days.

Remington resumed his studies in the spring of 1886, after a western sojourn and a series of important personal events—the death of his father, the squandering of his inheritance, and his marriage to Eva Caten. He was already working as an illustrator (the first of his sketches, redrawn by a staff artist, had appeared in *Harper's Weekly* four years before) and so was looking for a particular type of training, one that would hone his skill in his chosen profession. The Art Students League of New York appealed to him for any number of reasons. Founded in 1875, when a group of irate students left the National Academy of Design in protest, the League a decade later still maintained a liberal reputation. "There is little of the academic in [its] methods," explained one writer in 1884. "Study is given a picturesqueness by the absence of cast-iron regulations which would confine a student to a branch of art he had no sympathy for, simply because it was a part of the course."[14] Some of Remington's fellow students were already professional illustrators, and many well-known painters and sculptors attended the lectures, exhibitions, and informal lectures offered there. Remington enrolled in the painting class taught by J. Alden Weir (1852–1919), the younger brother of his instructor at Yale, and in this class, which was, incidentally, open to women, he painted the draped nude, the head, and still life.[15] At the time he entered the League, Remington could have chosen to study with Weir or with William Merritt Chase, both of whom offered painting courses. Students were urged to select the instructor whose "individuality may best advance them in their studies,"[16] so we must conclude that Remington preferred Weir, who had studied with Gérôme in Paris, to Chase, who practiced the virtuoso technique of the Munich school. Weir had not yet adopted the Impressionist style for which he is best remembered; he was still working in a more restrained realistic mode, influenced by such academic naturalists as Jules Bastien-Lepage and by more progressive artists like

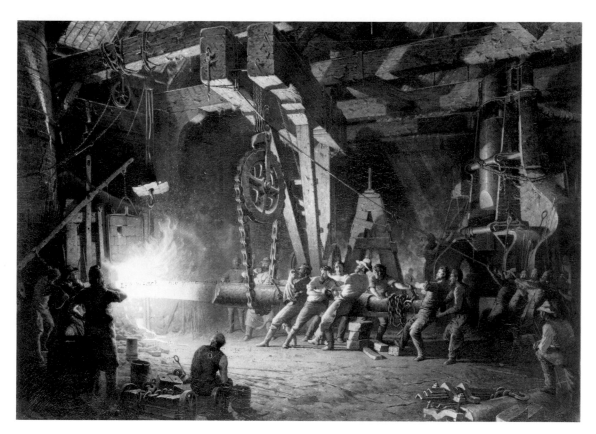

FIGURE 20. John Ferguson Weir (American, 1841–1926).
FORGING THE SHAFT. 1874–77. Oil on canvas, 52 × 73¼ in.
(132 × 186 cm.). The Metropolitan Museum of Art,
New York. Gift of Lyman L. Bloomingdale, 1901

Edouard Manet. During the 1880s Weir's figure paintings, often domestic composi-
tions featuring his wife, Anna, and their daughter, Caro, were alien to Remington's
work in their subject matter. *Idle Hours* (Fig. 21), painted two years after Remington
studied with him, displays some of the formal elements of Weir's art that may have
attracted the younger artist. Although Weir had begun to paint in a lighter key, incor-
porating the effects of light and atmosphere, his drawing was careful, his brushwork
controlled, and his composition consciously balanced. Even at so advanced a date in
his career, a decade after his return from Paris, Weir was still working in a manner
inspired by Gérôme: his compositions, based on preliminary drawings and sketches,
were assembled in the studio. Weir's tutelage doubtless reinforced the painstaking
working procedure that Remington learned at Yale and was already using as an
illustrator.

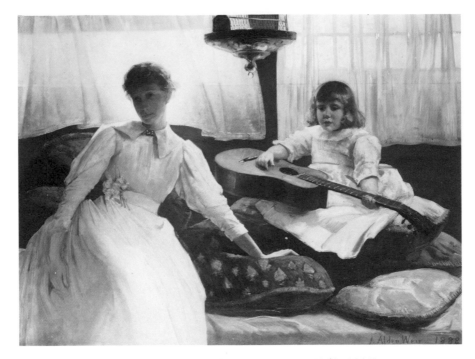

FIGURE 21. J. Alden Weir (American, 1852–1919). *IDLE HOURS*. 1888. Oil on canvas, 51¼ × 71⅛ in. (130.2 × 180.7 cm.). The Metropolitan Museum of Art, New York. Gift of Several Gentlemen, 1888

"I stand for the proposition of 'subjects'"

Subject matter was, perhaps, Remington's primary concern as an artist. For many of his contemporaries, as we shall see, it was not. From the outset of his career, during a period when foreign subjects as well as foreign styles were enormously popular, Remington chose American subject matter, and though he did experiment from time to time with new themes, for the most part he specialized in one particular aspect of his chosen area. In 1890, declining a commission to do some Civil War drawings, he explained: "I do not know enough about it. It is a mistake to think I can handle that subject. I am weak enough at times to attempt things which I know little or nothing about but if I ever give it a second thought I withdraw."[17] His early success with his subjects is due in part to the manner in which he treated them: his realistic style, direct presentation, and dramatic compositions greatly enhanced their impact. Finally, as Remington's career progressed and he strove to become a painter and not merely an illustrator, the character of his subjects changed: he depicted quieter, less

action-packed moments, suggesting moods and emotions rather than relating a narrative.

During the 1880s, when Remington began to paint seriously and to exhibit his work for critical appraisal, many American painters recently returned from study in Paris and Munich preached what the art critic Mariana G. van Rensselaer described as a "gospel of technique": "the painter's first privilege, first task, first duty was *to learn the art of painting.*"[18] Influenced by Aestheticism, many became absorbed in the formal qualities of their art—in line, color, and design—and sought subjects that enabled them to transcend external appearances and to suggest moods and emotions. James McNeill Whistler (Fig. 22) is perhaps the best-known exponent of these ideas, which are often summarized as "art for art's sake," but the American landscape painters George Inness and J. Francis Murphy and the American figure painter Thomas W. Dewing, for example, also painted works that demonstrate a concern for decorative elements and invite quiet contemplation through their choice of subject. Remington initially espoused a very different and a more traditionally American point of view. "I stand for the proposition of 'subjects'—painting something worth while as against painting *nothing* well—merely paint," he wrote to his friend Al Brolley. "I am right—otherwise I should as soon do tatting, high-art hair pins or recerchia ruffles on women's pants."[19] As early as 1890, he noted a "fundamental split" between himself and "the school which holds that subject matter is of no importance in painting" and proclaimed, "I was born wanting to do certain phases of life and I am going to die doing them."[20]

Even among those who shared Remington's commitment to subject, few embraced strictly American themes with his degree of enthusiasm. During the 1880s, the art world was dominated by cosmopolitan painters, many of whom depicted European subjects—genre scenes set in exotic or historical settings, peasants at work and at rest, and even mythological and allegorical figures. "To the sore plague of a swarming immigration of actual European peasants . . . is added the weariness of painted ones—German, Italian, Dutch and French—who swarm over the walls of our exhibition-rooms," lamented Clarence Cook in 1888.[21] The call for *American* subjects had begun. Even George W. Sheldon, a supporter of the younger, more international painters, admitted that "an influential minority" has made " 'America for the Americans' . . . their watchword; 'let the painter study art in his own land, and paint the subjects that suggest themselves around him.' "[22] Several writers pointed to

western subjects as a particularly fruitful choice for American painters. "Just think of the life of the pioneers in the West; of the gold-diggers, miners, trappers; of the collisions with the Indians, Mexicans, Chinese, negroes," urged Friedrich Pecht.[23] Any number of American painters and illustrators responded to this challenge. Worthington Whittredge, Albert Bierstadt, Thomas Moran, and Thomas Hill had long since captured the splendor of the western landscape. George de Forest Brush, Willard L. Metcalf, and Henry Farny all traveled west during the early 1880s and produced illustrations of Indian life. A new generation of painters soon took up western subjects in their figure paintings.

Remington's western pictures, while original in their treatment, can be related to more obviously cosmopolitan art. His friend Julian Ralph, writing in 1895, observed of him, "Without imitating any Frenchman, without an inspiration that he consciously owes to France, he yet is French in the stubborn allegiance to the truth that he puts in every picture he makes."[24] So regularly, for example, does Gérôme's name appear in the biographies of Remington's teachers and so widely was he known in New York that it seems reasonable to ask what indirect influence this important French teacher may have exerted on Remington. Gérôme's Middle Eastern subjects appealed to European and American audiences in part because they appeared to be such accurate depictions of life in unfamiliar, even exotic places. Many of Gérôme's pictures depict or suggest violence, albeit violence distanced by time or place, and this is a common theme in Remington's work, even in his scenes of contemporary life.

The works of two of Gérôme's American students—George de Forest Brush and Thomas Eakins—are particularly interesting to compare with Remington's. Brush and Eakins were both closely associated with the Art Students League while Remington was a pupil there in 1886—Brush as an instructor and Eakins as a lecturer on anatomy—and their work demonstrates a continued dependence on Gérôme's example. After spending the summer of 1887 on a ranch in the Dakota Territory, Eakins painted *Home Ranch* (1892) (Philadelphia Museum of Art), a figure study whose transported musician recalls Gérôme's *Bashi-Bazouk Singing* (1868) (Walters Art Gallery, Baltimore), and *Cowboys in the Bad Lands* (Fig. 23), whose figures looking out over the vast western landscape are the human counterparts of the majestic lion in Gérôme's *The Two Majesties* (Fig. 24).[25] In the American Indian, Brush found a native parallel to what he described as Gérôme's "semi-barbaric" subject matter. As in Gérôme's *The Prisoner* (Fig. 25), Brush's Indian hunters in *The Moose Chase* (Fig.

FIGURE 22. James McNeill Whistler (American, 1834–1903). *NOCTURNE IN BLACK AND GOLD: ENTRANCE TO SOUTHAMPTON WATER.* c. 1872–74. Oil on canvas, 20 × 30 in. (50.8 × 76.2 cm.). The Art Institute of Chicago. The Stickney Collection, 1900

26) are figures detailed in anatomy, powerful in gesture, and arranged in a dramatic composition.[26]

The differences between Brush's and Remington's Indian paintings are clarified by the criticism written during the late 1880s in connection with exhibitions of work by both artists. In 1887 Brush was praised by Clarence Cook for choosing a quintessentially American subject and for "eschewing Greeks and Romans, as well as French and German peasants," but condemned for "presenting these tribes to us under a romantic or sentimental guise." Cook explained, "If the Indian is to be interesting to us at all, it will only be by showing him to us as he is today, in real life, not in weak compromises between that reality and the unreality of Cooper or Chateaubriand."[27] Remington elicited just the opposite response the following year: his *Return of the Blackfoot War Party* (Fig. 17) was described as "a caricature instead of a reality."[28] In another review, Cook maintained that beside Remington's picture, Brush's "really looks like the work of a clever person." In a sweeping condemnation he concluded: "the meanness of Mr. Remington's subject is matched by the meanness of his painting."[29]

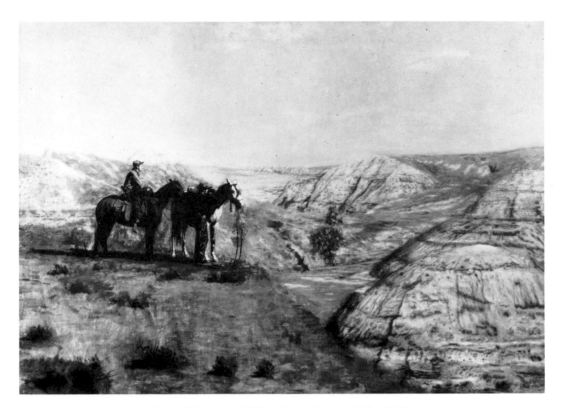

FIGURE 23. Thomas Eakins (American, 1844–1916).
COWBOYS IN THE BADLANDS. 1888. Oil on canvas, 32½ ×
45½ in. (82.6 × 115.6 cm.). Private collection. Photograph
courtesy of Sotheby Parke-Bernet Inc., New York

Of all the French painters, it was Jean-Baptiste-Edouard Detaille, Alphonse-Marie
de Neuville, and even Jean-Louis-Ernest Meissonier who had the strongest and most
visible effect on Remington's work, particularly his depictions of American cavalry-
men and cowboys. The work of these three French military painters was often exhib-
ited and discussed during the 1880s, the decade when Remington was formulating a
style and compositions appropriate for depicting the American military man (Fig.
27). Remington, who rarely hinted at his interest in other artists, asked for de Neu-
ville's "last autotype" as a Christmas present in 1879.[30] Years later, on a trip to Mexi-
co, he likened the cavalrymen there to "the happiest phase of soldier vagabondism
that De Neuville ever conceived."[31] In works like *Through the Smoke Sprang the
Daring Soldier* (Plate 14) Remington utilizes some of the compositional devices em-
ployed in de Neuville's *Combat sur une Voie Ferrée* (Fig. 28). The viewer seems to

FIGURE 24. Jean-Léon Gérôme (French, 1824–1904).
THE TWO MAJESTIES. 1883. Oil on canvas, 27¼ × 50¾ in. (69.2 ×
128.9 cm.). Layton Art Collection, Milwaukee Art Museum

FIGURE 25. Jean-Léon Gérôme (French, 1824–1904).
THE PRISONER. 1861. Oil on panel, 18⅞ × 30¾ in.
(47.9 × 78.1 cm.). Musée des Beaux-Arts, Nantes

FIGURE 26. George de Forest Brush (American 1855–1941).
THE MOOSE CHASE. 1888. Oil on canvas, 37⅝ × 57⅝ in.
(95.6 × 146.4 cm.). National Museum of American Art,
Smithsonian Institution, Washington, D.C.

participate in the battle: standing with the soldiers, who occupy the foreground, he faces an unseen enemy. The drama of the scene is heightened by the theatrical poses of the combatants. Some rush into battle silhouetted against the landscape and others fall injured, the interrupted action of their demise recorded with almost photographic accuracy.

When Remington began painting the American soldier, a group of established painters—Thure de Thulstrup, Gilbert Gaul, Julian Scott, William T. Trego, and John Mulvany—all slightly older than Remington, had already made a specialty of Civil War scenes. Many had served in the army during that war or gone to the front as observers. The works that these and other American military painters exhibited during the 1870s and 1880s (Fig. 29) were mentioned in reviews, sometimes favorably, but as a category of subject matter, Civil War battle scenes hardly elicited a strong positive response. Assessing Frederick Rothermel's *Pickett's Charge, Battle of Gettysburg* (1870) (Pennsylvania Historical and Museum Commission), on view at the Centennial Exposition in Philadelphia, Susan N. Carter called its theme "an unsuitable reminder . . . of discords that are past and troubles which will scarcely be renewed."[32]

A. T. Rice, editor of the *North American Review*, expressed similar sentiments in an essay on the progress of American painting published the following year. After noting the lack of public interest in American battle subjects, Rice commented that "artists and public were willing that the recollections of our Civil War should drop into oblivion" and declared: "If this be so, it is well that painters should have led the way in this patriotic feeling, and done nothing to commemorate a struggle which all are now willing to forget."[33] Curiously, this was just when battle subjects by European painters like Detaille, de Neuville, and Meissonier were extremely popular with American collectors. It seems not to have been the violent content of such scenes that was distasteful but rather the violence of the *national* conflict. Remington took a type of subject to which patriotic sentiment had attached a taboo and made it acceptable. Instead of showing American soldiers fighting each other he depicted American soldiers and cowboys fighting the American Indian.

Remington remained committed to Western subjects throughout his career, but after 1900, as he struggled to establish himself as a painter, the subject matter of his art took on a new flavor. He eschewed action for contemplation. Turning from what one of his contemporaries described as "the 'beer and skittles' side" of western life, he chose subjects that same writer believed told its "serious tale"—"the tale of the man who spends most of his time by himself, communing with nature."[34] The enormous change of attitude is evident in a comparison between *A Cavalryman's Breakfast on the Plains* (Plate 6), an elaborate series of vignettes about military camp life crowded into a single canvas, and *Night Halt of the Cavalry* (Plate 37), in which the men and horses huddled beneath a starry sky are barely visible. *Night Halt* was hailed as exemplifying Remington's "new method" when it was on view at Knoedler's in 1908:

> He is either forgetting or purposely putting aside the recollection and influence of the color and technique employed by his first art heroes, de Neuville and Detaille, and is achieving a manner that has been evolved out of the subjects which he paints, so that his color is more and more inevitably related to his ideas, as if Nature herself had spread his palette. He has grown to think through his paint so freely and fluently that in some of his more recent work he seems to have used his medium unconsciously, as a great musician does his piano and score.[35]

This new approach is also evident in some of his sculpture, for example, *The Norther* (Plate 54), where one man and his mount confront the elements with stoic bravery.

"I wonder if this bunch will make artistic New York sit up?"

The exhibition and promotion of Remington's work was determined not only by opportunity, but by the goals the artist set for himself first as an illustrator, then as a painter, and finally as a sculptor. However he displayed or sold his work in any medium, Remington was always concerned about his reputation. Even late in life, when success seemed assured, he remained apprehensive about how his colleagues would react to his work. "I wonder if this bunch will make artistic New York sit up?" he was still pondering in 1909.[36] He was actually embarrassed by some early work that later appeared on the art market, and he even burned some paintings that he considered inadequate, noting with relief in his diary, "They will never confront me in the future—tho' God knows I have left enough that will."[37]

Remington's options for exhibition and sale were set by the time and place in which he worked, yet within these limitations he pursued a remarkably independent and imaginative course. It is interesting that he recognized the national appeal of his art. He displayed his work not only in obvious East Coast cities like New York and Boston, but also in Chicago and St. Louis. (A list of dealers in one of his many address books notes potential agents in Rochester, Buffalo, and Syracuse, New York, as well as in New Haven, Pittsburgh, Cincinnati, Milwaukee, and San Francisco.)[38] When he began to work in bronze, Remington sometimes marketed his sculpture through luxury stores like Tiffany's, which specialized in jewelry and fine decorative objects.

As the American art market expanded, he was quick to perceive ways in which he could use new forums for the promotion of his work. He began to exhibit at a time when the commercial art world was first really developing in New York. Before the Civil War, and even during the 1870s, painters had often sold their work themselves, attracting patrons at studio receptions or at the much-anticipated spring exhibitions of the National Academy of Design. By the 1880s, there were more art galleries in New York, although, like Knoedler's or the gallery run by Samuel P. Avery, most specialized in European rather than American art. The hegemony of the Academy was also challenged by any number of new artists' organizations sponsoring annual exhibitions, the Society of American Artists among them, but many of these catered to the needs of artists who had studied and traveled extensively abroad, so Remington remained outside their orbit. He was not generally a joiner of art organizations, nor did he often display his work in the many annual and special exhibitions held in New York and elsewhere during the 1880s and 1890s. He exhibited with the Society of

FIGURE 27. Frederic Remington. *MILITARY SCENE*. c. 1875–77.
Frederic Remington Art Museum, Ogdensburg, New York

American Artists only twice, in 1891 and 1892, and never joined; he was not a member of the American Watercolor Society; he never even displayed his work at the Salmagundi Club, a group of illustrators with whom he had much in common.

Remington's wavering involvement with the National Academy of Design demonstrates the relation between his ambitions and the way in which he exhibited his work. His greatest interest in the Academy dates to two crucial periods when he strove to establish his reputation as a fine artist rather than as a mere illustrator: during the late 1880s and early 1890s and, again, in the final years of his life. He first displayed his work at the Academy in its spring annual in 1887 and continued to do so intermittently until the end of the century; he also contributed to the less important autumn show from 1888 to 1891. His exhibition pieces received mixed reviews. Whereas *Return of the Blackfoot War Party* had been severely criticized in 1888, *A Dash for the Timber* (Plate 1), on view the following year, was described in the *Daily Tribune* as "a perfectly truthful study, painted with care for facts rather than pictorial effect."[39] A writer for the *New York Times* was more positive. This critic praised Remington's ability as a draftsman and his "render[ing] with unusual truth effects of

FIGURE 28. Photograph after Alphonse-Marie de
Neuville (French, 1836–1885). *COMBAT SUR UNE VOIE
FERRÉE*. 1874. Oil on canvas, 67¾ × 85 in. (1.72 ×
2.16 m.). Musée Condé, Chantilly. Thure de Thulstrup
Papers, The Metropolitan Museum of Art, New York.
Gift of Mrs. Robert Ingersoll Aitken, 1951

FIGURE 30. Model posed on a wooden barrel.
Photograph in Remington's collection.
Frederic Remington Art Museum, Ogdensburg,
New York

FIGURE 29. Julian Scott (American, 1846–1901).
CIVIL WAR SCENE. 1872. Oil on canvas, 20 × 16 in.
(50.8 × 40.6 cm.). The Newark Museum. Gift of Dr.
J. Ackerman Coles, 1920

strong sunlight," noting that *A Dash for the Timber* was the picture that attracted most of the Academy's visitors.[40] But as the next decade wore on, Remington failed to receive rave reviews; worse still, the artistic qualities of his work were ignored and it was simply praised for its "vim," its "vigor," its "accent either richer or more strenuous"—comments that alluded to its unusual, even peculiar, subject matter.[41]

Remington did not exhibit at the Academy after 1899. His decision to seek other outlets for the promotion and sale of his work may have been reinforced by an event that occurred in 1900. At that year's spring annual, Charles Schreyvogel, a relatively unknown New Jersey painter, won the prestigious Thomas B. Clarke prize for figure painting with a western subject, *My Bunkie* (c. 1899) (The Metropolitan Museum of Art), gaining precisely the sort of recognition that Remington coveted for himself.

The artist members of the Academy must have responded with some enthusiasm to Remington's work at the beginning of his career. He could have been proposed as an associate member any year he contributed to the Academy's spring exhibition (this rule was altered over the years); election required a two-thirds vote of the Academicians attending the annual meeting. Remington received no votes in 1887 and 1888; he did not contribute to the spring annual in 1889 or 1890 and so was not considered then; and finally, in 1891, he was elected an associate with forty-two votes, the same number received by John Singer Sargent. Only two painters, Charles S. Reinhart and William L. Picknell, received a greater number, forty-seven and forty-four, respectively.[42] He immediately fulfilled the last requirement for associate membership—a portrait of himself—and then seems to have lost interest in his status at the Academy. There is some indication that he was later considered for election as an Academician. In 1897 and 1899 his name was recorded in the Academy's nominations ledger, albeit with only one or two names endorsing his membership.[43] After the turn of the century, he garnered more support, but never enough to ensure his election: in 1906 he received only 28 of the 128 votes needed for election, and in 1908 and 1909 his friends Gilbert Gaul and Childe Hassam continued to promote his election, but to no avail.[44]

From the outset, Remington looked to the commercial world for ways to promote his reputation and sell his work. In 1890 he participated in a group exhibition held at the American Art Association, where he was one of ten artists, William Merritt Chase and Francis D. Millet among them, who displayed what was described as the best and most representative of their work. One critic, writing for the *New-York Daily Tribune,*

was quick to compare Remington's work with Chase's, stating that Remington's paintings seemed "illustrative rather than pictorial." He also pointed out the feature of his work that would be lauded throughout the decade: its "historical value." "His pictorial record of the conflict between savagery and the agents of civilization in the far West may become of as permanent usefulness in its way as Catlin's ethnographical studies."[45] While generally praised for his choice of subject, Remington was repeatedly taken to task for his lack of technical ability.[46] While questioning whether such a large display of his work was advisable, a critic itemized his failings:

> His colors are so shrill and his temperament is so prone to violent movement that a collection of his pictures gives the impression of a thousand discordant noises, yells of battle, screams of dying horses, and the crudeness of existence between a pitiless sky and a pitiless earth, without the compensation of beautiful colors and noble forms.... He remains the illustrator in black and white who, with a magnificent but short-sighted audacity, has taken to color. He is not at home with oils and brushes; his paintings hurt.[47]

Meanwhile, Remington's reputation had been bolstered by flattering notices in *Harper's Weekly*. Since so many of his illustrations appeared in this magazine, its editors featured articles that described his "robust personality" and the "lightning speed of his thought and speech and movement."[48] It was *Harper's Weekly* that heralded the first exhibition and auction sale of Remington's work at the American Art Association in 1893 as including "some of Mr. Remington's largest and most ambitious canvases illustrating scenes accompanying the conquest of our West."[49] This and a second sale, held in 1895, took place at a time when American illustrations were first being exhibited and collected seriously; new photomechanical processes made it possible to reproduce a work of art without damaging or destroying it, an advance over wood engraving, where the original was sacrificed as the engraver worked on the block. The issue of illustration aside, in these sales Remington was following the example of such contemporaries as Chase, John La Farge, J. Alden Weir, and John H. Twachtman; a lack of dealer interest in American art forced them to seek patrons through public auction. In terms of critical notice, Remington's 1893 sale was the more successful, perhaps because it was the first major display of his work as a painter. Writers pointed to his accomplished draftsmanship and noted a decided improvement in his painting technique.[50] As usual, however, his ability as a colorist was questioned: "His color is dry and opaque; there is nothing artistic in his

textures, nor is there personal feeling in his brushing, and there is not one of his paintings which would not look as well, if not better, in a black and white reproduction on a smaller scale."[51]

By the turn of the century, when New York art dealers had begun to exhibit American works more often, Remington turned to commercial art galleries. In 1901 he had the first of many one-man shows at the Clausen Gallery, New York, but he achieved greater recognition through a series of exhibitions at Knoedler's from 1906 until 1909. The Knoedler exhibitions established his reputation as a painter. "Each time that his work has appeared in public of late it has denoted an advance," wrote one of the enthusiastic reviewers about his 1908 exhibition.[52]

"I am no longer an illustrator"

The crucial shift in Remington's artistic career came as he moved away from illustration—at least reportorial illustration—and toward independent easel painting. Although he exhibited paintings in the late 1880s, it was not until 1908, the year before his death, that he could assert with confidence: "I am no longer an illustrator."[53] This pronouncement resulted from the success of his exhibitions at Knoedler's and the end of his long-term relationship with *Collier's* magazine, which since 1903 had retained him to produce monthly illustrations. In a sense the *Collier's* assignment had served as a transition in Remington's transformation from illustrator to painter: he had had the freedom to choose his own subjects and, due to advances in technology, was able to work in oil, in full color, rather than in the black-and-white mediums that had previously been the illustrator's domain.

Never in Remington's career was his working method or painting style innovative. In his early paintings, and even in those done after the turn of the century, he used the techniques commonly employed by most painters and illustrators of the period. He researched his subjects carefully and amassed visual material that would provide convincing detail for his pictures. As early as 1887, Remington owned a camera, which he soon used to record "lots of instantaneous shots."[54] He even commissioned friends and acquaintances, the soldiers Powhatan Clarke and Alvin Sydenham among them, to take or collect photographs for his use.[55] He was also an enthusiastic collector of Indian artifacts. "I want an Apache saddle so bad that I cant eat till I get

one," he confided to Clarke in 1890.[56] On his trips west Remington also made rather precise descriptive notes to help him remember colors and atmospheric conditions. One of these, labeled "Description of an Effect," demonstrates the care with which he made his observations: "yellow black plain foreground quite yellow with light warm purple shadows—brown red blue middle distance of mesquite deep blue mountain horizon and dark blue sky—troubled."[57] All this material as well as his own sketches he brought back to the studio, where he could use it to assemble complex compositions. To work out the poses of individual mounts or riders, he painted studies of horses or, having arranged models on impromptu mounts (apparently barrels), he shot study photographs of them (Fig. 30). The results of these efforts were accurate, often exciting compositions packed with action and information, but not so different from those of the French military painters with whom Remington was often compared or, indeed, of most academically trained American painters at the end of the last century. Even the self-conscious arrangement of his studio, with its Indian artifacts and military paraphernalia, was not unique. For example, Remington's contemporary Edwin Lord Weeks, a Gérôme student, also traveled extensively (in the Near and Middle East), wrote and illustrated articles on his adventures, and worked in a lavishly decorated studio filled with mementos of his journeys.

After 1900 Remington began to work in the styles that were attracting some of his most successful American contemporaries—Tonalism and Impressionism. He tried to downplay the importance of these influences. For example, according to a well-known anecdote, he reacted to some Impressionist paintings by exclaiming: "I've got two aunts…that can knit better pictures than those!"[58] Nevertheless, he often commented enthusiastically about the paintings of the American Impressionists. Several of them—Robert Reid, Childe Hassam, J. Alden Weir, and Willard L. Metcalf—were his friends. His association with these artists grew closer near the end of his life, when he was building and then living in a house in Ridgefield, Connecticut, not far from Weir's farm. He also admired American Impressionists outside his own circle, like Emil Carlsen and John H. Twachtman.

Under the influence of these artists Remington modified his approach. As early as 1895 he had spoken of "'forgetting the things we know'—and striking for the ideal."[59] Late in his career, as he moved from the real to the ideal, Remington's trips west were not made to record specific settings, events, or details, but to renew "impressions" or simply to paint landscapes out-of-doors.[60] His new attitude toward

photography also reveals the shift in his point of view; he described some of his own photos as "unsignificant like all photographs."[61]

As Peter H. Hassrick observed in an essay on the artist's late paintings, Remington's interpretation of Impressionism was influenced both by his prior experience and by the style as it had already developed in the United States.[62] During the 1890s his colleagues had devised a distinctive brand of Impressionism, selecting certain aspects of the style that the French had inaugurated in the 1860s and 1870s. While using the characteristic broken brushstrokes, brilliant palette, and rough, unfinished paint surfaces, they often eschewed visual accuracy for decorative effects achieved by color, line, and pattern. Many of these artists had been trained in Paris and, as H. Barbara Weinberg has demonstrated, academic study of the nude remained evident in their figure paintings, while their landscapes and even landscape backgrounds more fully evinced the liberating influence of the Impressionists.[63] This disjuncture manifests itself in Remington's late work as well, both in his methods and in his finished work: he painted landscape backgrounds outdoors and then added figures after returning to the studio (see page 139). He may have tried to capture the light and atmosphere of particular locations, but studio work was the heart of the matter for him. "These transcript from nature fellows who are so clever cannot compare with the imaginative men in [the] long run," he wrote in 1908.[64]

The exacting realism of his earlier career—as well as the photographs, sketches, notes, and props and costumes he had collected—had given way to a new romanticism. In his later work, particularly in his nocturnes, Remington was trying to suggest a mood. There is little action in works like *The Outlier* (Plate 46), for example. The mounted Indian is alone, lost in thought, illuminated by the full moon behind him. Remington often commented on moonlight effects in his diaries for 1907 and 1908, calling them "elusive" and maintaining that "a world of monkeying" was required to achieve the desired result, a *"silver sheen."*[65] It is tempting to attribute the painter's enthusiasm for night scenes to the influence of James McNeill Whistler, but Remington was not at all sympathetic toward this Anglo-American artist. After viewing some of his work in 1908, he quipped, "How people can see everything in there I do not know."[66] Instead, it was the California painter Charles Rollo Peters whose 1894 exhibition of moonlight pictures (Fig. 31) is said to have given Remington the initial impetus toward this type of subject.[67]

Remington's moonlights were the most highly acclaimed paintings in his Clausen

Gallery exhibition of 1901, and the critics continued to prefer them throughout the next decade. According to one reviewer, his *Night Herd* (present location unknown) proved what "Remington can do when he takes off his illustration thinking cap and views his problem seriously and solely from the painter's point of view."[68] Remington's investigation of this theme may even have inspired some of the American Impressionists to tackle it. Among the artists settled at the colony in Old Lyme, Connecticut, Remington's friend Willard Metcalf was one of the first to undertake night views. His *May Night* (Fig. 32), of 1906, prompted Weir and Hassam to follow suit. In this picture Metcalf, like Remington in his nocturnes, chose a unifying tone—a deep blue—which not only offered the opportunity to create richly colored shadows, but also helped confer a mood upon the scene. Remington's night paintings, while in many ways a world apart from Thomas Dewing's depictions of women (Fig. 33), actually share a certain contemplative quality with these genteel pictures. Clearly, in the final years of his career Remington was attracted by a new kind of sensibility. He admired Emil Carlsen's large, decorative landscapes (Fig. 34), called Metcalf "the boss of landscape painters," and yearned to own *Haystack at Ipswich* (present location unknown) by Arthur W. Dow, an advocate of japonism and an influential teacher of Georgia O'Keeffe's.[69] Remington had traveled far from illustration.

"I am to endure in bronze"

Remington moved from medium to medium with an ease and a degree of accomplishment that seem extraordinary, even in an age that admired eclecticism and rewarded virtuosity. In 1895 he quipped about his new interest in sculpture, "I only have one idea now—I only have an idea every seven years & never more than one at a time."[70] This was not entirely accurate. He did move regularly into new areas—illustration in 1881, painting about 1887, sculpture in 1894, fiction in 1899—but he was able to sustain the quality and quantity of his work in several of these fields simultaneously. Even Remington, however, found the transition from painting to sculpture and sculpture to painting difficult. "After modeling a time one has to change his point of view...but in a few days I shall think in color again," he wrote in his diary.[71]

Sculpture was perhaps his most remarkable achievement because the solutions to its technical problems seem so far outside the realm of his experience. It is said that he was introduced to sculpture by F. Wellington Ruckstuhl (later Ruckstull), an aca-

FIGURE 31. Charles Rollo Peters (American, 1862–
1928). *CARMEL MISSION BEFORE RESTORATION*. n.d. Oil,
19¼ × 25½ in. (48.9 × 64.8 cm.). Courtesy California
Historical Society, San Francisco

FIGURE 32. Willard Leroy Metcalf (American,
1858–1925). *MAY NIGHT*. 1906. Oil on canvas,
39½ × 36⅜ in. (100.3 × 92.4 cm.). The Corcoran
Gallery of Art, Washington, D.C. Museum Pur-
chase, Gallery Fund

FIGURE 33. Thomas Dewing (American, 1851–1938). *THE RECITATION*. 1891. Oil on canvas, 30×55 in. (76.2×139.7 cm.). The Detroit Museum of Art, Purchase, Picture Fund

FIGURE 35. John Quincy Adams Ward (American, 1830–1910). *INDIAN HUNTER*. 1860. Bronze, h. 16 in. (40.6 cm.). The Metropolitan Museum of Art, New York. Purchase, Morris K. Jesup Fund, 1973

FIGURE 34. Emil Carlsen (American, 1853–1932). *CONNECTICUT HILLSIDE*. c. 1920. Oil on canvas, 29¼×27⅜ in. (74.3×69.5 cm.). The Art Institute of Chicago, Walter H. Schulze Memorial Collection

demic sculptor at work on a model for an equestrian monument to Major General John F. Hartranft (Harrisburg, Pennsylvania) in the backyard of Remington's friend and neighbor the playwright Augustus Thomas. Remington was impressed by the durability of the medium. "My oils will all get old and watery—that is they will look like *stale molasses* in time—my watercolors will fade—but I am to endure in bronze," Remington proclaimed to Owen Wister early in 1895.[72] But profitability, always a concern for the artist, may have been as much a motive as immortality. He immediately recognized the commercial potential of a work of art that could be readily replicated, and casts of his sculpture were soon offered for sale through Tiffany's in New York and Spaulding's in Chicago.

In his sculpture Remington followed the successful pattern he had already established with his paintings. He picked the same themes—the cowboys, cavalrymen, and Indians of the American West—and then adapted the style of European artists, in this case *animaliers,* notably the Frenchman Antoine Barye and the Russian Eugène Lanceray, to this specifically American subject matter. Here too, Remington was not breaking fresh ground—American sculptors had been exploring these themes since as early as 1860, when John Quincy Adams Ward modeled the *Indian Hunter* (Fig. 35), but as he had in his painting Remington revitalized them. Abandoning the restraint of his predecessors, he created sculptural images that expressed the energy and violence of the West, not only through his choice of subject but also through the vigor of his style. Many specific correspondences—in subjects, poses, and even entire compositions—exist between his works in the two mediums, and there are other, more general parallels as well. Two-dimensional effects linger in Remington's sculptures, which, though executed in the round, often favor one rather descriptive viewpoint. The greater technical command achieved in his paintings after the turn of the century is also evident in his sculptures. In his oils he progressed from a rather simple, reportorial realism to an evocative impressionism, exploiting the painterly qualities of his medium; in his sculptures, as Michael Shapiro observes (see page 171), he moved from the linear realism of his early bronzes to the richly tactile surfaces of his lost-wax pieces.

Remington's work in bronze reflects a revival of American interest in the medium, an interest shared by many of his contemporaries who had studied at the Ecole des Beaux-Arts, including Augustus Saint-Gaudens. Yet, perhaps because Remington was essentially self-taught, his work developed slightly outside the academic estab-

lishment, with tremendous originality in its conception and execution. He demonstrated a great concern for surfaces that can be achieved through the lost-wax casting process. Especially in those pieces confined to limited editions, he demonstrated a fascination with patina, which he shared with his contemporaries. For Remington, however, even surface and color were secondary: each piece was an opportunity to explore a daring composition in which the poses of animals and men challenged the physical laws of gravity and the technical limitations of casting. In *The Bronco Buster* (Plates 47–49), for instance, Remington's horse and rider have been captured in an asymmetrically balanced pose that seems impossible to maintain.

Although he is best remembered for his smaller bronzes, Remington shared his contemporaries' enthusiasm for monumental sculpture. As early as 1899, A. W. Drake, director of the art department at *Century Illustrated Magazine,* wrote to Remington to suggest that he work on a larger scale: "I shall not die happy until I see in a public square in New York, and I hope in many other cities in America, a large bronze group or single figure of something of yours, done in your large and noble style."[73] Although an enlarged reproduction of *Coming Through the Rye* was installed at the Louisiana Purchase Exposition of 1904, Remington's only completed large-scale monument is *The Cowboy* (see Fig. 82).[74] Even before beginning work on the piece, he visited Fairmont Park in Philadelphia and personally selected the most suitable site. His cowboy does not rest on an elaborate Beaux-Arts pedestal designed by a prominent architect; rather, the rocky ledge on which it stands helps to integrate the piece with its setting. Nor are his figures the familiar sedate horse and ennobled rider that preside over innumerable American city squares and ultimately trace their heritage to Renaissance models. As Remington wrote to Leslie Miller, a painter and teacher of art on the committee reviewing his work, "I am trying to give you a Remington broncho and am not following the well known receipt of sculptors for making a horse."[75]

In spite of its unconventionality, the piece was admired by its patrons, and its success must have whetted Remington's appetite for monumental work. Throughout his diaries of the period, there are hints that he hoped to work on other monumental pieces, and he expressed a desire to create statues of the Indian and the cavalryman.[76] When Frederick MacMonnies won the commission for Denver's Pioneer Monument, Remington lamented, "I ought to have had that," and he reported that friends were attempting to get him other large-scale commissions.[77] Remington be-

lieved that his smaller bronzes could be enlarged. In 1908 he wrote of *The Rattle-snake* (Plates 59, 60), "saw some defects in…model and went at it again—all morning and now think it is good enough to throw up to 10 feet without—developing any unmapped peninsulas."[78] All this suggests that had his career not been cut short monumental sculpture might have become a more important aspect of his work.

"I have lots to be thankful for this year"

On Thanksgiving Day, 1909, the last year of his life, Remington observed that he had had a good year.[79] His death, just a month and a day later, ended the career of a man at the height of his power and confidence. Personally and professionally, Remington was, as usual, moving into new areas with determination and enthusiasm. He had given up illustration to pursue the fine arts; in painting he was working in a new, more interpretive style; and in sculpture he was contemplating a more ambitious scale. On a practical level, he had just built a new home and studio, and his relationship with his dealer, Knoedler's, seemed to be drawing to a close. Nearly every aspect of his life seemed in a state of flux.

If Remington's world was evolving in new directions, the art world in which he lived and worked was about to undergo a virtual revolution. In 1908 Robert Henri and his followers, The Eight, had staged an exhibition that challenged the established academic conventions; their bold, realistic painting style and daring choice of urban subjects made Remington's work seem almost genteel. Within a few short years, certainly by 1913, European modernism would be introduced to America at the Armory Show and in the salesrooms of prescient art dealers like Alfred Stieglitz.

In the decade following Remington's death, his generation lost control of the art scene: many of its important leaders died or lapsed into inactivity or ineffectuality; Impressionism was perceived as old-fashioned and was replaced by realism, even by abstraction; and established art organizations, such as the National Academy, lost power to new organizations like the Society of Independent Artists that emerged to serve new constituencies. How would Remington have responded to these changes? The answer seems hardly as important as what Remington actually achieved. His ability to overcome the limitations of his training, to explore new avenues of interpretation, and to adapt to new mediums—all these accomplishments mark him as a great American master.

REMINGTON
THE PAINTER
By Peter H. Hassrick

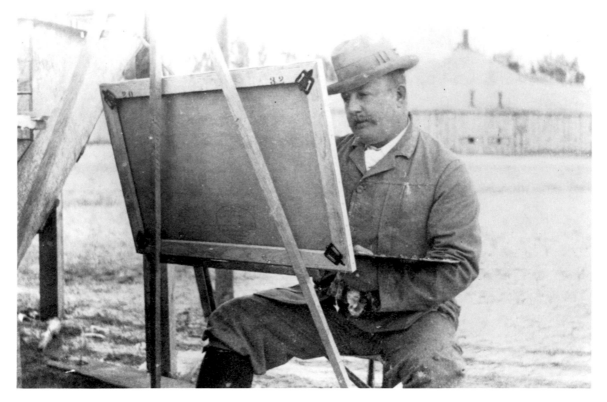

FIGURE 36. Remington at Fort Robinson, Nebraska. 1905. Frederic Remington Art Museum, Ogdensburg, New York

At the end of the nineteenth century, when figure painting enjoyed unprecedented popularity in America, Frederic Remington made his mark with epic interpretations of the West and its heroes. He was in the vanguard of illustrators during the closing years of the century, America's golden age of illustration. His imagery of the frontier and its history were iconic in the popular mind. Yet his accomplishments as illustrator and painter garnered respect and recognition and contributed to the development of American art not so much because he discovered these niches to fill but because he filled them with such independence of spirit. Inspired by academic models, yet generally unencumbered by academic constraints, and excited by various schools of painting throughout his career, Remington prided himself on being unconventional in his approach to art. His resilient and bold personal response to current trends reinforced his strong aesthetic vision.

Remington began his life's work by expressing an empirical naturalism. He concluded his career in a different direction, concentrating on pictorial harmony and a nostalgic, almost mystic point of view. His early work brimmed with physical action and bravado, while his mature pieces were visual echoes of mystery and full of quiet pattern. Through it all, there was one consistent element, the figure. Without it, there was, in Remington's mind, no imagination and no creative force. As a consequence, he would not depart from human themes, and it was through these themes that American audiences grew to recognize him as an artist and a recorder of their national epoch.

Although he was recognized as an illustrator much earlier, Remington's career as a painter began in the late 1880s. Like most of his distinguished colleagues, he soon sought international recognition for his work, submitting examples to the grand Paris Universal Exposition, which opened in May 1889.

What attracted the American jury to this relatively unknown artist from a younger generation? The five Remington works selected by the jury included four black-and-white drawings and one colored oil titled *The Last Lull in the Fight* (Fig. 37). In the exposition catalogue, this work in color was described as "Un moment de répit pendant un combat à Llano Estacado, en 1861;—d'après le récit d'un guerrier Comanche qui y prit part."[1] Although outnumbered by the paintings of cosmopolitan artists like

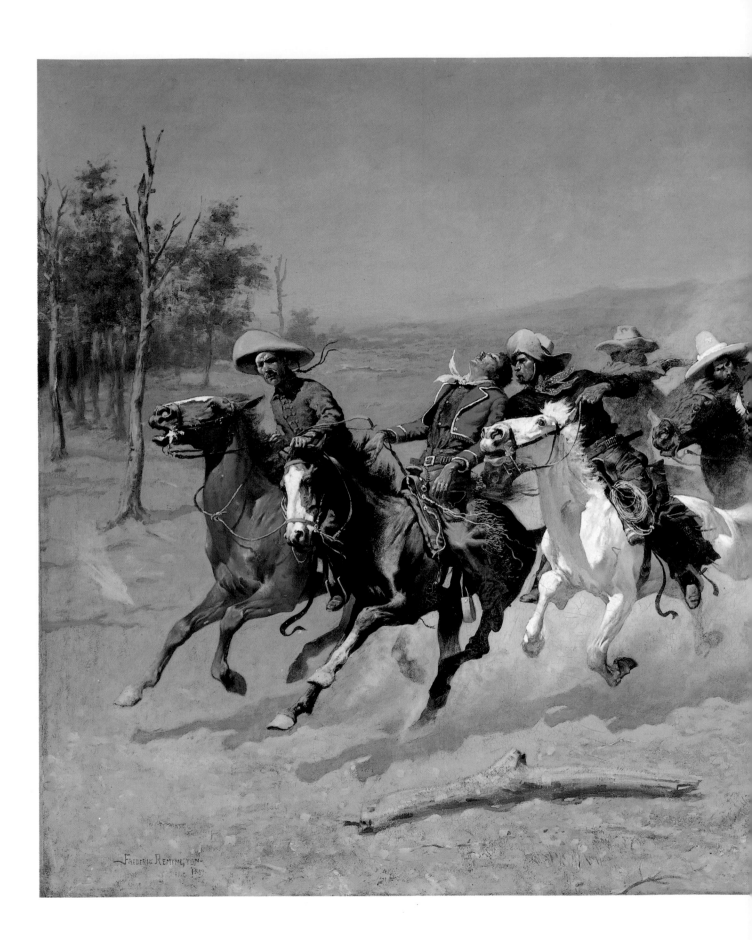

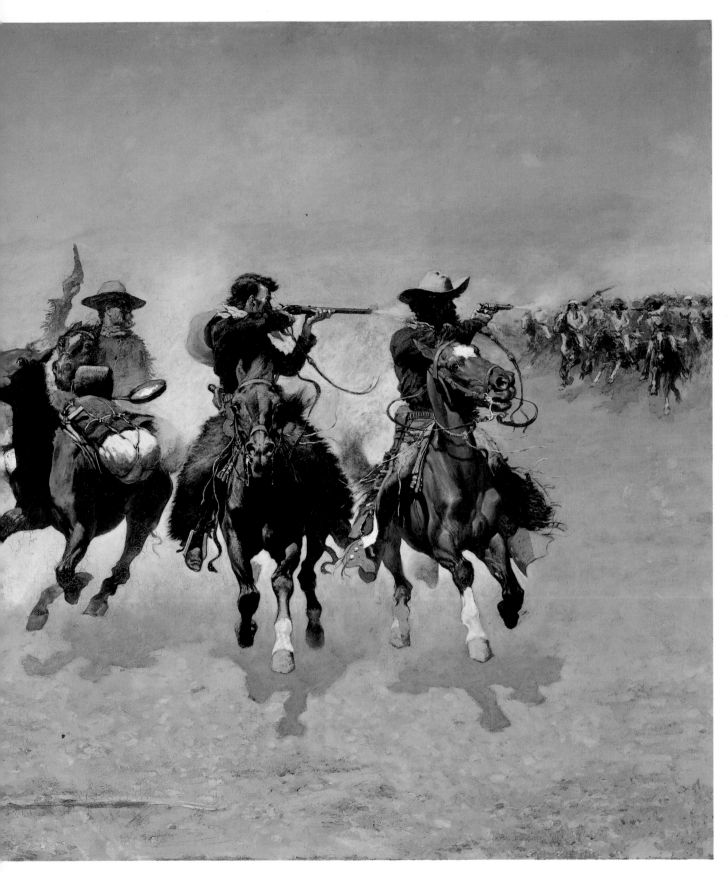

PLATE 1. *A DASH FOR THE TIMBER.* 1889.
Oil on canvas, 48¼ × 84⅛ in. (122.6 × 213.7 cm.).
Amon Carter Museum, Fort Worth, Texas

FIGURE 37. Frederic Remington. *THE LAST LULL IN THE FIGHT.* 1889.
Wood engraving, 12½ × 30¼ in. (31.8 × 76.8 cm.). Harold McCracken
Research Library, Buffalo Bill Historical Center, Cody, Wyoming

J. Alden Weir and William Merritt Chase, Remington's works offered precisely what
the jury wanted: attention to the reality of American life and to themes of social con-
flict. As described in an article titled "American Subjects for American Artists" by the
jury's president, John George Brown, subjects were to "play an essential part in every
artist's life, and this great country, with its vast expanse of varied nature, populated
by all nationalities, its centres of commerce throbbing with enterprise, cannot be
other than a boundless workshop for the painter."[2] What Brown wished for was an
American school of painting that would treat subjects drawn from the particulars of
current national experience. Remington sought contemporary subjects that would
reveal a pictorial history of the times.[3]

His chosen subjects were American, and most of them were drawn from observa-
tion of national life. He was employed by both *Harper's* and *Century Illustrated Maga-
zine,* whose publishing mission coincided precisely with his own. Remington's focus

on the American frontier was sufficiently contemporary to invite a realistic interpretation and yet historical enough to engender a romantic appeal. Furthermore, he represented what appeared to be the native American school: trained at home, largely self-taught, he was perceived as untainted by European ideas and styles.

When his friend William Poste stood observing *The Last Lull in the Fight* in Remington's studio in January 1889, he made some interesting observations about the artist's past and future course. "Fred's the same as ever—very ambitious and confident. . . . I glory in his spunk and unconventionality. He is bound to kick and fight his way to the front, and will do it without going to Paris and Rome."[4] Unconventionality was really what set Remington apart from his peers; he reveled in his detours around the accepted artistic mode. His themes and subjects, though recognizably American, were not customary fare for painters of the day, and, at a time when foreign study for a painter was the accepted norm, his avoidance of European training was unusual. Even the newspapers included cautions about the dangers of reliance on study at home. One noted that "the ability to treat ably does not come from provincial training" and admitted that America was provincial.[5] That which was not informed by French art—Paris being the undisputed center of the art world—was deemed unworthy. So how had Remington been able to impress the French with his pile of dead horses and motley Texan herders on a barren hill of the Llano Estacado? And how was it that when he exhibited his painting *A Dash for the Timber* (Plate 1) at the autumn exhibition of the National Academy of Design that same year, one newspaper noted that it attracted the most people of all, while another claimed it to be a "large and excellent work . . . the drawing is true and strong, the figures of men and horses are in fine action . . . the sunshine effect is realistic and the color is good"?[6] In fact, for all his seeming individuality, Remington's paintings were substantially informed by French art (see pages 40–42). The pervasive literalness of his early work, its empirical bent, the clarity of color and form, and the basic compositional elements in his larger paintings often had direct French antecedents, in the works of Jean-Louis-Ernest Meissonier, Jean-Léon Gérôme, Jean-Baptiste-Edouard Detaille, and Alphonse-Marie de Neuville. These are not men whom Remington had known personally, but he had become familiar with their paintings through prints, lectures, and in the originals at such museums as the Metropolitan in New York City.

(overleaf) detail of *A DASH FOR THE TIMBER*, 1889 (Plate 1)

FIGURE 38. Frederic Remington. *BUGLER OF CAVALRY*. 1889. Wood engraving, 7⅝ × 4⅞ in. (19.4 × 12.4 cm.). Helen Card, Remington Scrapbooks, Thomas J. Watson Library, The Metropolitan Museum of Art, New York

FIGURE 39. Alphonse-Marie de Neuville (French, 1836–1885). *BUGLER.* c. 1875. Watercolor on paper, 11¼ × 9⅛ in. (28.6 × 23.2 cm.). The Wenneker Collection, University of Kentucky Art Museum, Lexington

In paintings like *A Cavalryman's Breakfast on the Plains* (Plate 6), Remington was continuing a tradition of the French *peintre militaire,* although he always conveyed the sense of firsthand observation and participation and even of personal identification. Just as Remington's portraits of Mexican soldiers, such as *Bugler of Cavalry* (Fig. 38), updated de Neuville's Franco-Prussian War imagery (Fig. 39), so his camp scenes relied for their inspiration primarily upon Detaille. Remington's admirer George W. Sheldon had noted in Detaille's work a dependence not on the dramatic and the histrionic but rather "upon a simple and faithful naturalism" that carried with it "the impress and assurance of truth."[7] Like Detaille's, Remington's subjects were simple men with a common and significant purpose, and Remington wanted

them to be believable. Under the cloudless western sky, they display a reality controlled by a certain hardness of contour. In that western landscape of arid color and light, harmony was not to be found; nevertheless, Remington had achieved success, and in 1895 the writer Julian Ralph was able to explain what had thus far been his secret: "Without imitating any Frenchman, without an inspiration that he consciously owes to France, he yet is French in the stubborn allegiance to truth that he puts in every picture he makes."[8]

Another artist whose works Remington greatly admired, and whose life-style impressed him even more, was a Russian who studied in St. Petersburg and in Paris before embarking on a career as a reportorial painter of war. Remington may have first learned of Vasili Vereshchagin in the pages of *Scribner's* in 1881. In November 1888 notices began to appear that an exhibition by this soldier-artist would soon be on view at the American Art Galleries in New York City. Vereshchagin, the articles noted, had traveled to numerous exotic corners of the globe—central Asia, India, and the Caucasus—to record gruesome scenes of human carnage. Most especially, he was praised for his depictions of "the ghastly experiences of the Turco-Russian War."[9] Remington and his wife, Eva, visited the show and came away powerfully impressed. According to Eva, it was "a magnificent collection...the finest I ever saw."[10] More significantly, word got back to Remington from important artistic sources that *he* was America's Vereshchagin.

The pattern of Vereshchagin's life is reminiscent of Remington's. As a student, the Russian had avoided Gérôme's lessons on the antique in order to explore nature, much as Remington had done by leaving Yale. Vereshchagin's travels as an "art volunteer" in the ranks of General Kauffmann to the battlefields of central Asia immediately call to mind Remington's trips to Arizona in 1886 and 1888 in search of Geronimo and campaign life among the "yellowlegs." Remington's penchant for statements about violence, death, and the hazards of war owed significantly to Vereshchagin, as well as to the French military painters. The Russian's influence confirmed in Remington not only an interest in the brutal aggressions of man against man, but also a guiding philosophy about war that is observable in *The Frontier Trooper's Thanatopsis* (Fig. 40), a work that directly followed on Remington's visit to Vereshchagin's 1888 exhibition. The trooper stands squarely upright and contem-

PLATE 2. *CABIN IN THE WOODS.* 1890.
Oil on canvas, 28½ × 20 in. (72.4 × 50.8 cm.).
Frederic Remington Art Museum, Ogdensburg,
New York

PLATE 3. *CAVALRY OFFICER IN CAMPAIGN DRESS.*
1890. Watercolor and pen on paper, 19⅞ × 10⅜ in.
(50.6 × 26.4 cm.). The Virginia Museum of Fine
Arts, Richmond, Virginia. Gift from the Estate of
Sally Dunlop Eddy

PLATE 4. *GENTLEMAN RIDER ON THE PASEO DE
LA REFORMA (DANDY ON PASEO DE LA RE-
FORMA, MEXICO CITY).* 1890.
Oil on canvas, 32½ × 23 in. (82.6 × 58.4 cm.).
Collection Larry Sheerin

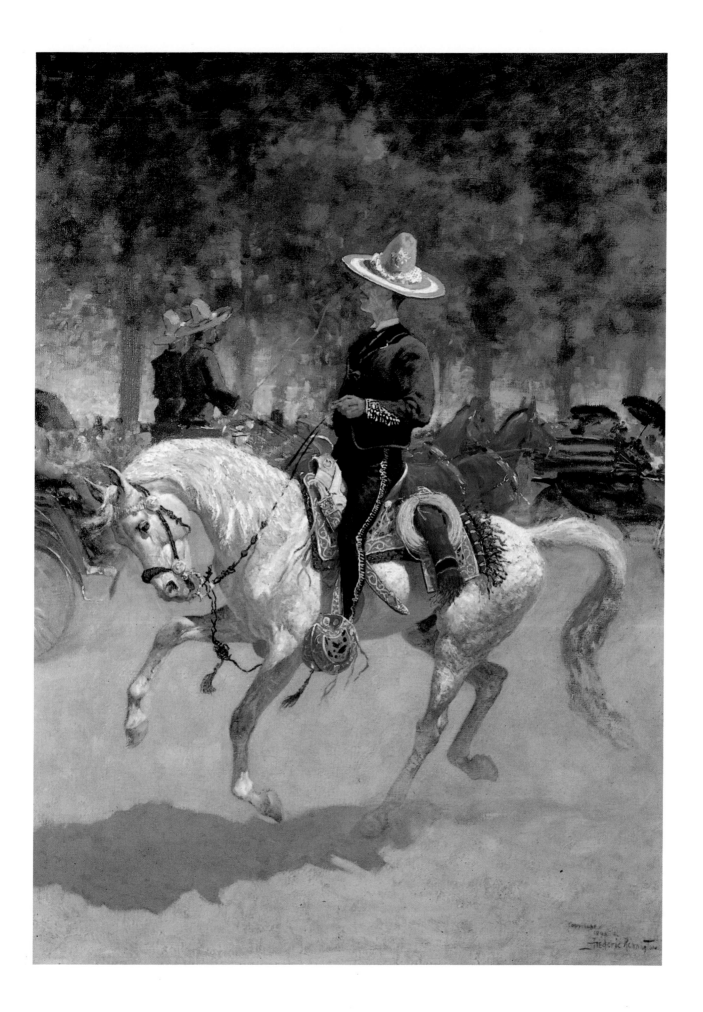

FIGURE 40. Frederic Remington. *THE FRONTIER TROOPER'S THANATOPSIS*. 1889. Oil on canvas, 28¼ × 21¼ in. (71.7 × 54 cm.). Collection Mr. and Mrs. Britt Brown. Photograph courtesy Kennedy Galleries, Inc., New York

plates the remnant of his fallen adversary as if convinced that through the acts of war they together had surpassed their individual destinies. In Remington's mind, war as the ultimate test of men was ample subject for art. As *Harper's Weekly* put it, with "the days of frontier warfare...nearly over,"[11] the time, energy, and passion Remington expended on it were justified.

Remington planned the direction of his early career quite methodically. His schooling after 1885, his travels, his illustrations, and the articles he wrote were all part of a conscious procedure to garner the attention of the public in a step-by-step fashion. Several months spent at the Art Students League of New York in 1886 afforded him an opportunity to refresh and augment his skills. He knew that taking J. Alden Weir's class in painting at the League was crucial to his chances of moving ahead. In addition to painting techniques, he learned how to make shorthand color notes in his diaries when paints were not available, and his journals are replete with references to such matters under the abbreviation "CN" (color note). He also learned to sketch with color in mind, noting reflected and local color as well as highlights—a technique used to special advantage in his early works (Fig. 41). The other two classes in which he enrolled, life drawing and a sketch class, were also vital. The sketch class prepared him to work in the field, the destined studio for an artist-journalist who had staked out the Far West for his domain.

FIGURE 41. Frederic Remington. Study for *THE LAST LULL IN THE FIGHT*. c. 1888. Pencil on paper, 9½ × 11 in. (24.1 × 27.9 cm.). Frederic Remington Art Museum, Ogdensburg, New York

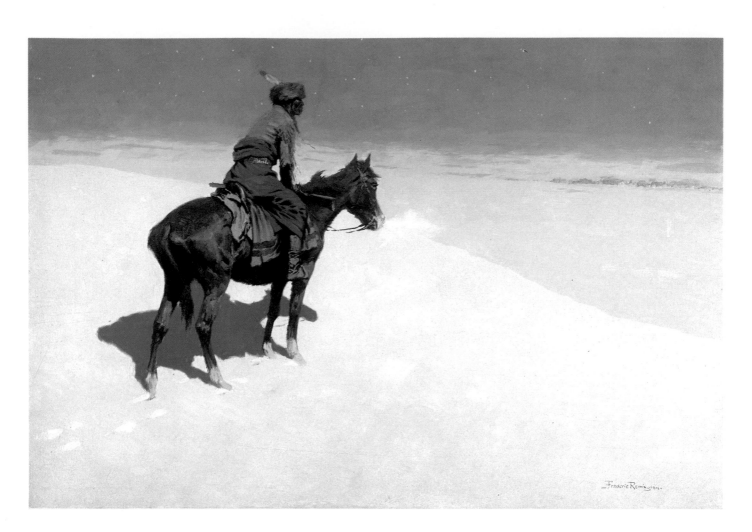

PLATE 5. *THE SCOUT: FRIENDS OR ENEMIES?* c. 1890.
Oil on canvas, 27 × 40 in. (68.6 × 101.6 cm.). Sterling
and Francine Clark Art Institute, Williamstown,
Massachusetts

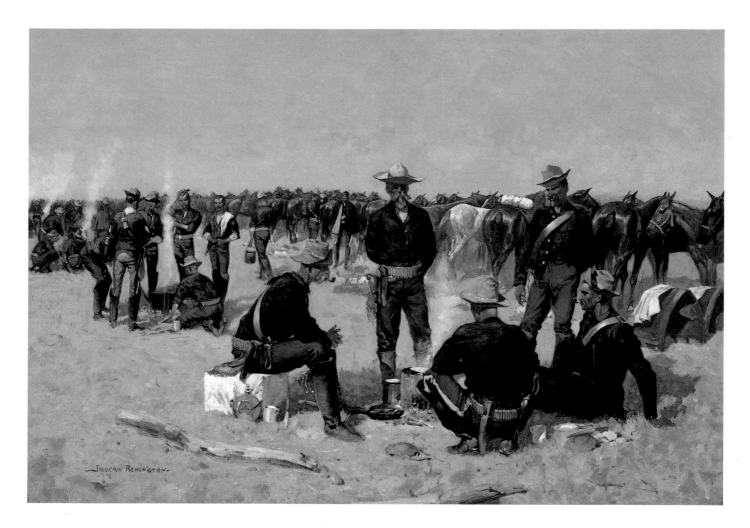

PLATE 6. *A Cavalryman's Breakfast on the Plains.* c. 1890.
Oil on canvas, 22 × 32⅛ in. (55.9 × 81.6 cm.). Amon Carter
Museum, Fort Worth, Texas

Remington was not the only artist of his generation to be drawn to the Far West. Rufus Fairchild Zogbaum had been among the Sioux in Montana in 1884 and two years later was producing illustrations to accompany his own articles, including "With the Bluecoats on the Border." Zogbaum had already portrayed the cowboy in such illustrations as *Painting the Town Red* (Fig. 42), which helped to alter the cowpuncher's image from hooligan to freewheeling, good-natured youthful American. This was a part of western life that Remington wanted to explore, and by 1889 the spirit of Zogbaum's work had so pervaded Remington's own sense of the subject that he nearly duplicated it in *Cow-boys Coming to Town for Christmas* (Fig. 43).[12] Other illustrators who stimulated Remington included Thure de Thulstrup, of *Harper's;* Matt Morgan, A. C. Redwood, and James Gerry, of *Leslie's;* and Stanley Wood, of the *New York Daily Graphic.* All were producing scenes of cowboys, Indians, and war on the frontier during the late 1880s. By 1889, even Charles Russell's vigorous depictions of broncos also filled a page in *Leslie's,* but by then Remington was a successful illustrator. "He was the first to put on canvas the true types of the West and paint honest pictures of the cowboy and the Indian, and his pictures, strikingly original in style and evidently realistic in conception and purpose, made a sensation in the field of pictorial art," maintained one newspaper reporter as early as 1891.[13]

While Remington's first success was as an illustrator, his accomplishments as a painter and the innovative themes he explored in paint were more substantial and worthy of public appreciation and praise. Having decided, in 1885, to embark on an artist's career, Remington first had to choose where he would work. While he wanted to paint western subjects, he knew it was not necessarily prudent to stay in the West to pursue that goal. In 1886, Theodore Roosevelt succinctly summarized what had motivated Remington, among others, to return from the West to New York: "Literary or artistic talent is of no use out there."[14] Moreover, his livelihood as an illustrator required proximity to the publishing houses, so the Remingtons moved east in 1885. Remington said himself, "I found that I...was rubbing against natural laws and so I came East and entered Art."[15] They lived in various residences, all less than satisfactory, until 1890, when the household moved to New Rochelle, where Remington eventually added on a large, well-lighted studio.

How did Remington in his eastern studio assemble the material he needed to cre-

FIGURE 42. Rufus F. Zogbaum. *PAINTING THE TOWN RED.* 1886.
Wood engraving, 14⅜×20½ in. (36.5×52.1 cm.).
Reproduced in *Harper's Weekly,* October 16, 1886.
Photograph courtesy Library of Congress

FIGURE 43. Frederic Remington. *COW-BOYS COMING TO TOWN
FOR CHRISTMAS.* 1889. Wood engraving, 14⅜×20½ in.
(36.5×52.1 cm.). Harold McCracken Research Library,
Buffalo Bill Historical Center, Cody, Wyoming

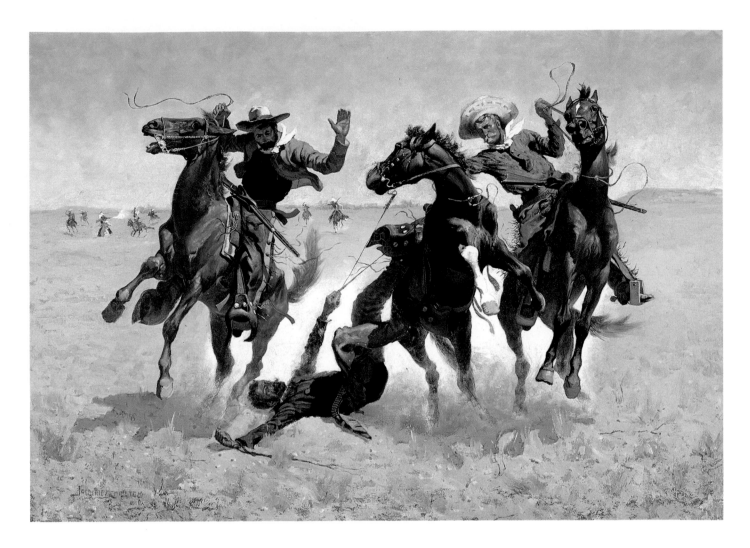

PLATE 7. *AIDING A COMRADE.* c. 1890.
Oil on canvas, 34¼ × 48⅛ in. (87.2 × 122.2 cm.). The
Museum of Fine Arts, Houston, Houston, Texas.
The Hogg Brothers Collection

PLATE 8. *CONJURING BACK THE BUFFALO.* 1892.
Oil on canvas, 35 × 20 in. (88.9 × 50.8 cm.). Private
collection

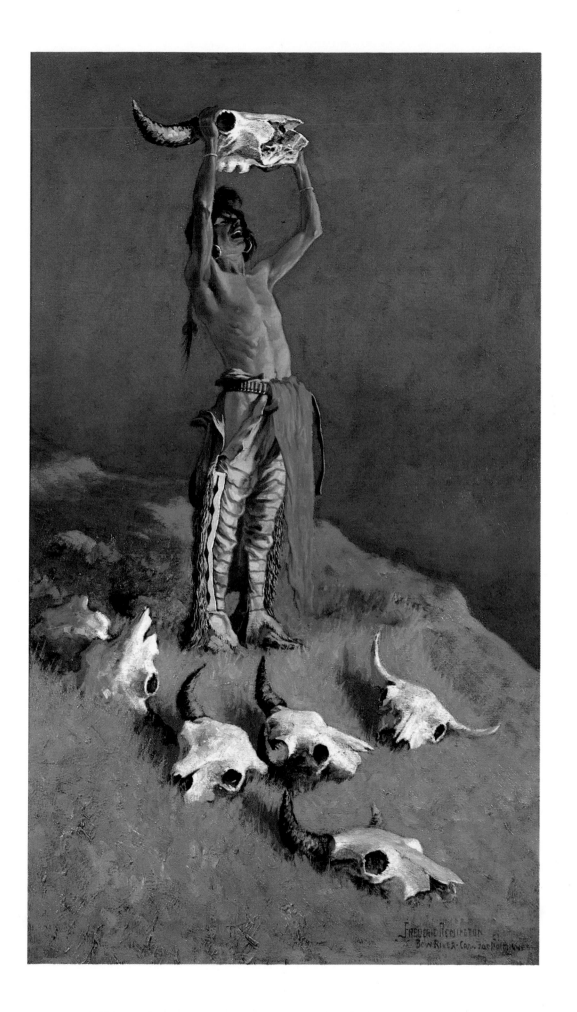

FIGURE 44. Frederic Remington. *IN THE LODGES OF THE BLACKFEET*. 1887.
Pen and ink on paper, 14¼ × 22⅝ in. (36.2 × 57.5 cm.). Harold McCracken
Research Library, Buffalo Bill Historical Center, Cody, Wyoming

ate western scenes? Much was accomplished on trips he made to the West. In the summer of 1887, for example, Remington traveled to western Canada to visit the Blackfeet and the Canadian militia. The first finished illustration resulting from this trip to the Bow River and Calgary was a pen-and-ink drawing titled *In the Lodges of the Blackfeet* (Fig. 44), which appeared as a full-page reproduction in the July 23, 1887, issue of *Harper's Weekly*. This group of vignettes in one composition creates the sense that the illustration is an assemblage of field sketches or pages from a sketchbook. Since Remington rarely went into the field without a camera, and since the Blackfeet were often belligerent about his sketching, Remington used the lens as well as the pencil to record their likenesses.[16] The still life of artifacts in the lower right corner of the drawing was probably set up later in the artist's studio from effects brought home with him. Many of these objects are extant in the Remington Studio Collection in Cody, Wyoming (Fig. 45).

Remington's creative force did not wane once the assigned magazine illustrations had been completed: his goal was to produce paintings worthy of exhibition. For, as

PLATE 9. *THE FRENCH TRAPPER*. 1891.
Pen and ink wash on paper, 17¾ × 14⅛ in.
(45.1 × 35.9 cm.). Buffalo Bill Historical Center,
Cody, Wyoming

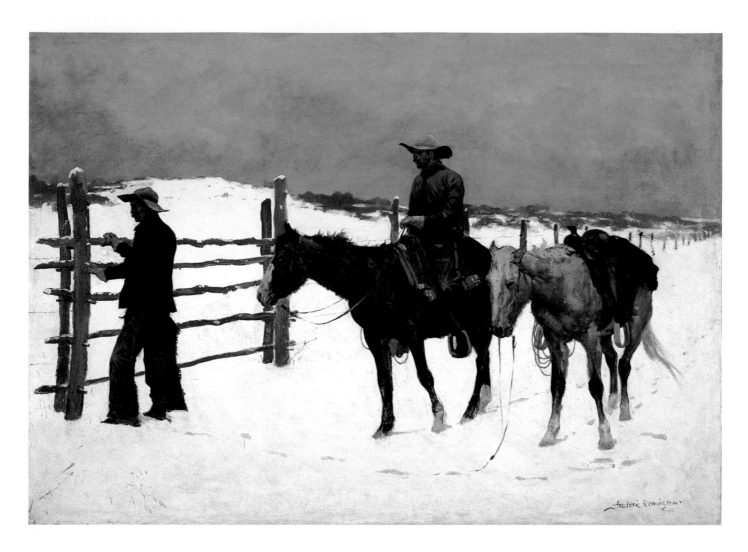

PLATE 10. *THE FALL OF THE COWBOY.* 1895.
Oil on canvas, 25 × 35⅛ in. (63.5 × 89.2 cm.). Amon
Carter Museum, Fort Worth, Texas

PLATE 11. *THE BLANKET SIGNAL.* c. 1896.
Oil on canvas, 27 × 22 in. (68.6 × 55.9 cm.). The
Museum of Fine Arts, Houston, Houston, Texas.
The Hogg Brothers Collection

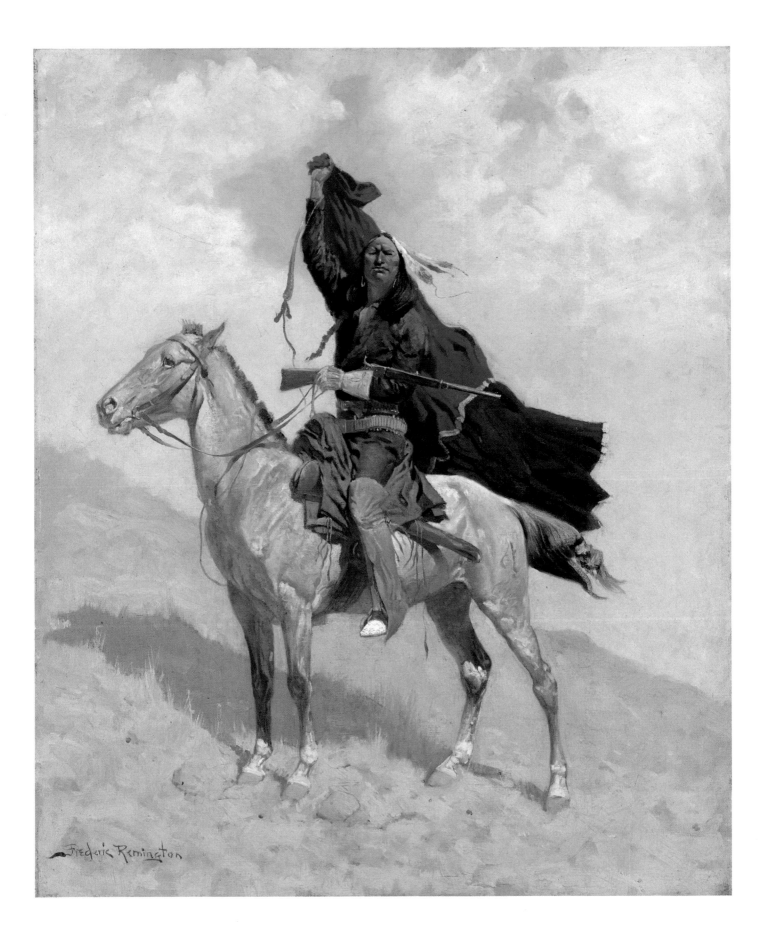

FIGURE 45. Northern Plains Indian artifacts. Remington Studio Collection, Buffalo Bill Historical Center, Cody, Wyoming

the critic George W. Sheldon observed at the time, Remington's "splendid reputation as an illustrator for the magazines has failed to satisfy the ambition of an artist who bids fair to become equally established as a professional painter."[17] For a large oil such as *An Indian Trapper* (Fig. 48), Remington first composed his thoughts in a small pen-and-ink sketch (Fig. 46). Having prepared the canvas by painting in the landscape and sky, he completed the central figure, perhaps from a model. The finished painting incorporates some studio items that had appeared in Remington's illustration of Blackfeet lodges, for example, the moccasins and leggings; other objects in the artist's collection, like the trade rifle (Fig. 47), were introduced in this picture for the first time.

From the beginning until the end of his career, Remington used photographs. Some were his own, some those of others, notably the photographs of Montana ranch life by Laton Alton Huffman. They provided ideas and a record of accoutrements and settings for later reference when the artist was in the studio. In the field, photography

FIGURE 46. Frederic Remington. *THE FRENCH TRAPPER.*
c. 1889. Pen and ink on paper, 14×10¾ in.
(35.6×27.3 cm.). Frederic Remington Art Museum,
Ogdensburg, New York

FIGURE 47. Percussion trade rifle. 1840–60. L.
45 in. (114.3 cm.). Remington Studio Collection,
Buffalo Bill Historical Center, Cody, Wyoming. Gift
of The Coe Foundation

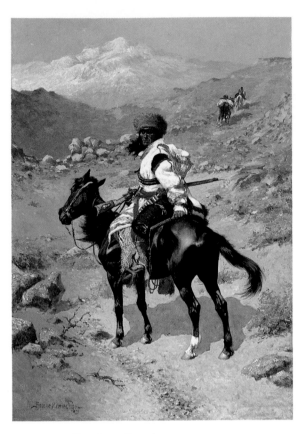

FIGURE 48 Frederic Remington. *AN INDIAN TRAPPER*.
1889. Oil on canvas, 49×34⅛ in. (124.5×86.7 cm.).
Amon Carter Museum, Fort Worth, Texas

offered an alternative to sketching when time or circumstance did not permit. In some situations photography was simply Remington's only means of capturing a scene, as he himself explained, recalling his experience among the Apaches at San Carlos, Arizona, in 1888:

> After a long and tedious course of diplomacy it is at times possible to get one of these people to gaze in a defiant and fearful way down the mouth of a camera; but to stand still until a man draws his picture on paper or canvas is a proposition which no Apache will entertain for a moment. With the help of two officers, who stood up close to me, I was enabled to make rapid sketches of the scenes and people: but my manner at last aroused suspicion, and my game would vanish like a covey of quail.[18]

In Figure 49, the artist has portrayed himself endeavoring to sketch an Indian by using a soldier as a shield so the subject would not know what he was trying to do.

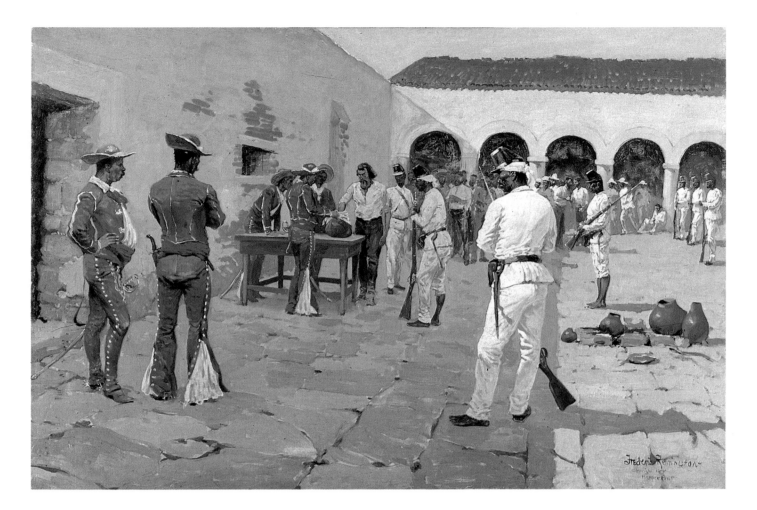

PLATE 12. *Mier Expedition:*
The Drawing of the Black Bean. 1896.
Oil on canvas, 27 × 40 in. (68.6 × 101.6 cm.).
The Museum of Fine Arts, Houston, Houston,
Texas. The Hogg Brothers Collection

FIGURE 49. Frederic Remington. *METHOD OF SKETCHING AT SAN CARLOS.* 1889. Wood engraving, 3⅜ × 3 in. (8.6 × 7.6 cm.). Helen Card, Remington Scrapbooks, Thomas J. Watson Library, The Metropolitan Museum of Art, New York

Several observers have contended that photography had a seriously negative effect on Remington's art. The printmaker Joseph Pennell, for example, concluded that "photography killed Remington" because he used it in excess and could not achieve "good results" from it.[19] More recently, Estelle Jussim has suggested that by hiding from the public the fact that he relied upon it he was artistically dishonest.[20] And Remington himself confused the situation by creating, or at least helping to perpetuate, the myth that his accurate portrayals of horses in motion were developed independently of Eadweard Muybridge's photographic revelations.[21]

It is important to keep the impact of photography on Remington's work in perspective. Those who contend that until the last decade of his career "Remington's role was primarily to serve as an intermediary between the camera and the printed

page"[22] have left themselves little room to enjoy or understand the artist beyond his tools. One must not lose sight of Remington's consummate skill as a draftsman (for example, see Fig. 49); his quickness to grasp the limitless opportunities of the painter; his skill at composing; and his ability to impart dramatic intensity, to render perspective, and to convey the qualities of western color and light—in short, his capacity for transcending photography while using it as a tool. The evidence of these talents in his great exhibition pieces at the National Academy, the American Watercolor Society, and the Paris Universal Exposition held viewers spellbound.

Nevertheless, some of Remington's works do suffer from his reliance on photography. For example, the eye-level vantage point of many works, especially the illustrations, becomes repetitive and tiresome, as does the stop-action pose of his subjects. Remington was aware that an artist could easily abuse the medium: "Photography when used judiciously is all right, but—there's the rub."[23] He endeavored to discipline himself from overuse of the camera because he knew its dangers. "The best reason I use them [cameras] so little," he wrote in 1892, "is that I can beat a Kodac—that is get more action and better action because Kodacs have no brains—no discrimination.... Photography bears the same relation to an illustrator as a typewriter does to a lawyer or a reporter to an editorial writer. The artist must know more than the Kodac and the writer more than the reporter."[24] Remington demonstrated his independence from the camera the next year, when he traveled west. He carried his sketchbook and Kodak through Yellowstone National Park, then down along the front range of the Rockies and into northern Mexico, where he spent most of his time at the Hacienda San José de Bavicora. Several of the photographs he took there show that he observed the active life of the ranch (Fig. 50), but when he finished drawings, such as *Mexican Vaqueros Breaking a Bronc* (Fig. 51), Remington supplied the action and the figures himself—only the setting had been preserved for him by his camera.

The idea, encouraged if not started by Remington himself, that he preceded or paralleled Muybridge in showing correctly the motion of horses is simply not so. Remington's horse depictions did not become naturalistic until after his study at the Art Students League in the spring of 1886. By that time, Muybridge's discoveries were widely known among the reading public, having been reviewed, for example, in 1882, in *Century Illustrated Magazine,* and were a common topic of discussion

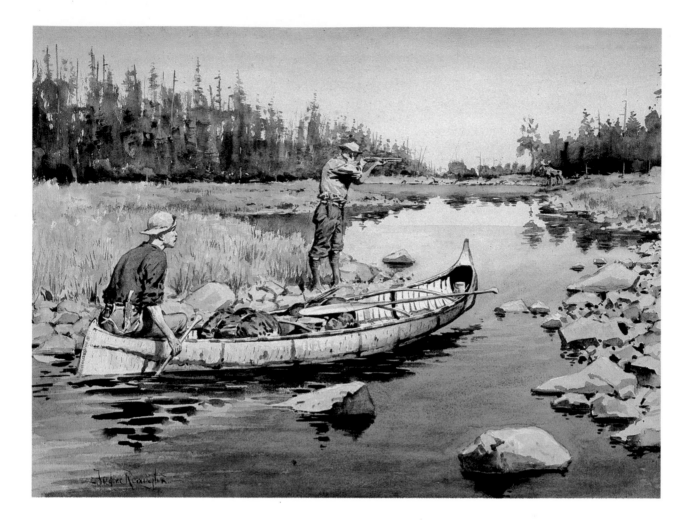

PLATE 13. *UNEXPECTED SHOT*. c. 1896.
Pen and ink wash on watercolor board, 22 × 30 in.
(55.9 × 76.2 cm.). The Shelburne Museum, Shel-
burne, Vermont

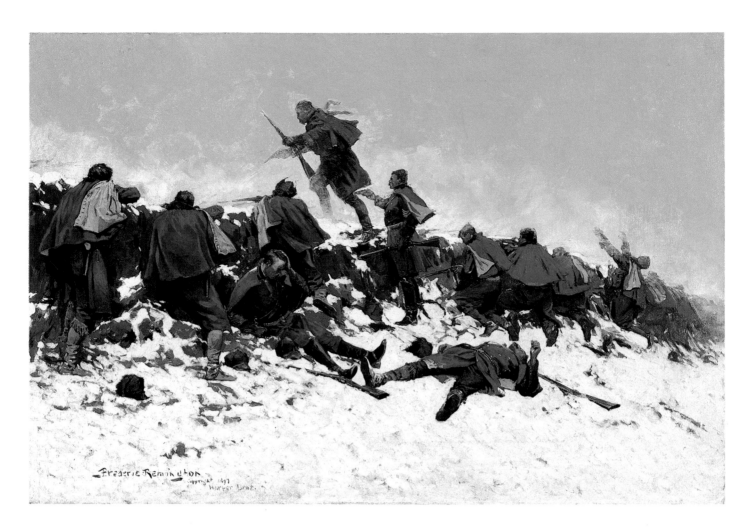

PLATE 14. *Through the Smoke Sprang the*
Daring Soldier. 1897.
Oil on canvas, 27¼ × 40⅛ in. (69.2 × 101.9 cm.).
Amon Carter Museum, Fort Worth, Texas

PLATE 15. *PORCH AT TAMPA BAY HOTEL.* 1898.
Pen and ink wash on paper, 20 × 30 in. (50.8 × 76.2
cm.). Collection Mr. and Mrs. Robert M. White II

among artists and students of art. Muybridge had lectured at the National Academy of Design in 1882, and Thomas Eakins, who taught a weekly class at the Art Students League in New York during the mid-1880s, was intimately associated with Muybridge's photographic studies. Like Remington, Eakins was expressly interested in equine anatomy, and in his teaching he concentrated on horses as well as humans. Eakins was a controversial figure when Remington was enrolled in the Art Students League. In February, Eakins had resigned as director of the conservative Pennsylvania Academy of the Fine Arts and within weeks had been instrumental in founding the Art Students League of Philadelphia, modeled after its New York namesake. Through the ensuing months, Eakins's classes in New York continued. Although it is not known if Remington took any classes with Eakins, the young student must have come in contact with the great teacher and his work. It is probable that Remington's ability to understand and render equine anatomy and motion stems from direct or indirect association with Eakins in New York.

Remington's early reliance on his own photographs and on the published work of Muybridge is evident in his first published self-portrait, *A Peccary Hunt in Northern Mexico* (Fig. 52). Although *Harper's Weekly* did not publish it until December 1, 1888, the painting had its origins in a trip to Hermosillo, Mexico, two years before. While the source of the composition was the Mexican chaparral, Remington's pose was probably staged in some backyard in New York (Fig. 53), and the artist adopted the naturalistic position of the horse's legs at full gallop from a Muybridge photograph, such as Figure 54. That this was still something of an experiment with Remington is suggested by the old-fashioned calliope pose of the horse at the upper left corner of the painting; the same one he had been using for horses before he left Kansas City for New York and the Art Students League. In the final analysis, it was Muybridge's work that lent credence to Remington's depictions of horses. "Whether Remington would have dared to draw his horses before Muybridge's photographs of a horse running may be open to question—at any rate, the public would hardly have accepted Remington's horses if it had not seen the Muybridge photographs," observed a writer for the *Philadelphia Record* in his obituary of Remington, on December 28, 1909. Without Muybridge's pioneering works, the audience standing before *A Dash for the Timber* at the National Academy of Design in the fall of 1889 would have been aghast, not

(overleaf) detail of *THROUGH THE SMOKE SPRANG THE DARING SOLDIER,* 1897 (Plate 14)

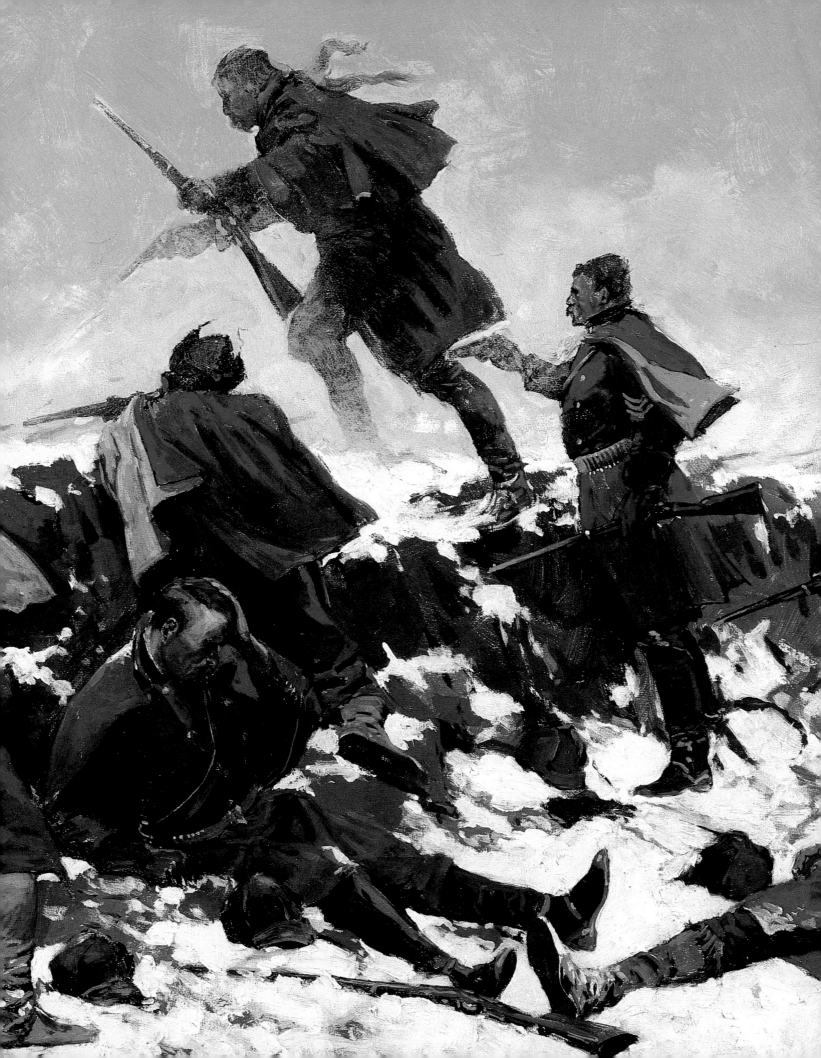

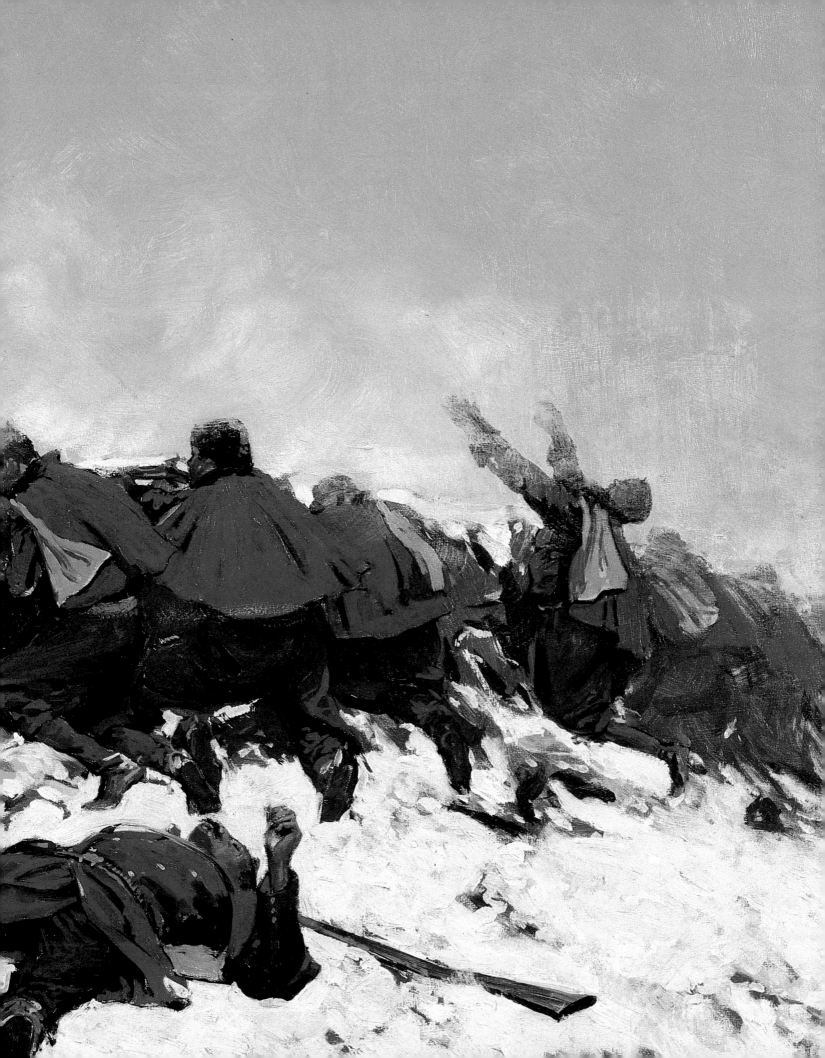

enthralled. The painting's underlying drawing would not have been gauged by the critics as true and strong; they would have deemed it faulty and uninformed.

By 1890 Remington had established a pattern of painting simultaneously for exhibition and for illustration. His *Harper's Monthly* commission to illustrate a three-part article by Colonel Theodore Dodge titled "Some American Riders," for instance, afforded him a chance to use as an illustration his painting previously exhibited at the Brooklyn Art Club, *An Indian Trapper.* The commission also allowed him to expand on his initial pictorial statement in "Horses on the Plains," published in January 1889 in *Century,* by portraying a broader cross section of riders and equine types—from Comanche pintos to polo ponies. Of special note was one of the eighteen pieces, *Gentleman Rider on the Paseo de la Reforma* (Plate 4). Exceptional in its brilliant color, and genteel in theme, the painting shows Remington at his best while yet in his twenties. The subject was observed during a trip to Mexico City in February-March 1889. Since he was gone for six weeks, Remington may have painted this picture, along with nearly two dozen scenes of Mexican military life, while in Mexico. Certainly this oil is full of life and color born of firsthand observation. The quiet elegance of the scene establishes a pleasant contrast to the desperate charge of the horsemen in *A Dash for the Timber.* In his portrait of the Mexican dandy, the focus is entirely on the central compositional element. The rider glances haughtily at a procession of carriages that together with the forward momentum of his prancing steed and the airiness of its step, gives kinetic force to the picture. The color, animation, and tension caused viewers to applaud Remington's vitality.

Such a painting compares favorably with Thomas Eakins's *The Fairman Rogers Four in Hand* (Fig. 55). Each artist worked with a distinct purpose in mind. For Eakins, his coach scene was an exercise in adapting a photographic vision to a painter's vision. It was executed to provide as exact a representation of trotting horses as possible. His secondary purpose was to picture Fairman Rogers, the noted authority on coaching who commissioned the work, with his family and friends. Remington's practical purpose was to provide Colonel Dodge with one of his eighteen illustrations and, in addition, to create a salable painting (in this he was successful three years later). Like Eakins, too, the western artist made a serious study of motion and of light. In both paintings the treatment of horses is essentially academic. Remington's

FIGURE 50. Photograph by Remington of the Haci-
enda San José de Bavicora (Bavicore Ranch), Mexi-
co. 1893. Frederic Remington Art Museum,
Ogdensburg, New York

FIGURE 51. Frederic Remington. *MEXICAN VAQUEROS
BREAKING A BRONC*. 1897. Pen and ink wash on paper,
24⅝ × 36⅝ in. (62.5 × 93.1 cm.). Museum of Fine
Arts, Boston. Bequest of John T. Spaulding

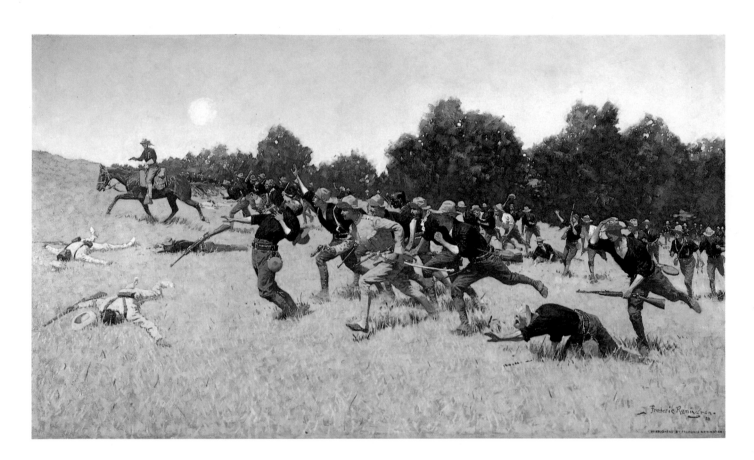

PLATE 16. *CHARGE OF THE ROUGH RIDERS AT*
SAN JUAN HILL. 1898. Oil on canvas,
35 × 60 in. (88.9 × 152.4 cm.). Frederic
Remington Art Museum, Ogdensburg, New York

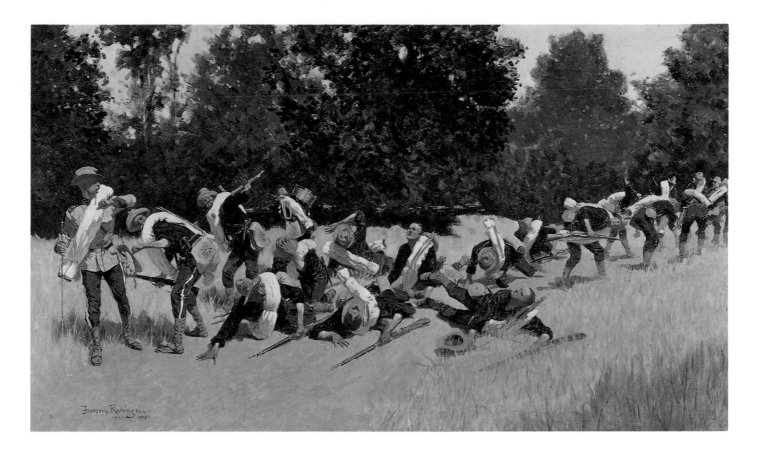

PLATE 17. *SCREAM OF SHRAPNEL AT SAN JUAN HILL, CUBA.* 1898. Oil on canvas, 35¼ × 60¾ in. (89.5 × 154.3 cm.). Yale University Art Gallery, New Haven, Connecticut. Gift of the artist, 1900

prancer and Eakins's bays are informed by photography and keen personal observation of equine anatomy. Remington's rendition is somewhat more vital and, as academic treatment, equally successful.

Because they were attempting to emphasize the actual motion of horses, both artists posed their subjects in near profile. Remington had usually painted horses in the field in that position, a technique that allowed him to give complete information on an animal's shape, coloring, and size in comparison to a rider. (For such plein-air studies, lone horses were held by a groom; mounted ones were posed by the artist.) Remington, who viewed human and animal figures as primary, filled his canvas with the man on horseback and depicted the parade of carriages as secondary.

In its general tonality, Remington's painting is considerably more heightened than Eakins's. Light floods on the horse and rider and is reflected back not only from the bright white and crimson highlights but from highly articulated impasto areas. Although there are fewer colors in Remington's palette, they are considerably brighter. Where Eakins's shadows are almost black, Remington, following observations gleaned south of the border, made them a light, cool blue-gray with a tint of red. He also used the reflected light on the horse's belly to give the creature a visual lightness, to create an effect of backlighting, and to model form.

During the 1890s, Remington was concerned strictly with what he called "our modern notion of fidelity—naturalism,"[25] and he remained unresponsive, at least for a while, to some of the more innovative artistic trends of the period—Impressionism and Aestheticism, to name two. The history of one ambitious painting, *Right Front Into Line—Come On,* completed in 1891, reveals the artist's dilemma. A photograph of the painting (Fig. 56), probably taken in William Kurtz's photographic studio in New York City, is all that remains. The thundering frontal assault was a motif Remington explored in a number of associated works of that year, including *Captain Dodge's Colored Troopers to the Rescue* (Fig. 57) and *Dismounted: The Fourth Troopers Moving the Led Horses.*[26] Except that there were American prairies rather than the ruins of a European city in the background, this was a Detaille cuirassier charge. *Right Front Into Line* commanded such attention that Remington sent it to the 1891 autumn exhibition of the National Academy, where its price was $5,000, five times the amount he had ever asked at the Academy. When it did not sell there, he packed it

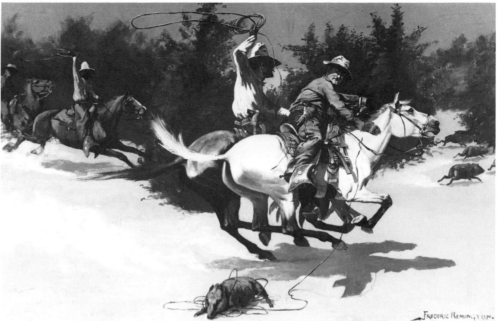

FIGURE 52. Frederic Remington. *A PECCARY HUNT IN NORTHERN MEXICO*. c. 1888. Oil on canvas, 18 × 28 in. (45.7 × 71.1 cm.). Collection Mr. and Mrs. Troy Murray, Scottsdale, Arizona

FIGURE 53. Remington on horseback in Canton, New York. c. 1888. Frederic Remington Art Museum, Ogdensburg, New York

FIGURE 54. Eadweard Muybridge. *TRANSVERSE-GALLOP (FRAME 2)*. 1887. Photograph. Reproduced in Eadweard Muybridge, *Animals in Motion* (London: Chapman & Hall, 1925)

(overleaf) detail of *CHARGE OF THE ROUGH RIDERS AT SAN JUAN HILL*, 1898 (Plate 16)

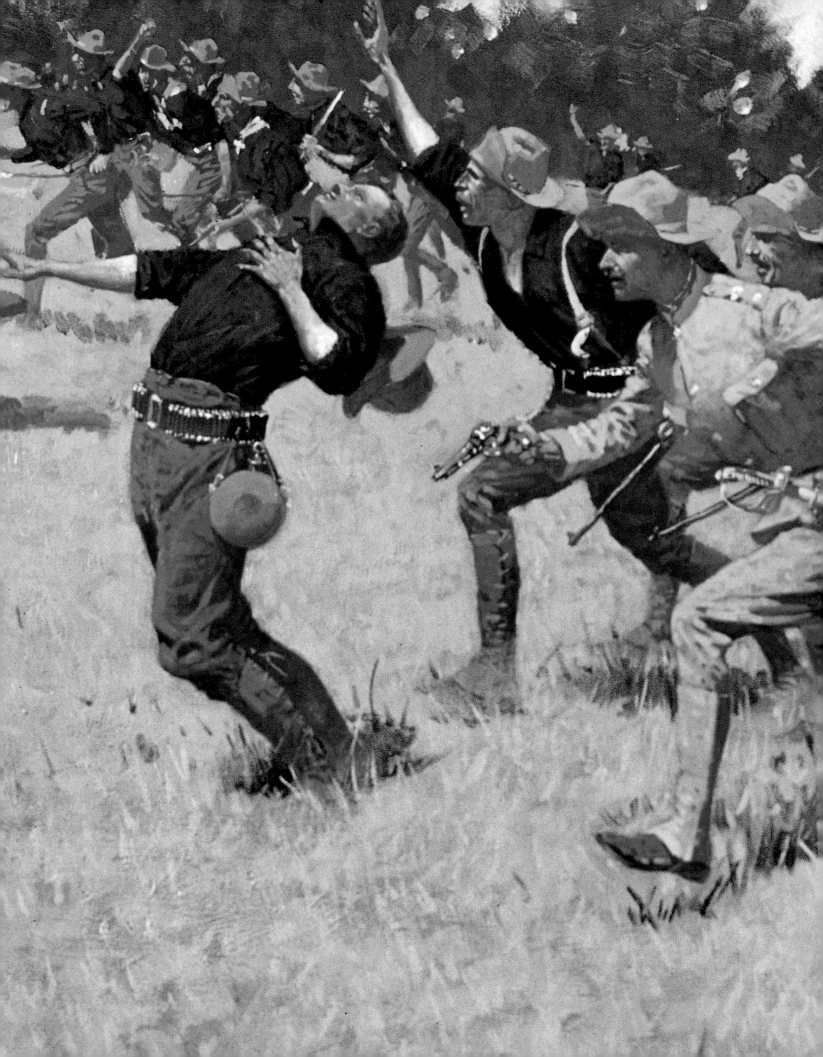

FIGURE 55. Thomas Eakins (American, 1844–
1916). *THE FAIRMAN ROGERS FOUR IN HAND*. 1879. Oil on
canvas, 24 × 36 in. (61 × 91.4 cm.). Philadelphia
Museum of Art. Given by William Alexander Dick

off the next year to Philadelphia and the sixty-second annual exhibition of the Penn-
sylvania Academy of the Fine Arts. Since this was as monumental, as naturalistic, and
as academic a painting as Remington could achieve, he must have been distressed
again that it did not sell and dismayed further at the reviews from that 1892 showing.

Instead of considering his pictures, the critics concentrated on a group of Impres-
sionist paintings at the east end of the west galleries, especially four works by Claude
Monet. Impressionism was not yet widely accepted in Philadelphia, and it caused a
sensation in the press. The *Philadelphia Inquirer* damned Remington's big canvas
with faint praise, commenting that "Frederick [*sic*] Remington has a large cavalry
scene, which is excellent in drawing, but is more fitted for illustration or mural deco-
ration."[27] When the painting was returned to the artist, Remington reconsidered the

piece. Eventually it underwent major alterations—two-thirds were cut away, the horizon line lowered by about six inches, and all secondary figures eliminated or repainted as distant riders in the background. Only the central figure, the captain, remained in the new composition, titled *The Trooper* (Fig. 58).[28]

Despite such adversities, Remington's career as an illustrator had taken such giant strides in the early 1890s that he had little time to produce paintings intended exclusively for sale or exhibition. He missed a major opportunity to show important work when, in 1893, he submitted only black-and-white paintings and drawings to the World's Columbian Exposition in Chicago. There were fifteen of them, and they were all sent from either the Century Company or Harper and Brothers. The fair would have provided Remington an inviting forum for his pictorial observations about the universality of western genre and myth and about the ways in which increased urbanization, industrialization, and the influx of European immigrants had altered American social values. Having no serious work hanging on the walls of the art pavilion of Chicago's White City, unable to confirm with his aesthetic the irrepressible national force of Manifest Destiny, Remington was artistically left behind. His concentration on the next story, the next trip to gather material, and the next deadline from the magazine art editors had diverted him from his chosen course to become a recognized painter.

Remington's preoccupation with narrative painting ran counter to what by 1893 were the prevailing interests of American artists.[29] Whereas the literal transcription of nature was Remington's strength and conflict with nature was his theme, harmony and mood were the bywords of the new Aestheticism, which pervaded the artworks at Chicago's fair. The call was for the evocation of spiritual union with nature, and this, at the time, was anathema to Remington. He was not willing to modify the order of his world as a concession to artistic unity. His forms were too real, his images too vital, and the myth too fresh with potential to be softened by the illusory visions of such artists as George Inness, James McNeill Whistler, and John La Farge.

And so in the mid-1890s, when he sought change and fresh vision, it was not to his artistic contemporaries that Remington turned but to a more focused view of his tried-and-true motif—the West. Rather than do combat in an unfamiliar arena—Impressionism and Aestheticism—he turned to something more precise and more

PLATE 20. *MISSING.* 1899.
Oil on canvas, 29½ × 50 in. (74.9 × 127 cm.). The
Thomas Gilcrease Institute of American History
and Art, Tulsa, Oklahoma

(opposite top) PLATE 18. *THE PURSUIT.* c. 1898.
Oil on canvas, 27¼ × 40 in. (69.2 × 101.6 cm.). The
Virginia Museum of Fine Arts, Richmond, Virginia.
Gift from the Estate of Sally Dunlop Eddy

(opposite bottom) PLATE 19. *THE INTRUDERS.* 1900.
Oil on canvas, 27 × 47 in. (68.6 × 119.4 cm.). Courte-
sy of The Gerald Peters Gallery, Santa Fe, New
Mexico

(overleaf) detail of *SCREAM OF SHRAPNEL AT SAN
JUAN HILL, CUBA,* 1898 (Plate 17)

FIGURE 56. Photograph of Remington's *RIGHT FRONT INTO LINE—COME ON*, 1891, probably in William Kurtz's studio, New York City. Frederic Remington Art Museum, Ogdensburg, New York

comprehensible. The center of Remington's world had long been the horse, and he revitalized his career by rediscovering the central equestrian figure of the West, the cowboy. With his newfound friend Owen Wister, whom he had met in Yellowstone National Park in 1893, Remington elevated the image and myth of the cowboy while temporarily sidestepping questions of style. By September 1895, Wister had been pulled firmly into Remington's camp and, after months of cajoling and instruction from the artist, had produced his famous essay for *Harper's Monthly,* "The Evolution of the Cow-Puncher." Remington's melancholy *The Fall of the Cowboy* (Plate 10) was the last of five illustrations for that article. With its somber tone yet underlying summational brilliance, Remington expressed in paint the pathos of the transformation of the West, as he had in words the year before: "The West is all played out in its romantic aspects."[30]

The soldier, of course, fit the same mold as the cowboy. Disappointed by the termination of the Indian Wars at Wounded Knee, Remington longed for a war in which he might participate. During the mid-1890s, he hoped hostilities would break out in Europe or Chile. He had missed real action all his life—born too late to record Custer, arrived too late to see action against Riel or Geronimo, and close but at the wrong place to witness the massacre at Wounded Knee. He had to content himself not with the role of war correspondent in the fashion of Vereshchagin, but as a recounter of old war tales in such pictures as *Through the Smoke Sprang the Daring Soldier* (Plate 14), used to illustrate his story of valor "A Sergeant of the Orphan Troop," in *Harper's Monthly* for August 1897.

Remington had met the story's hero, Carter P. Johnson, in 1888 while visiting Fort Grant in Arizona. Carter's Indian-campaign recollections fascinated Remington. The artist's diaries record that he had "sat up until all hours—talked with Lieutenant Johnson," who recounted, among other things, an "amazing story—about experiences with the Cheyennes."[31] During an especially desperate standoff with Dull Knife and his Cheyenne warriors, the soldier had leaped forward from the ranks and

FIGURE 57. Frederic Remington. *CAPTAIN DODGE'S COLORED TROOPERS TO THE RESCUE.* 1891. Tempera on board, 18⅝ × 35⅞ in. (47.3 × 91.1 cm.). Collection Charles Stewart Mott. Photograph courtesy Flint Institute of Art, Flint, Michigan

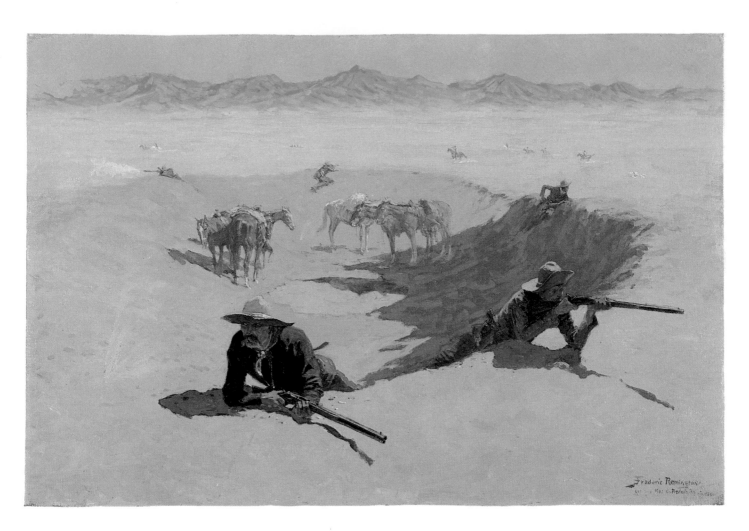

PLATE 21. *FIGHT FOR THE WATER HOLE.* 1901.
Oil on canvas, 27 × 40 in. (68.6 × 101.6 cm.).
The Museum of Fine Arts, Houston, Houston,
Texas. The Hogg Brothers Collection

discharged his revolver at the foe. Johnson's feat of bravery brought a close to the action and victory to his side. *Through the Smoke* illustrates this moment of high drama and makes a clear statement of Remington's remarkable skill. A strong pyramidal composition stabilizes the work, and vitality is provided by the thrust of the rifles over the ledge and Johnson's forward momentum. The wide band of blue frock coats with yellow-lined capes dramatically divides the cold blue Montana sky and the snowy slope below. The broad brushwork, heightening the excitement with which the painting is perceived, affords pictorial dynamics not seen in Remington's work before the late 1890s. Perceptible in the subtle color balance is the beginning of a tonal harmony that was crucial to Remington's future success, because with this story, for the first time, one of the illustrations was reproduced in color by *Harper's Monthly*.

The tragic impact of war finally enveloped Remington in 1898 with the declaration of war on Spain. Cuba provided his chance for experience in the field, his chance to observe what, in his opinion, men were meant to do—lend their lives to determine the destiny of nations. However, the realities of brutal confrontation and misery were so real as to tear at the fabric of his notion of the ideal soldier. Two large paintings resulted from the experience. One of them, *Scream of Shrapnel at San Juan Hill, Cuba* (Plate 17), portrays the random horror of an artillery shower. The picture demonstrates Remington's skill at the depiction of human anatomy. The soldiers—as their line rises, falls, and rises again—appear as if they were a single acrobat running, tumbling, and standing to run once more. It is as if he had transposed a whole series of Muybridge's photographs into one masterful, sequential composition. The second major painting that resulted from the Cuban experience, *Charge of the Rough Riders at San Juan Hill* (Plate 16), is a statement of heroic courage: Roosevelt in the vanguard is the emblem of solitary resolve and leadership.[32] The cry of battle and the thunder of the charge, albeit not a cavalry charge, were frozen in a moment of time. From a different vantage point, this is a restatement of Carter Johnson's leap to victory and an end run such as Remington's teammates might have made in his Yale football days—but now in a man's rather than a boy's game.

Disillusioned with war, Remington returned to the United States and found timely consolation in the advance of his artistic career. The West was still mythic in its

FIGURE 58. Frederic Remington. *THE TROOPER*.
c. 1902. Oil on canvas, 48¾ × 34 in. (123.8 × 86.4
cm.). The John F. Eulich Collection, Dallas, Texas

appeal, and the chance to apply historical hindsight in portraying its tests still whet-
ted his appetite. In 1899 with *Missing* (Plate 20) he made an effort to return to his old
world. The painting was displayed in the annual exhibition of the National Academy
of Design, where Remington, a long-time associate, again hoped to achieve full
membership. He had become an associate member eight years before, but since then
the Academy had failed to award him full membership. The theme of the painting
was quieter than usual—a solemn procession on an arid prairie. In the minds of the
critics and academicians, however, there had been no real change, and they denied
him membership. When the exhibition closed, Remington retrieved his painting and
never exhibited there again. He looked for his artistic laurels elsewhere and was

PLATE 22. *CHEYENNE BUCK*. 1901.
Pastel on board, 28½ × 24 in. (72.4 × 61 cm.). National Cowboy Hall of Fame Collection, Oklahoma City, Oklahoma

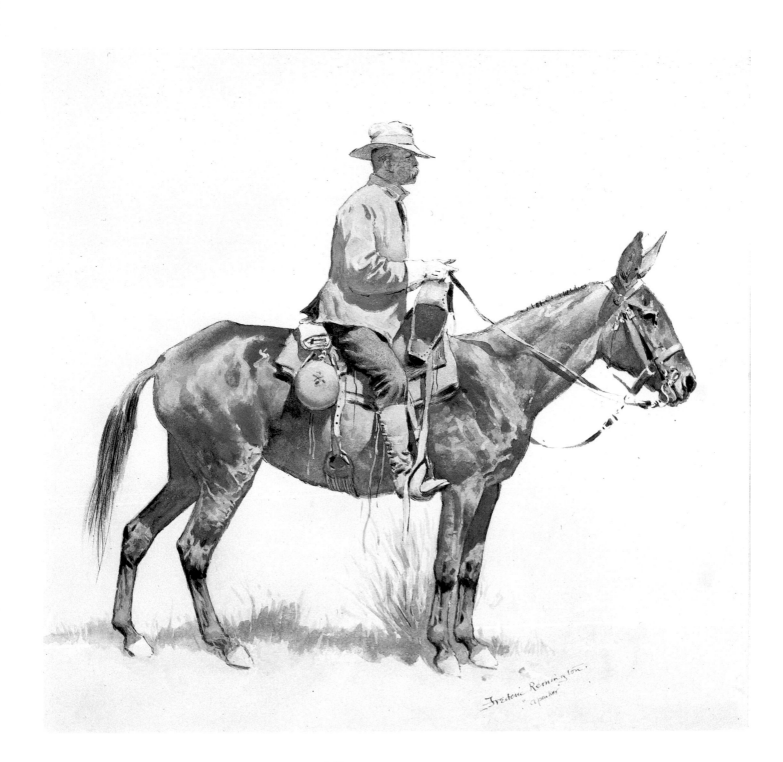

PLATE 23. *A PACKER*. c. 1901.
Watercolor on paper, 16½ × 16½ in. (41.9 × 41.9
cm.). Collection Gerald Peters Gallery, Santa Fe,
New Mexico

gratified, to begin with, the very next year, when Yale conferred on him an honorary degree in art.

Although Remington deliberately returned to old themes after the turn of the century in such paintings as *The Intruders* (Plate 19), he simultaneously began to venture in other directions in order to break free of the limitations of illustration and to rid himself of the label of being a "black and white man." The use of color had always troubled him, and the fact that American publishers were experimenting with color illustration provided a challenge. Pastel was a medium he had not yet tried. His first ventures in this direction were for the most part figure studies, colorful but not compositionally innovative, such as *Cheyenne Buck* (Plate 22), drawn for publication as part of *A Bunch of Buckskins,* a portfolio of eight color photolithographs. His aim was to discover a lighter and more delicate means of delineating form through color and shade. However, he rarely accomplished a successful landscape treatment with pastel: the figures in his Buckskin series seemed to pop off the unadorned page that served as their backdrop. He abandoned the medium after about a year.

When he was not successful in pastel, Remington turned his efforts after 1900 to harmonizing color and unifying his compositions by painting the subtle tones of night. In doing so, he established a mode of experimentation that guided his art for the remainder of his career. His exploration of nocturnal effects earned him his first official accolades as a painter since the tentative critical approval he had gained in 1889 with *A Dash for the Timber* and some of his early academic efforts.[33]

Remington did not have to look far for models as he embarked on his romantic interlude with night. Using a tonal style, artists such as Inness had been successfully rendering the harmonies of a veiled vision for a generation. Remington's painting of 1901 *The Old Stagecoach of the Plains* (Plate 24) evinces some of the fundamental tenets of those seekers of reverie. He reduced his palette essentially to two colors—a dark blue-green and brown—which suggested atmosphere (although not altogether successfully in this case) and a mood of mystery or nostalgia. The night effects dissolved his figures, and the shadows and horses' blazes became powerful abstract forms.[34] But the shadows were somewhat lifeless and the picture was still quite literal. Unlike Whistler, Remington refused to allow his patterns to become fully abstract. The lanterns punctuated the scene, keeping the theme from being lost in an ethereal

haze. Theme for Remington was always the imaginative part of the creative process; without it, he felt, an artist was no more than a technician. Through the next several years he labored to reconcile his reliance on theme and figure work with his aspirations to rejuvenate his artistic style. He would also attempt to resolve the criticism that Sadakichi Hartmann leveled against him that year: like Charles Dana Gibson, Remington was able only to "represent" with his imagery and could "'suggest' absolutely nothing."[35]

The success of his nocturnes was almost immediate. In a group of canvases exhibited at the Clausen Gallery in December 1901, Remington hung sunlit paintings next to night scenes. A critic's response probably did not surprise him. "In the bright ones, showing stretches of level country in boiling sunlight, Mr. Remington has given a gay color scheme with brilliant pure pigment and a general *coup de l'oeil,* which those familiar with the place will probably pronounce just like it. Depicting night the artist is more successful, and…he secures considerable sentiment with his paint." It was especially gratifying when the reviewer also commented that Remington's themes were "the real thing, never for a moment of the stage."[36]

Remington's prime inspiration in his search for tonal resolution was the Californian Charles Rollo Peters. Ironically, Peters had been influenced by Whistler, whose works Remington could never abide—they were all black holes with no imagination in them, he contended. Remington had seen a moody canvas by Peters at the Union League Club in 1899, and the two artists exhibited at both the 1901 Pan-American Exposition in Buffalo and the 1904 Louisiana Purchase Exposition at St. Louis. Remington particularly appreciated Peters's compositional use of large reflective surfaces, such as adobe walls, which served as secondary light sources and as important planes and surfaces against which to silhouette figures and action. *The Scout: Friends or Enemies?* of about 1890 (Plate 5) exemplifies an early nocturne in which Remington employed snow as the reflective surface. He used similar large tilted planes of snow in subsequent works.

Some of Remington's sunlit scenes painted after 1900 began to manifest more tonal control. *The Quest (The Advance)* (Plate 25), for example, has a reduced value range and considerably softened forms and achieves a greater sense of atmosphere when compared to a painting like *Missing,* completed only two years earlier. Because the

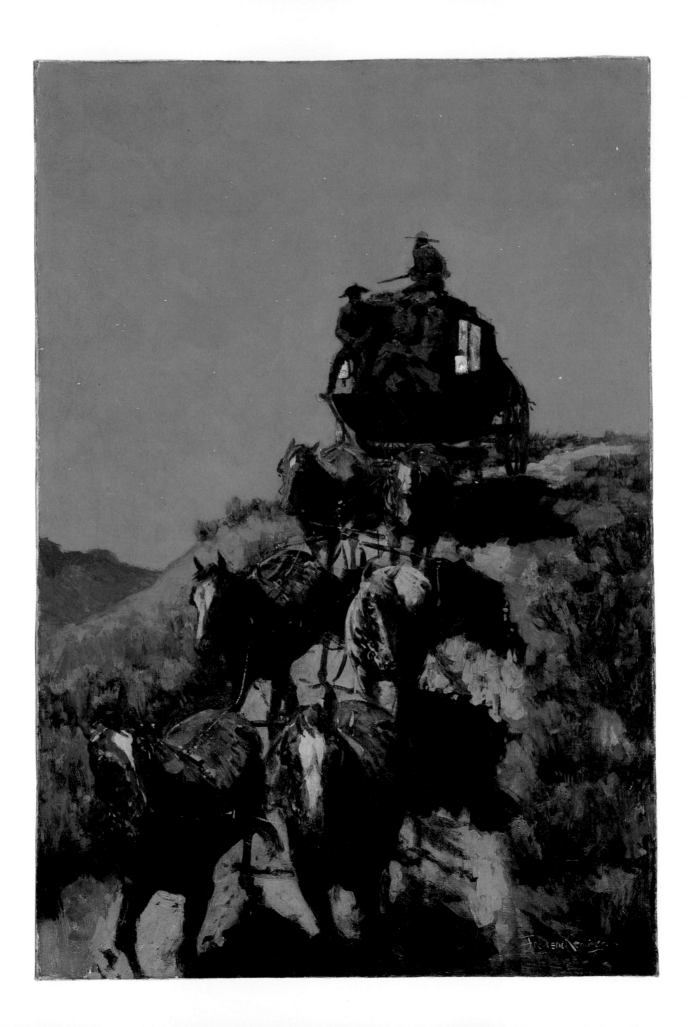

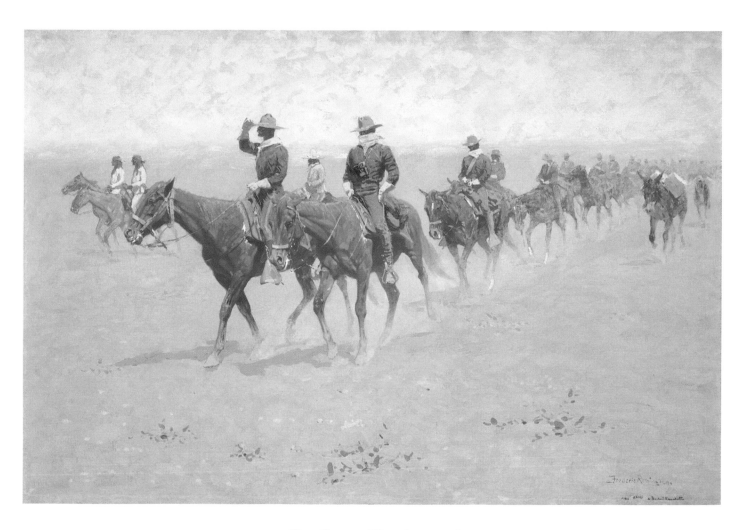

PLATE 25. *THE QUEST (THE ADVANCE).* 1901.
Oil on canvas, 26 × 39½ in. (66 × 100.3 cm.). Collec-
tion Anschutz Corporation, Denver, Colorado

(opposite) PLATE 24. *THE OLD STAGECOACH
OF THE PLAINS.* 1901. Oil on canvas, 40 × 27 in.
(101.6 × 68.6 cm.). Amon Carter Museum,
Fort Worth, Texas

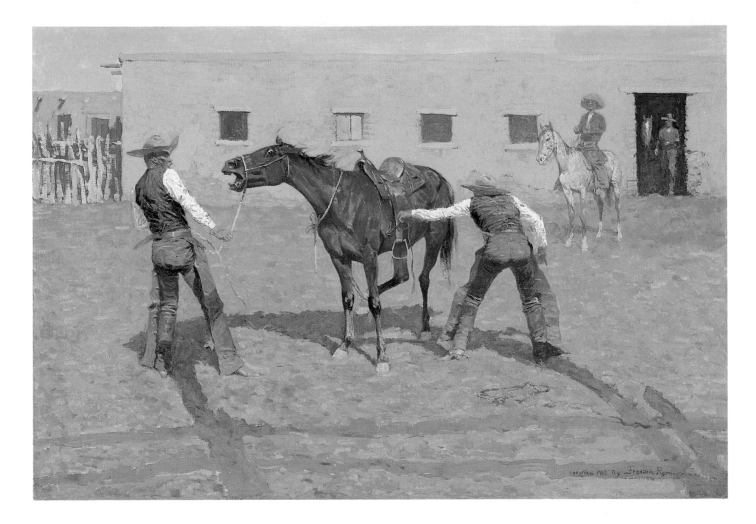

PLATE 26. *HIS FIRST LESSON.* 1903.
Oil on canvas, 27¼ × 40 in. (69.2 × 102.2 cm.).
Amon Carter Museum, Fort Worth, Texas

critics complained of what appeared to be an unnatural brilliance and heat in his work, Remington counteracted the unpopular effect by introducing a blue overcast. The broadly articulated brushwork in the sky enlivened the painting, as did the strong perspectival plunge of the column of horses into the distance. With this device Remington counterbalanced the absence of receding perpendicular references and the vagueness of the horizon. The result was an ambivalence of spatial relations that in itself proved both abstract and mysterious. In this desert scene Remington was approaching a synthesis of natural and suffused light, loose brushwork, and broken form.

In other paintings of the period Remington achieved more compositional control with a centering of major elements for pictorial emphasis. The cavalry column moving forward from the distant right or the fence line or building line (see Plate 10 and Fig. 51) were all intended to be read, as on the printed page, from left to right. With *His First Lesson* (Plate 26), Remington divorced himself from the production of literary adjunct in order to explore the notion of pure painting. Here the broad planes of color against which the figures were set become decorative surfaces, indifferent to illusionary definitions of space or line. The shadows, the gestures and tensions were calculated to express a latent kinetics in the picture, whose painterly presentation is enhanced and in which there is evident a modest dissolution of form.

The artist's awakening sense of color and less literal deployment of figures came about in part because of a contract he signed with *Collier's* in 1903. The agreement called for Remington to provide twelve paintings a year, one to be published each month in color. The pictures would not illustrate stories but would simply decorate the magazine. The agreement, which left the artist strictly on his own to select themes, represented both a challenge and an opportunity.

By 1905 Remington felt the full impact of his new freedom. He began to realize that he might soon escape from what had become the onerous title of illustrator to find full recognition as a painter. "Art is a she-devil of a mistress, and, if at times in earlier days she would not even stoop to my way of thinking, I have persevered and will so continue," he wrote that spring in *Collier's*. His own inclination as a painter now was to remove from his pictures all unnecessary detail—all extraneous information. Through simplification, as his nocturnes had taught him, paintings achieve power.

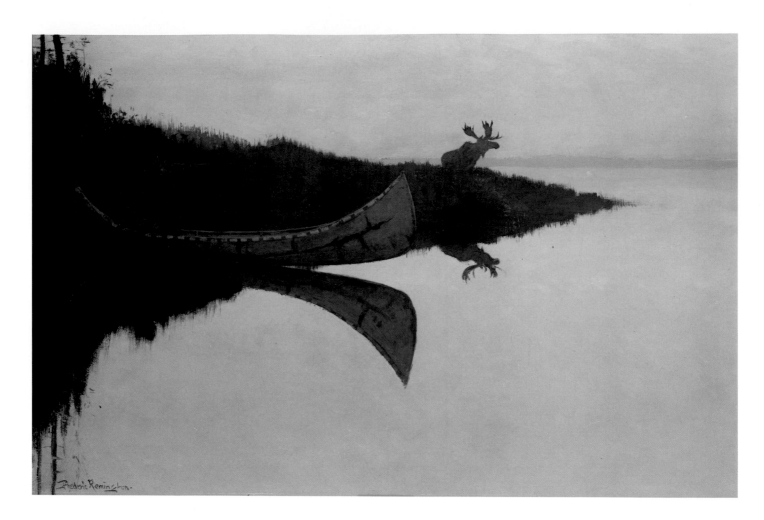

PLATE 27. *COMING TO THE CALL.* 1905.
Oil on canvas, 27 × 40 in. (68.6 × 101.6 cm.). Collec-
tion William Koch

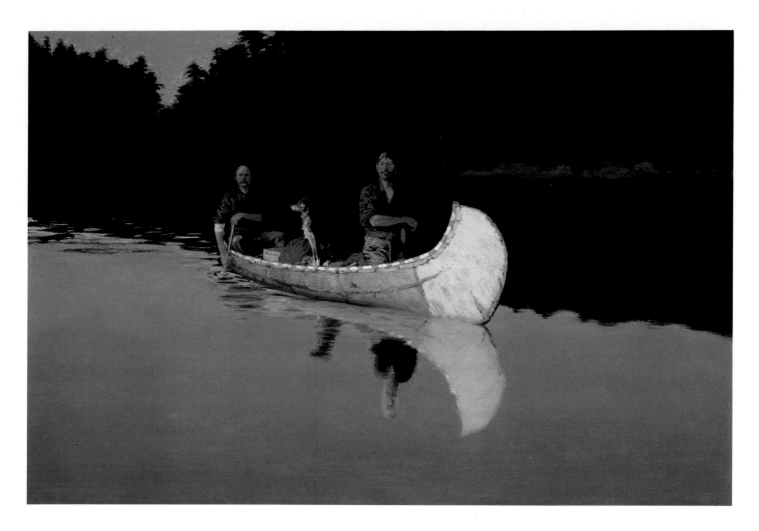

PLATE 28. *EVENING ON A CANADIAN LAKE.* 1905.
Oil on canvas, 27¼ × 40 in. (69.2 × 101.6 cm.). Col-
lection William Koch

FIGURE 59. Frederic Remington. *UNTITLED (TREES ON POINT OF LAKE).* c. 1905. Oil on board, 9 × 12¼ in. (22.9 × 31.1 cm.). Buffalo Bill Historical Center, Cody, Wyoming

"Big art is a process of elimination," he had observed in 1903, "cut down and out—do your hardest work outside the picture, and let your audience take away something to think about—to imagine.... What you want to do is just create the thought—materialize the spirit of a thing, and the small bronze—or the impressionist's picture—does that."[37] Simplicity and economy of pictorial expression in works such as *Coming to the Call* (Plate 27) and *Evening on a Canadian Lake* (Plate 28) brought Remington welcome accolades as a painter. In the latter painting, Remington has revealed with great force his new perception of man's harmonious place in nature. The canoeists are reflected in the water's surface, mirrored in the placid and hushed countenance of nature. They do not intrude on the quiet of America's wilderness but seem invited to be part of its rhythm. Winslow Homer had evoked a similar mood with his scenes from the Adirondacks in the early 1890s.

The critic Royal Cortissoz was among the first to proclaim the advance that the artist had made. After having seen one, perhaps both, of these paintings he wrote, "I don't know any better sensation than that of looking on while a fellow human is

FIGURE 60. Frederic Remington. *UNTITLED COMPOSITIONAL SKETCH*. n.d. Ink on paper, 3¼ × 4½ in. (8.3 × 11.4 cm.). Frederic Remington Art Museum, Ogdensburg, New York

making one splendid stride after another, painting good pictures and these damned good ones, and then damneder, and all the time doing it to his own beat, being himself in the fullest sense, making something beautiful that no one else could make."[38]

As early as 1899 Remington had traveled west strictly for the purpose of making color studies. His nocturnes required hours of firsthand observation of moonlight. After 1900, when he bought an island called Ingleneuk in the St. Lawrence River, he spent whole evenings in his canoe on the water, watching and sketching the twilight tints and reflections. There he recorded the strong patterns of lengthening shadows, the shimmer of reflected light, and the haunting glow of sunset color, all of which enlivened his palette and emboldened his compositional schemes. Color studies (Fig. 59) would ultimately be combined with thumbnail sketches (Fig. 60) to be worked into finished paintings for exhibition and publication in *Collier's*.

Although Remington contended about this time that he had given up photography entirely, he in fact continued to use it in some measure throughout the remainder of his career. Photographic images of water lilies (Fig. 61), for example, may have aided

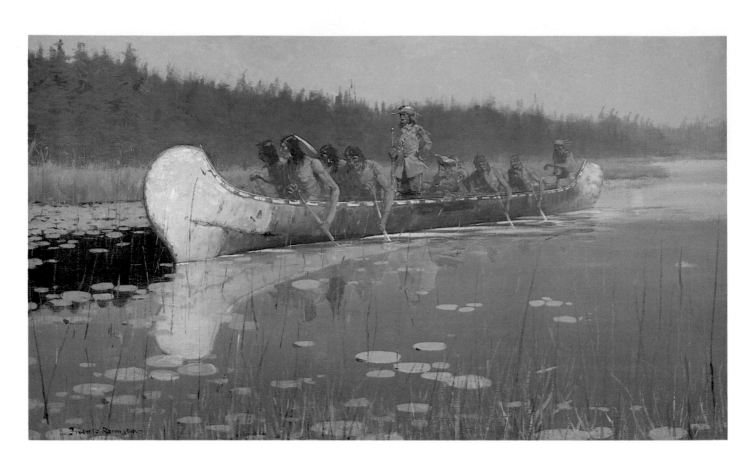

PLATE 29. *Radisson and Groseilliers.* 1906.
Oil on canvas, 17 × 29¾ in. (43.2 × 75.6 cm.). Buffa-
lo Bill Historical Center, Cody, Wyoming. Gift of
Mrs. Karl Frank

him—in addition to color studies—with such studio pieces as *Radisson and Groseil-liers* (Plate 29). For devout readers of *Harper's Monthly,* such a painting might have appeared as only a modest deviation from such illustrations of the previous decade as *The Missionary,* of 1892 (Fig. 62), and *This Was a Fatal Embarkation,* of 1898. However, he was learning something from his photographs that he had never seen before. No longer concerned with details, he now looked through his camera lens to record abstract patterns in nature. Compared with his previous work, the figures of Radisson and Groseilliers in the canoe represented essentially the same theme, yet had lost linear definition and begun to blend into those broad, natural patterns.

Remington cannot be considered a pure plein-air artist because at this time he finished most of his paintings in the studio. However, since his audience wanted western subjects and since he was more and more interested in the effects of color and light, field work became increasingly important. A couple of trips west each year became essential. A photograph taken of Remington on one such visit, to Fort Robinson, Nebraska, in 1905 (Fig. 36), shows his method of painting outdoors. The canvas on his easel, probably depicting the bluffs behind the fort, would have returned with

FIGURE 61. Photograph by Remington of water lilies.
After 1901. From an album in the collection of
Frederic Remington Art Museum, Ogdensburg, New York

137

PLATE 30. *CAVALRY CHARGE ON THE*
SOUTHERN PLAINS IN 1860. 1907–8.
Oil on canvas, 30⅛ × 51⅛ in. (76.5 × 129.9 cm.).
The Metropolitan Museum of Art, New York.
Gift of Several Gentlemen, 1911

him to his New Rochelle studio as an unfinished landscape painting, similar, per-haps, to *Untitled (Prairie and Rimrocks)* (Fig. 63).[39] He intended the incomplete work not to be a study but rather the first phase of a painting. To complete it, he would add a figure or figures to the foreground. He had probably utilized such a technique in *Missing,* of 1899, and would use it again nearly a decade later, in *Indians Simulating Buffalo* (Plate 38). Having substantially completed the landscape in the field, Rem-ington, back home, would first draw the figures separately in proportion to the can-vas. Then he would turn a red conté-crayoned tissue face down over the landscape, place the drawing on top of that, and trace it. This left a light red outline that he could subsequently paint in to complete the work. An example of the outline technique in progress can be seen in *Ghost Riders* (Fig. 64), an unfinished painting from about 1909. This was not the only method of painting that Remington employed. Photo-graphs of him at work in his later years show that he also conceived compositions directly, with charcoal, on canvas.

FIGURE 62. Frederic Remington. *THE MISSIONARY.* 1892.
Wood engraving, 4¾×6⅞ in. (12.1×17.5 cm.).
On loan to the Harold McCracken Research Library,
Buffalo Bill Historical Center, Cody, Wyoming

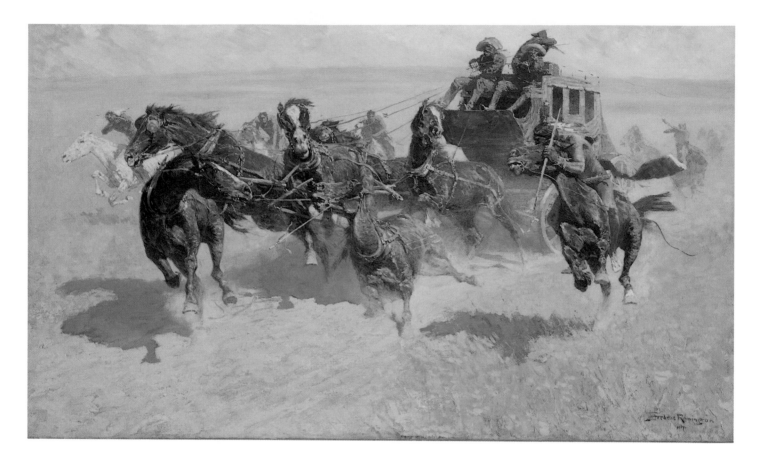

PLATE 31. *DOWNING THE NIGH LEADER.* c. 1907.
Oil on canvas, 30 × 50 in. (76.2 × 127 cm.). Museum
of Western Art, Denver, Colorado

PLATE 32. *FIRED ON.* 1907.
Oil on canvas, 27⅛ × 40 in. (68.9 × 101.6 cm.). National Museum of American Art, Smithsonian Institution, Washington, D.C. Gift of William T. Evans

(overleaf) detail of *DOWNING THE NIGH LEADER,*
c. 1907 (Plate 31)

FIGURE 63. Frederic Remington. *UNTITLED (PRAIRIE AND RIMROCKS)*. n.d. Oil on canvas, 20⅛ × 32⅛ in. (51.1 × 81.6 cm.). Buffalo Bill Historical Center, Cody, Wyoming

By 1906 Remington's diligent experiments with color began to succeed. Roland Knoedler, the dealer who had displayed Remington's bronzes the year before, offered to host a one-man show of his paintings. Critics were quick to respond to these new efforts, which heartened Remington and encouraged him further to explore harmonious color effects. One writer for the *New York American* noted that he "has worked out and away from his former hard and dry color and his pictures have now softness and almost delicacy of color." The *New York Times* extolled his efforts, similarly observing that Remington's brush had, of late, been victorious "against the hard academic style."[40]

But some of these more ethereal endeavors were not successful. *Collier's* received complaints, and the artist, who was his own most demanding critic, was unsatisfied. The process of deemphasizing contours was difficult and some of the pictures simply turned out to be weak. On February 8, 1907, Remington noted in his diary that he "burned every old canvas in house today out in the snow. About 75.—and there is nothing left but my landscape studies." Included in the blaze were the ten companion pieces to *Radisson and Groseilliers*—the rest of his *Collier's* series, The Great Explor-

ers—almost a full year's worth of what the reading public had seen of his art. Now all but one of the paintings, illustrative of the experimental nature of Remington's work in 1905 and 1906, were gone.

With much of his old work destroyed, Remington was left with the two most fundamental elements of his art: his imagination and his landscape studies. And, of course, he still possessed that driving force to be original that William Poste had recognized twenty years before. Remington's impulses were to stay on track with his western work, to continue to explore the West of his romantic vision, but also, enticed by his new appreciation for color, to explore light. In its muted and darkened tones, light could create a sense of mystery and dream that he had never before achieved. And at its glaring height, light could invite pictorial dynamics or, as he referred to it, "vibration," that would enliven the picture surface as never before.

In these late years, Remington increasingly befriended certain members of the group of painters known as The Ten—Robert Reid, Willard L. Metcalf, Childe Hassam, and his old acquaintance J. Alden Weir. He socialized with them, he encouraged their efforts, he went to exhibitions of their work, and—most important—when op-

FIGURE 64. Frederic Remington. *GHOST RIDERS*.
c. 1909. Oil on board, 12 × 18 in. (30.5 × 45.7 cm.).
Buffalo Bill Historical Center, Cody, Wyoming

PLATE 33. *Untitled (Early Autumn)*. c. 1907.
Oil on canvas, 26⅛ × 18⅛ in. (66.4 × 46 cm.). Buffa-
lo Bill Historical Center, Cody, Wyoming. Gift of
The Coe Foundation

PLATE 34. *CHIPPEWA BAY (ST. LAWRENCE RIVER SCENE).* c. 1908.
Oil on board, 12 × 16 in. (30.5 × 40.6 cm.). Buffalo Bill Historical
Center, Cody, Wyoming. Gift of The Coe Foundation

PLATE 35. *CHIPPEWA BAY.* c. 1908.
Oil on board, 12 × 18 in. (30.5 × 45.7 cm.). Buffalo
Bill Historical Center, Cody, Wyoming. Gift of The
Coe Foundation

portunity allowed he painted with them. In 1906 he told the New York art editor Perrington Maxwell that they were also beginning to influence him. "Lately some of our American landscape artists—who are the best in the world—have worked their spell over me and have to some extent influenced me, in so far as a figure painter can follow in their footsteps."[41] On March 7, 1907, for example, he suggested in his diary what an inviting challenge these fellow painters, these Impressionists, had offered him. "I [have been] trying for painting ideas but tired and ideas won't come. I yearn to get to work in the open." This was the same month he purchased property in Ridgefield, Connecticut, in order to be, among other things, close to Weir and his associates.

His chance to paint outdoors came in April, when he traveled to Texas, Arizona, and New Mexico in search of western color. When he got west, however, he found it so green that he almost turned around and came home. What he had hoped for was a dry, tawny landscape that he could use for such paintings as *Cavalry Charge on the Southern Plains in 1860* (Plate 30) and *Downing the Nigh Leader* (Plate 31), to be shown at Knoedler's that winter. He finally found it around Cloudcroft and near the Grand Canyon. In the two paintings, the landscape is generalized, suggesting that color, rather than topographical nuance, was all that mattered to Remington. He returned to New Rochelle with his studies of western light and there worked at designing compositions for his requisite dozen pictures for *Collier's*. The actual work of painting was postponed until the summer, at his island studio on the St. Lawrence.

On December 14, 1907, Remington recorded in his diary that his "unfortunate Knoedler show" had closed. He had received reasonably good reviews, but the country was experiencing an economic recession and few of his paintings had sold. Since he was hopeful of making a living as a painter rather than as an illustrator, his year's work was important as a salable commodity on the gallery walls—not just as illustrations between magazine covers. Besides, Remington could see problems developing with the new art editor at *Collier's,* Will Bradley, an exponent of Art Nouveau design whose taste did not extend to stagecoaches, cavalry charges, or Arizona light.

Remington's daylight scenes of western drama in the 1907 show received little critical praise. Cortissoz, who had paid him such gracious compliments a few years before, now remarked that some of Remington's paintings did "no more than repeat

the rather crude effects which he has found in the Western plains and has exploited again and again."[42] And the *American Art News* reacted similarly. "The artist has not yet ceased to be an illustrator while becoming a painter. His color is softening and becoming more natural, but the chief quality of his work is still dramatic choice of subjects and fierce action."[43]

It might appear that Remington had suffered a setback, but in at least one area of endeavor he had continued to advance—his nocturnes. Cortissoz described, for example, his painting *Fired On* (Plate 32) as the artist's consummate masterpiece to date. This was the painter's ultimate drama, accomplished through bold brushwork and a subdued tonal key. Most significantly, the "study of...moonlight appears to have reacted upon the very grain of his art, so that all along the line, in drawing, in brush work, in color, in atmosphere, he has achieved greater freedom and breadth."[44]

By December 1908, when a new Remington exhibition opened at Knoedler's, the artist had taken those lessons to heart. Three-quarters of his large canvases were nocturnes, including *Night Halt of the Cavalry* (Plate 37); most of the few daylight scenes were subdued, clouded views with the thunder of hoofs muffled by snow (Plate 42) or with the action diverted into reverie (Plate 41). On December 3 *The Globe* summarized Remington's technical advances. "Mr. Remington has greatly improved. He handles his pigment with surer brush, in a bigger way and a more logical manner, with greater simplicity than hitherto. His color is purer, more vibrant, more telling, and his figures are more in atmosphere."

These broadly painted canvases, whether washed with an almost liquid atmosphere of night or scintillating but suffused sunlight on snow, came close to what some of his American colleagues were accomplishing with Impressionism. Yet Remington's situation was perplexing. He refused to abandon the figure or to desert his imagination. "I sometimes feel that I am trying to do the impossible in my pictures in not having a chance to work direct but as there are no people such as I paint, it's 'studio' or nothing," he wrote. "Yet these transcript from nature fellows who are so clever cannot compare with the imaginative men in [the] long run."[45] No longer able to paint the Indian, the cowboy, or even the cavalrymen in the field as he had when he was an artist-correspondent during the 1880s, he had to rely on memory and imagi-

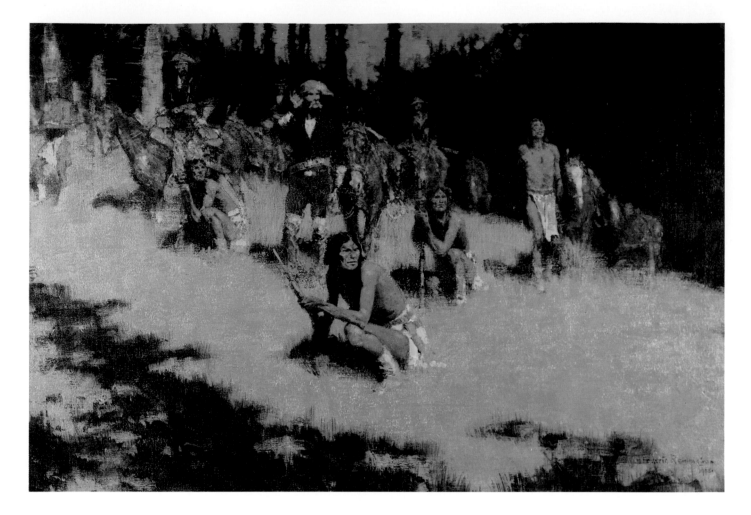

PLATE 36. *Apache Scouts Listening.* 1908.
Oil on canvas, 27 × 40 in. (68.6 × 101.6 cm.). Private
collection

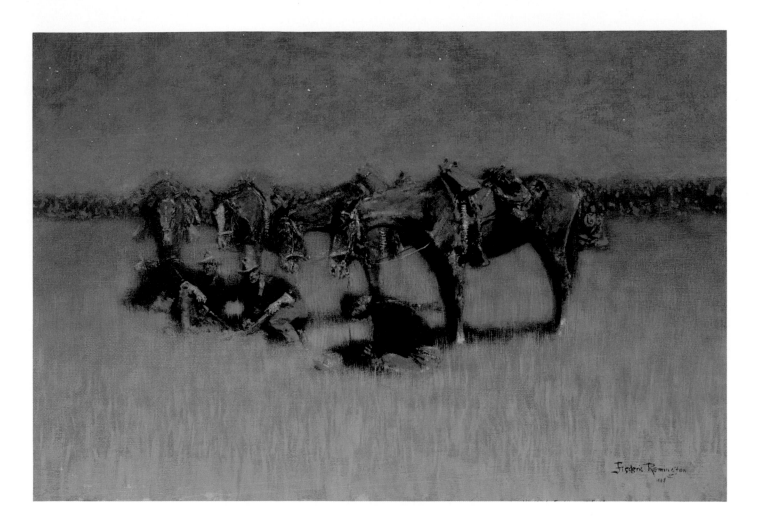

PLATE 37. *NIGHT HALT OF THE CAVALRY.* 1908.
Oil on canvas, 27 × 40 in. (68.6 × 101.6 cm.). Courte-
sy of The Gerald Peters Gallery, Santa Fe, New
Mexico

(overleaf) detail of *NIGHT HALT OF THE CAVAL-
RY,* 1908 (Plate 37)

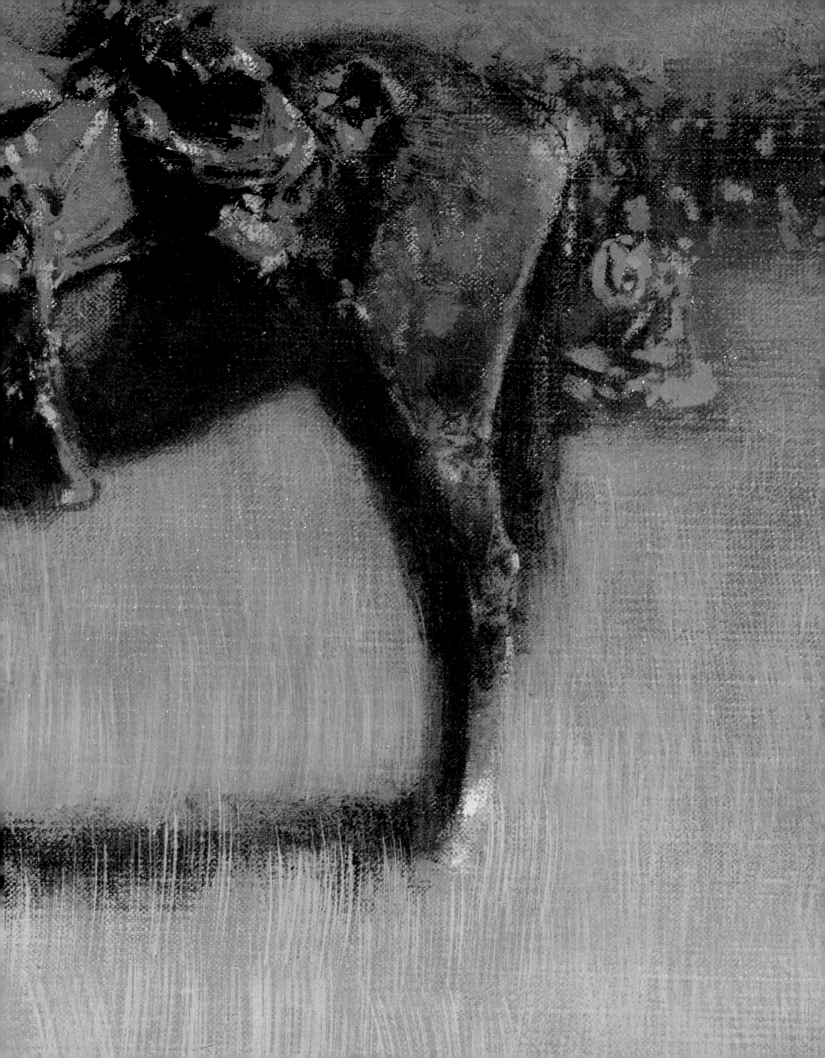

nation. His ego was not reflected in the horse and rider now but rather in the full pictorial and metaphorical force of his painting, as in *With the Eye of the Mind.*[46] Nor did Remington now want to have his audience view him as a sportsman, cowboy, or companion of the soldier. He felt himself complete as an American historical artist and a practitioner of painterly gesture.

Remington did sidestep his imagination in 1908, however, with a series of pure landscapes. These he had begun, in fact, early in the year, just when he was complaining about "trying to do the impossible." In January he traveled with his friend the illustrator Edward Kemble along the Farmington River in northeastern Connecticut to paint landscapes. There had been fresh snow, and Remington would use his studies of the sun setting on the winter hills (Fig. 65) for color inspiration when he painted *The Snow Trail,* probably later that year. Some visitors to his studio admired the plein-air studies as complete works in their own right. As a consequence, during the summer months at Ingleneuk Remington painted a good number of pure landscapes, such as *Chippewa Bay* (Plate 35), which he signed and inscribed. He entered six of them in his Knoedler's exhibition in December. These paintings, and others, like *Pete's Shanty, Ingleneuk* (Plate 40), for example, were Impressionist works in palette, technique, execution, and motivation.

Remington considered these landscape paintings so successful that he continued the practice of completing works in the field during his next trip west that fall. Visiting Cody, Wyoming, in September, he painted *Shoshone* (Fig. 66), a sage-covered sunlit hillside capped with a delicate line of clouds. His host, George T. Beck, watched Remington paint (Fig. 67) and recorded the process in his memoirs, describing how the artist used a small, smooth board as a palette:

> After the scene was sketched he would daub a lot of primary colors on the board and, taking a brush, he'd mix a shade he wanted. Then taking another brush he'd dab spots of this color all over the canvas. Throwing that brush on the ground, he would take another and start on another color, repeating the process of putting it on in spots wherever the color hit his eye. Finally he would get so many bright daubs of paint on the canvas that it looked more like a sample of Joseph's coat of many colors than a picture. And then he would begin mixing some dark paint for the shadows. Once he had his shadows in, the picture suddenly stood out— completed.[47]

FIGURE 65. Frederic Remington. *UNTITLED (IMPRESSIONIST WINTER SCENE).* n.d. Oil on board, 10 × 14 in. (25.4 × 35.6 cm.). Buffalo Bill Historical Center, Cody, Wyoming

FIGURE 66. Frederic Remington. *SHOSHONE.* 1908. Oil on board, 12 × 16 in. (30.5 × 40.6 cm.). Buffalo Bill Historical Center, Cody, Wyoming

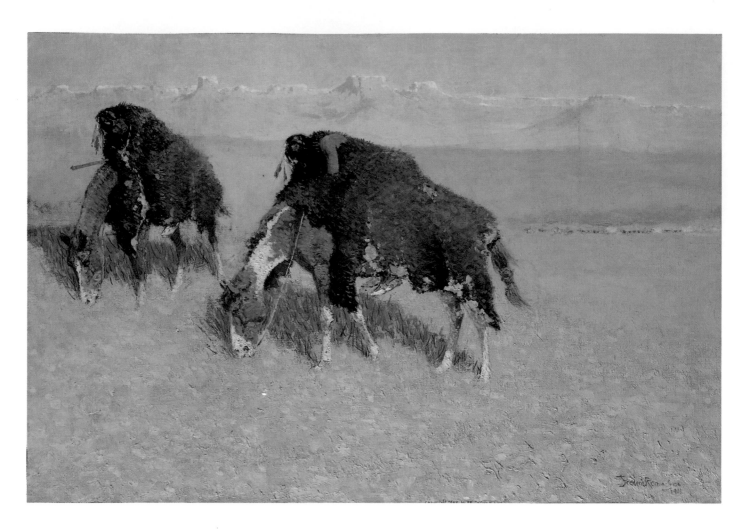

PLATE 38. *INDIANS SIMULATING BUFFALO.* 1908.
Oil on canvas, 27 × 40 in. (68.6 × 101.6 cm.). The
Toledo Museum of Art, Toledo, Ohio. Gift of
Florence Scott Libbey

PLATE 39. *EPISODE OF A BUFFALO HUNT.* 1908.
Oil on canvas, 28½ × 26½ in. (72.4 × 67.3 cm.). The
Thomas Gilcrease Institute of American History
and Art, Tulsa, Oklahoma

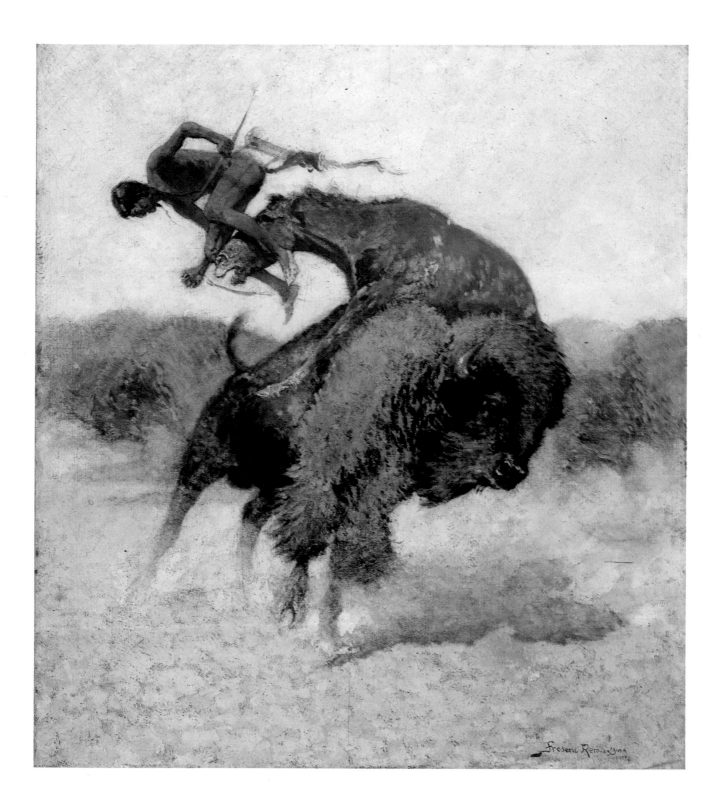

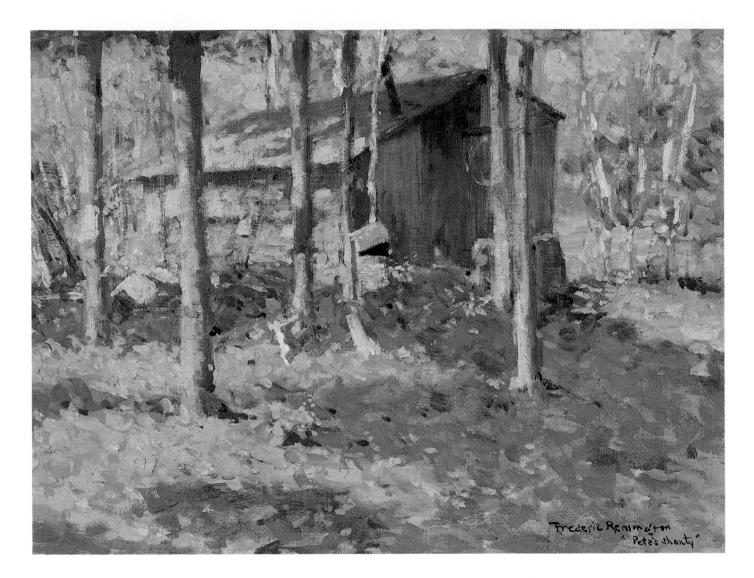

PLATE 40. *PETE'S SHANTY, INGLENEUK.* 1908.
Oil on canvas, 13×17 in. (33×43.2 cm.). Frederic
Remington Art Museum, Ogdensburg, New York

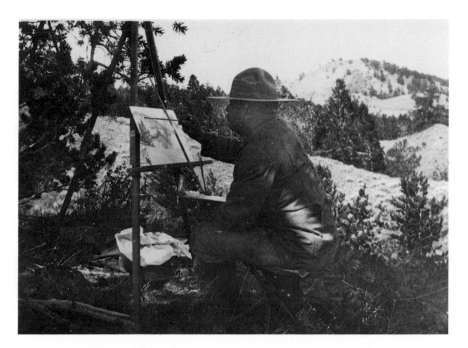

FIGURE 67. Remington painting in Wyoming. 1908.
Frederic Remington Art Museum, Ogdensburg, New York

By 1909 most serious Remington observers, whether critics or fellow artists or
collectors, had reached two conclusions. First, there was no longer any question that
Remington had achieved success as a painter as well as an illustrator. Second, his tie
to Impressionism was being increasingly acknowledged—still not perhaps in his
reliance on figural subjects, but certainly in his application of current theories about
light and its relation to art. Remington's friend the playwright Augustus Thomas ob-
served, "It was interesting to follow his awakened and developing sense of color.
Nature on that side made more and more appeal to him, until in our Sunday-morning
and weekday-evening tramps the tints of sky and field and road almost totally dis-
lodged the phantom soldiery from the hillside."[48]

Many of Remington's large studio pieces from his last two years expressed his own
form of Impressionism. Although not entirely composed outdoors and still generally
figure-oriented, such paintings as *Indians Simulating Buffalo* (Plate 38) and *The Out-
lier* (Plate 46) share much with Impressionism, including such techniques as vigor-
ous brushwork, juxtaposition of colors, reduced tonal range in favor of pure color,

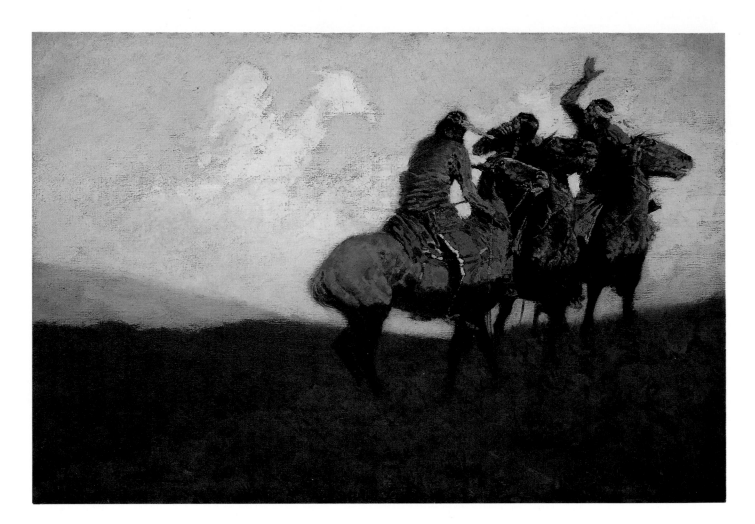

PLATE 41. *WITH THE EYE OF THE MIND.* 1908.
Oil on canvas, 27 × 40 in. (68.6 × 101.6 cm.). The
Thomas Gilcrease Institute of American History
and Art, Tulsa, Oklahoma

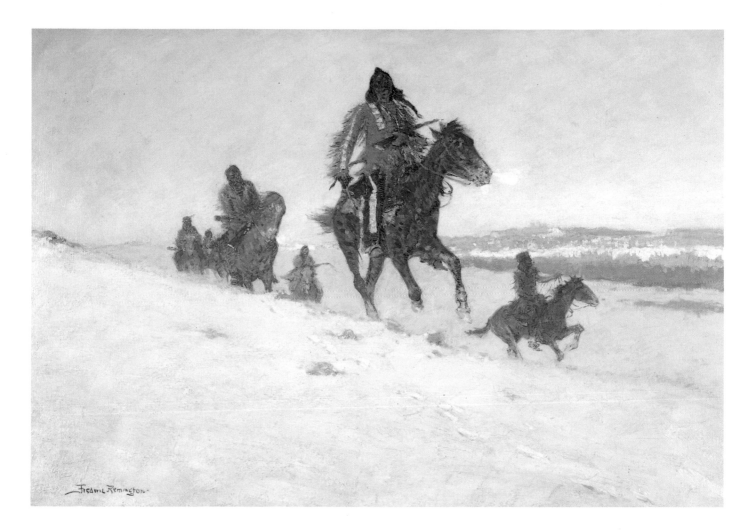

PLATE 42. *THE SNOW TRAIL.* c. 1908.
Oil on canvas, 27 × 40 in. (68.6 × 101.6 cm.).
Frederic Remington Art Museum,
Ogdensburg, New York

(overleaf) detail of *THE SNOW TRAIL*, c. 1908
(Plate 42)

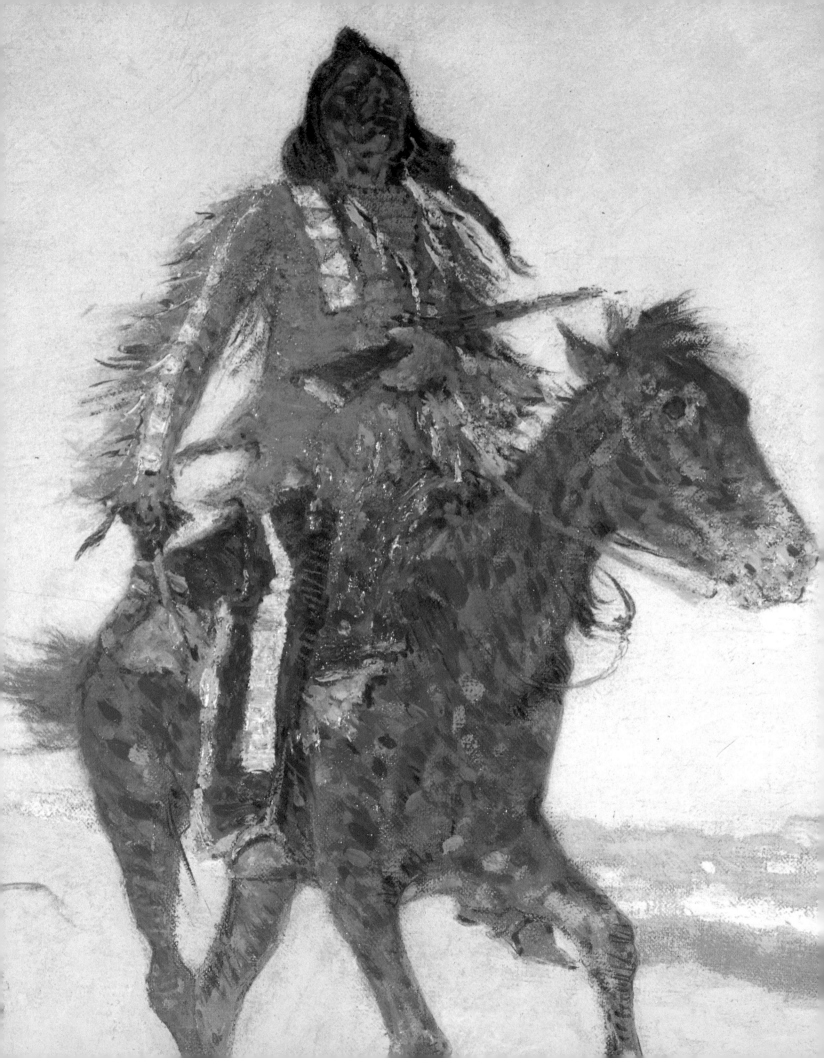

and the elimination of black from the palette. Yet because Remington was not willing to allow his western scenes to reflect dilettante tastes, was not interested in charm, and would not divorce himself entirely from narrative themes, most students of his work have denied him any association with Impressionism. Theodore Stebbins, recently confirming the notion of disassociation, commented, "Attempts have been made to link the artist with Impressionism, but his brushwork always remained conservative and academic."[49] Careful inspection of the brushwork in *Indians Simulating Buffalo* brings this statement into question, and a look at *Pete's Shanty* sets Remington's place firmly, if briefly, in the Impressionist ranks.

In the last year of his life, Remington moved beyond light. Like the Symbolists, who called for an art that was ideational, symbolic, synthetic, subjective, and decorative,[50] he grappled for a synthesis of painterly harmony and emotional mystery. In 1908 he had explored those forces in *With the Eye of the Mind*. The following year, in an effort to embody even more profound, invisible secrets and lock them into bold, decorative patterns of unified, subdued color, he painted *The Gossips* (Plate 43). Gone is his empirical investigation into the effects of light on form, and in its place has appeared the type of highly ordered design that was first strongly expressed in *Coming to the Call*. With the entrancing patterns of pictorial rhythms so evident in both paintings and the dream of the past so lyrically portrayed, Remington adopted and brought to maturity in *The Gossips* many of the Symbolists' credos.

Whether his adoption of Symbolist imagery and perception, abandonment of Impressionism, and turn to Tonalist harmonies in such paintings as *The Gossips* represented a permanent step for Remington will never be known. Many of his contemporaries, including his friend Childe Hassam and Willard L. Metcalf, the landscape artist he most admired, alternated between Tonalism and Impressionism during the same years. Certainly Remington's last works were considered by most of his contemporaries to be his greatest accomplishments.

The spontaneity and vitality of his techniques enabled Remington to complete one of his late works, *The Love Call*, in a single sitting. Others, such as *The Outlier*, demanded numerous reworkings and at least two versions (Plate 46 and Fig. 68) before he was satisfied. The low, cool tones of blue proved extremely difficult for him, whereas the russets and golds of *The Gossips* had not. When he finished *The Outlier* in

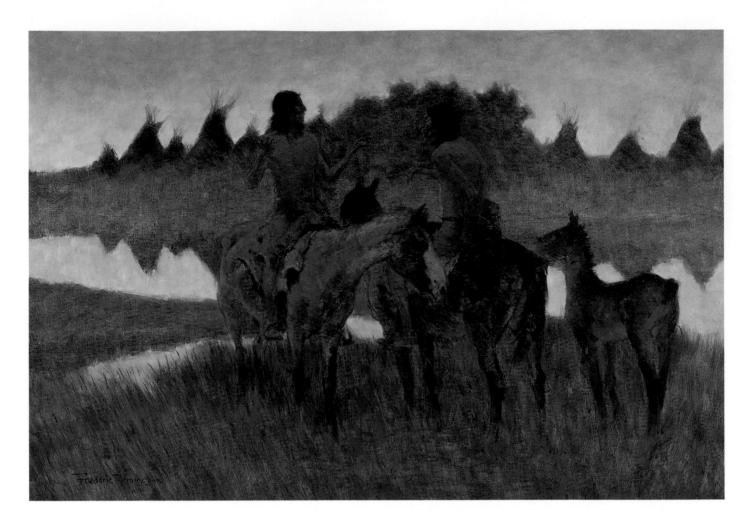

PLATE 43. *THE GOSSIPS*. 1909.
Oil on canvas, 27×40 in. (68.6×101.6 cm.). Private
collection

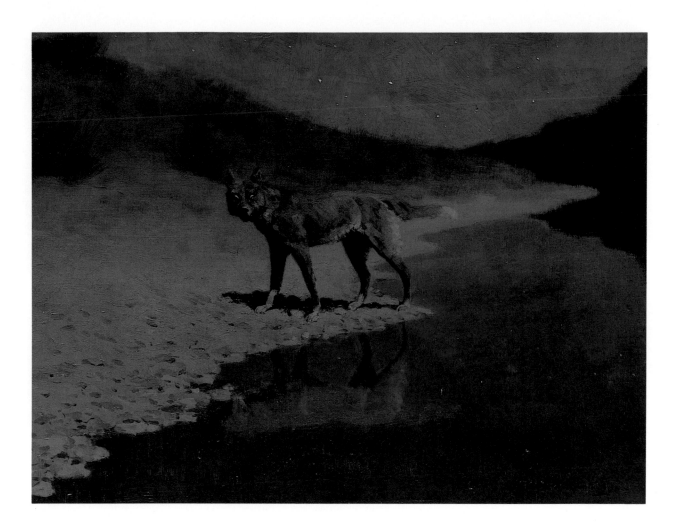

PLATE 44. *WOLF IN THE MOONLIGHT
(MOONLIGHT, WOLF)*. c. 1909.
Oil on canvas, 20 × 26 in. (50.8 × 66 cm.).
Addison Gallery of American Art, Phillips
Academy, Andover, Massachusetts

PLATE 45. *Pontiac Club, Canada.* 1909.
Oil on canvas, 12 × 16 in. (30.5 × 40.6 cm.). Frederic
Remington Art Museum, Ogdensburg, New York

October, he had been at the job so many months he referred to the painting as "my old companion." The effort was worth it. Hassam, who visited shortly thereafter, concluded that it was Remington's strongest painting ever.[51]

The Outlier presented the long-standing theme of the sentinel shrouded in reverie. In the mysterious, resolute figure there is an indisputable suggestion of nobility. Surely, there is some romantic nineteenth-century residue that, together with the quiet harmony of color and pictorial orchestration, invokes the ancient union of natural man and his natural world. The picture once again suggests an affinity— probably not conscious—with French Symbolist doctrines. Perceptual experience translated to canvas on the spot was replaced by subjective recollection of things once seen.[52]

Several of Remington's 1909 landscapes recall Symbolist paintings as well. As if now claiming affinity with Edward Steichen's photographs rather than Muybridge's, *Pontiac Club, Canada* (Plate 45), one of the products of that last summer's plein-air work, shows an abiding sympathy for nature's patterns. These proved to be his most powerful landscapes in both scale and pictorial expression.

In a letter to an old friend, Al Brolley, Remington, at the end of his life, referred to himself as a "plein-air man by instinct." Yet the figure remained absolutely central to the fabric of his art. He also told Brolley that he was "the bone in a big art war down here [in New York City]....I stand for the proposition of 'subjects'—painting something worth while as against painting *nothing* well—merely paint."[53] Remington also contended that without imagination, without the subjective force of creativity, art was valueless. It is probably safe to conclude that, had he lived longer, these three truths would have continued at the heart of his expression. Light and mystery and mankind would have continued to flow forth from his facile brush and uncommon genius.

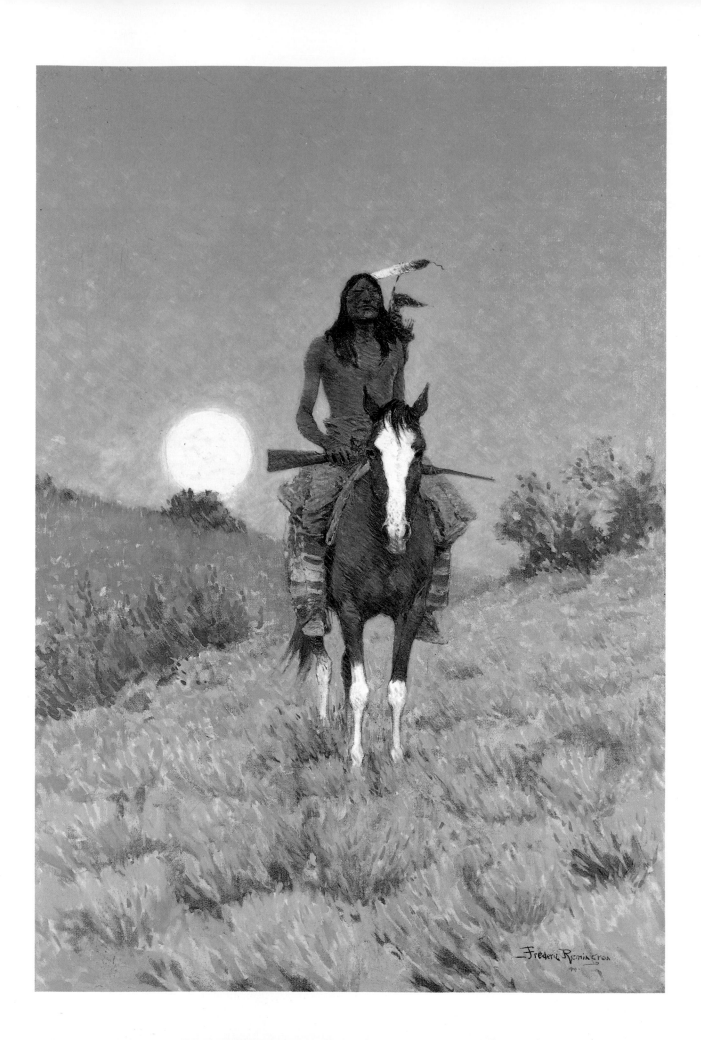

FIGURE 68. Frederic Remington. *THE OUTLIER*. 1909.
Oil on canvas, 30¼ × 27⅛ in. (76.8 × 68.9 cm.).
Frederic Remington Art Museum, Ogdensburg,
New York

(opposite) PLATE 46. *THE OUTLIER*. 1909.
Oil on canvas, 40⅛ × 27¼ in. (102 × 69.2 cm.). The
Brooklyn Museum. Bequest of Miss Charlotte R.
Stillman

REMINGTON
THE SCULPTOR
By Michael Edward Shapiro

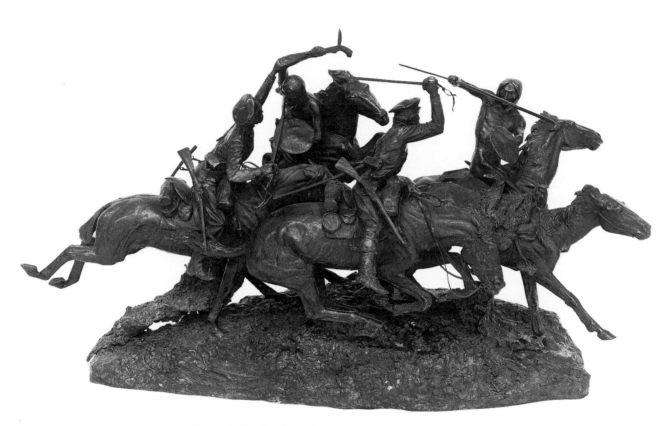

FIGURE 69. Frederic Remington. *THE OLD DRAGOONS OF 1850*. 1905. Bronze, h. 25⅝ in. (65.1 cm.). Courtesy Amon Carter Museum, Fort Worth, Texas

Remington's bronze sculptures fused complex sources, built upon the achievements of many of the most talented American and European sculptors of the time, and moved beyond the work of the artist's American contemporaries by realizing a *fin de siècle* vision of the American West so compelling that it enfolded suggestions of aspiration and struggle, victory and defeat within its forms. Moving from the smooth surfaces, translucent patinas, and linear realism of his initial sculptures, Remington became a modeler of richly kneaded, darkly encrusted, and increasingly expressive surfaces, who felt comfortable working on a large scale. Like Augustus Saint-Gaudens, he experimented with unusual patinas and subtle surface textures, and like Paul Bartlett, an American sculptor in Paris, Remington adopted lost-wax casting as his preferred method of sculptural reproduction and became the finest practitioner of the method in America.

Because he endorsed some of the conservative traditions of European sporting bronzes, Remington's links with Auguste Rodin, a radically innovative sculptor he admired greatly, have not been perceived. However, Remington's aggressive, cantilevered compositions were innovative from the first; the artist continually tested the limits of the medium of bronze to convey his combative vision of life. Agitated and fraught with energy, his bronze sculptures established visual stereotypes of Indians and introduced them into a pantheon of almost extinct American heroes: mountain man, cowboy, cavalry officer, and trooper of the plains. Locked in combat against man, beast, or the forces of nature, and usually retrospective and elegiac in mood, his sculptures transcended the formal compositions of his longer-lived American contemporaries Cyrus Dallin, A. Phimister Proctor, and Gutzon and Solon Borglum. Ironically, Remington's achievements in the invention of form, serial casting, and powerful imagery—compressed into one of the briefest and most intensive careers in American sculpture—have not yet been widely appreciated.

Remington's first significant contact with sculpture took place in 1878 at Yale University, when he and his friend Poultney Bigelow enrolled in a drawing class taught by John Henry Niemeyer. In the basement studio decorated with plaster replicas of ancient sculpture, the two students struggled to draw from a plaster cast of the *Dancing Faun* (Fig. 70).[1] Niemeyer, the professor of drawing at the Yale School of Fine

(right) PLATE 47. *THE BRONCO BUSTER*. 1895.
© October 1, 1895; cast 1895–96. Bronze, h. 24¾ in.
(62.9 cm.); base 20¼ × 7½ in. (51.4 × 19 cm.).
Henry-Bonnard Bronze Company cast no. 6.
Choate Rosemary Hall Foundation, Inc.,
Wallingford, Connecticut

(left) PLATE 48. *THE BRONCO BUSTER*. 1895.
© October 1, 1895; cast c. 1905–6. Bronze, h. 23¼
in. (59 cm.); base 22⅜ × 11⅝ in. (56.8 × 29.5 cm.).
Roman Bronze Works cast no. 40. Amon Carter
Museum, Fort Worth, Texas

(opposite) PLATE 49. *THE BRONCO BUSTER*. 1895,
remodeled 1909.
© October 1, 1895; cast c. 1912. Bronze, h. 32¾ in.
(83.2 cm.); base 29¼ × 18 in. (74.3 × 45.7 cm.). Ro-
man Bronze Works cast no. 4. The Art Institute of
Chicago. Gift of Burr Robbins

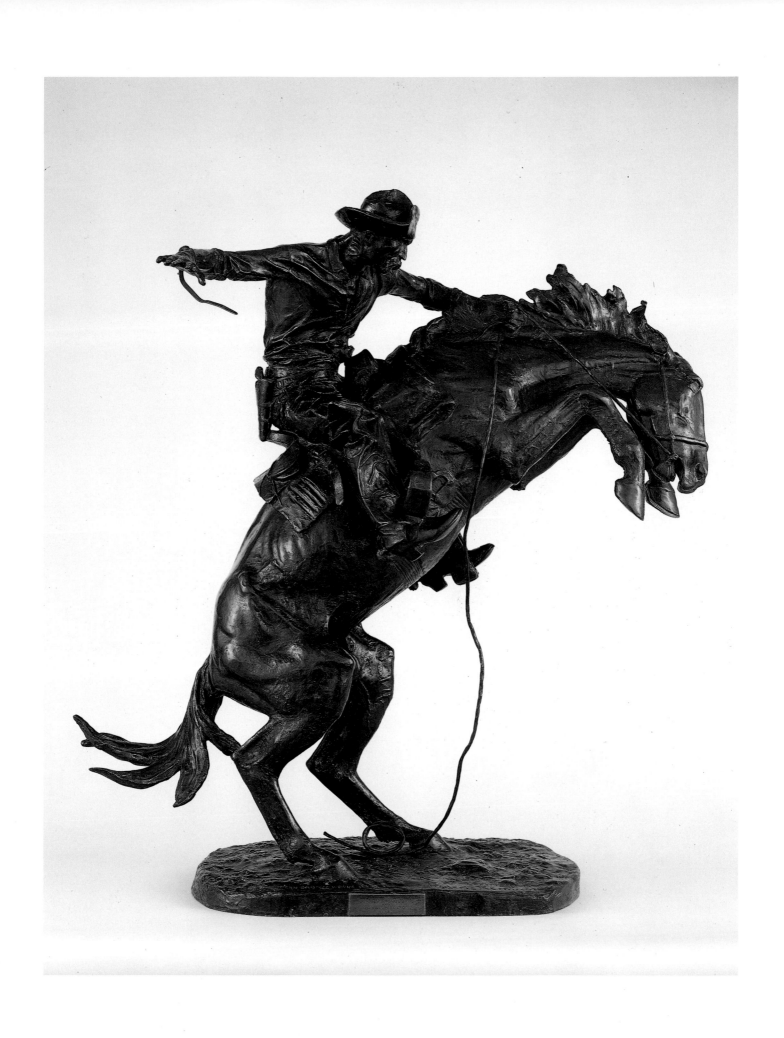

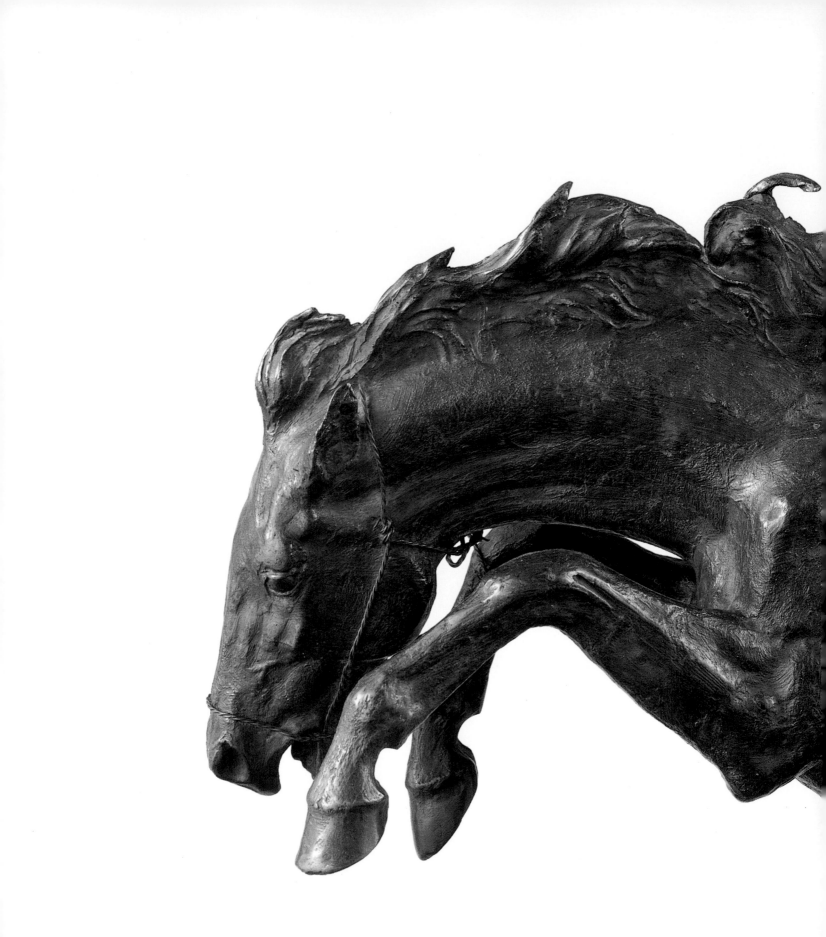

detail of *THE BRONCO BUSTER*, 1895 (Plate 48)

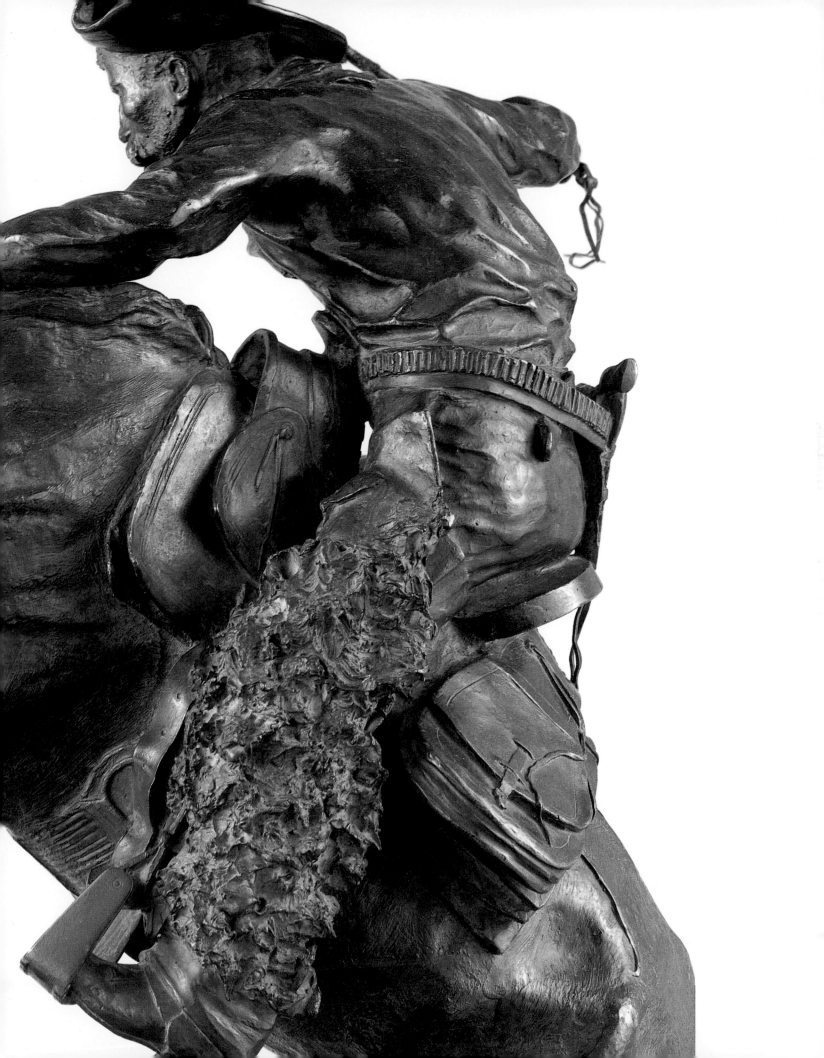

FIGURE 70. Drawing classroom, School of Fine Arts,
Yale College. c. 1879 (in the foreground is the *DANCING
FAUN*). Reproduced in William Kingsley, ed., *Yale College:
A Sketch of Its History* (New York: Henry Holt & Company,
1879). Courtesy Yale University Archives,
Yale University Library, New Haven, Connecticut

Arts, like most academically oriented art teachers, placed great emphasis on his students' ability to draw copies of ancient sculptures.

The impressions these academic exercises made on Remington cannot be overestimated. The raised hands and legs of the figure of the *Dancing Faun,* for example, would later be transformed into poses found in such sculptures as *Coming Through the Rye* (Plate 56), where the arms of the cowboys and the legs of the horses are lifted

in a similar pattern. The Yale studio certainly must have contained a plaster cast of the *Dying Gaul,* a pathos-suffused Hellenistic sculpture Remington would adapt for the bronze figure of a fallen cowboy in *The Wicked Pony* (Plate 51).

The imprint of such dynamic Hellenistic sculptures as the *Laocoön* also may have stimulated the youthful art student to look for equally heroic and tragic forms that would epitomize the men of his own time. Yet he never enrolled in formal sculpture classes either at Yale or, later, at the Art Students League in New York. What Remington learned from his earliest contacts with sculpture was incorporated first into his drawings and then into his paintings, before they were ultimately transferred into bronze almost twenty years after his classes at Yale.

Unlike the leading American sculptors of the previous generation, Augustus Saint-Gaudens and Daniel Chester French, or those of his own generation, Paul Bartlett, Frederick MacMonnies, and George Grey Barnard, Remington did not complete his education in sculpture with formal study in Europe, even though he turned to sculpture at the acme of French Beaux-Arts influence in America. Instead he absorbed his principles of construction indirectly from a variety of sources. Though he later proudly stated that he was independent of foreign influence, his denial was untrue. His apparently indigenous subject matter and the lack of serious scholarly attention to his sculptures have permitted his assertions of independence to obscure the connections between his work and that of European and American sculptors. For example, his preference for bronze over all other materials and for 24-inch or 36-inch formats reflects the pervasive influence of the small French bronze on both sides of the Atlantic at the turn of the century. While these and other factors link Remington to the dominant European and American styles of sculpture-making, the characteristics that set him apart from artists on both sides of the Atlantic are just as notable.

Remington's contemporaries MacMonnies, Bartlett, and Barnard were thoroughly steeped in French sculpture and were long-time residents of Paris. Of the three, Mac-Monnies, who had worked in Saint-Gaudens's studio in Paris, is the only sculptor with whom we know Remington had direct contact. It is likely that Saint-Gaudens, who was MacMonnies's mentor and Remington's friend, introduced the two artists. The relationship between MacMonnies and Remington was competitive rather than supportive. The sculpture of Paul Bartlett had technical rather than stylistic bearing upon Remington's work, for Bartlett, like Remington, became enamored of the lost-

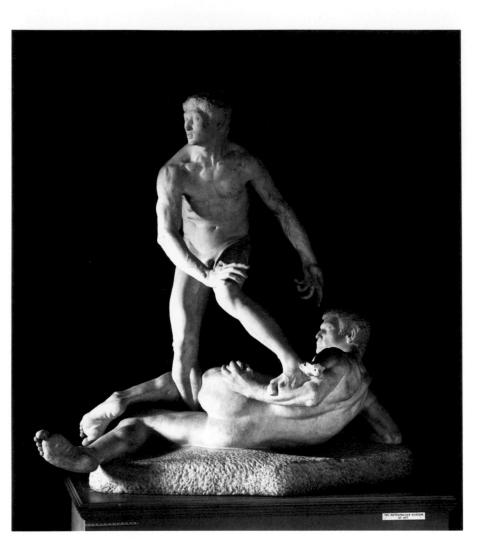

FIGURE 71. George Grey Barnard (American, 1863–1938). *STRUGGLE OF THE TWO NATURES IN MAN.* 1894. Marble, h. 8 ft. 6½ in. (25.78 m.). The Metropolitan Museum of Art, New York. Gift of Alfred Corning Clark, 1896

wax casting process. Both Bartlett and Remington promoted the revival of this technique and helped to popularize it in America.

More than any works produced by these three sculptors, it was Barnard's marble figures in *Struggle of the Two Natures in Man* (Fig. 71) that relate most closely in mood to Remington's embattled men and horses. Like Barnard, Remington broke from established formulas to create sculptures whose startling dramas suggest the

conflict between powerful human and natural forces in a mood of elemental struggle and decline. The energy Remington expended on his bronzes, which boldly defy classical modes of composition and construction, as well as his unending efforts to subvert the weighty nature of the medium and the pains he took to refine his small sculptures set him apart from these European-trained American contemporaries and ally him more closely with Auguste Rodin.

Another group of American sculptors of Remington's generation depicted western subjects in bronze after having been trained in France. Gutzon Borglum's *The Fallen Warrior* (Fig. 72) and Cyrus Dallin's *The Signal of Peace* (1894) (Lincoln Park, Chicago) predated Remington's entry into sculpture and surely challenged him to translate into solid form his own dynamic vision of the closure of the American frontier. But while Borglum's *The Fallen Warrior* has an element of romantic narrative sentiment—the horse is as important as the fallen Indian—Remington's work is unsentimentalized and direct. Borglum's Indian related more closely to Giovanni Duprè's

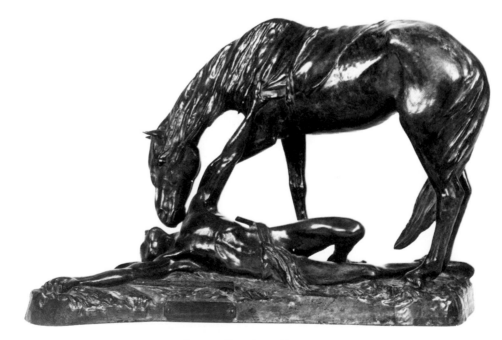

FIGURE 72. Gutzon Borglum (American, 1867–1941). *THE FALLEN WARRIOR*. c. 1891. Bronze, h. 11 in. (27.9 cm.). The Thomas Gilcrease Institute of American History and Art, Tulsa, Oklahoma

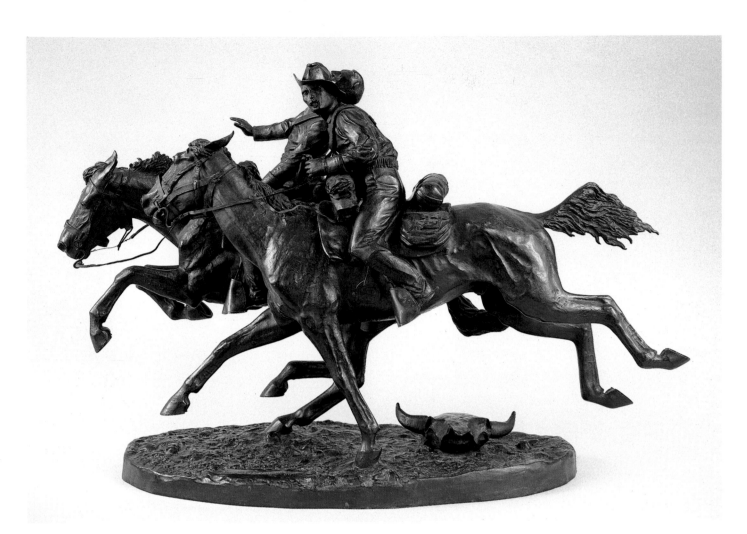

PLATE 50. *THE WOUNDED BUNKIE.* 1896.
© July 9, 1896; cast c. 1898. Bronze, h. 20 in. (50.8
cm.); base 22 × 12¼ in. (55.9 × 31.1 cm.). Henry-
Bonnard Bronze Company cast E. Yale University
Art Gallery, New Haven, Connecticut. Gift of the
artist, 1900

PLATE 51. *THE WICKED PONY.* 1898.
© December 3, 1898; cast c. 1899. Bronze, h. 22 in.
(55.9 cm.); base 21¼ × 8⅞ in. (54 × 22.5 cm.).
Henry-Bonnard Bronze Foundry cast no. 2. Amon
Carter Museum, Fort Worth, Texas

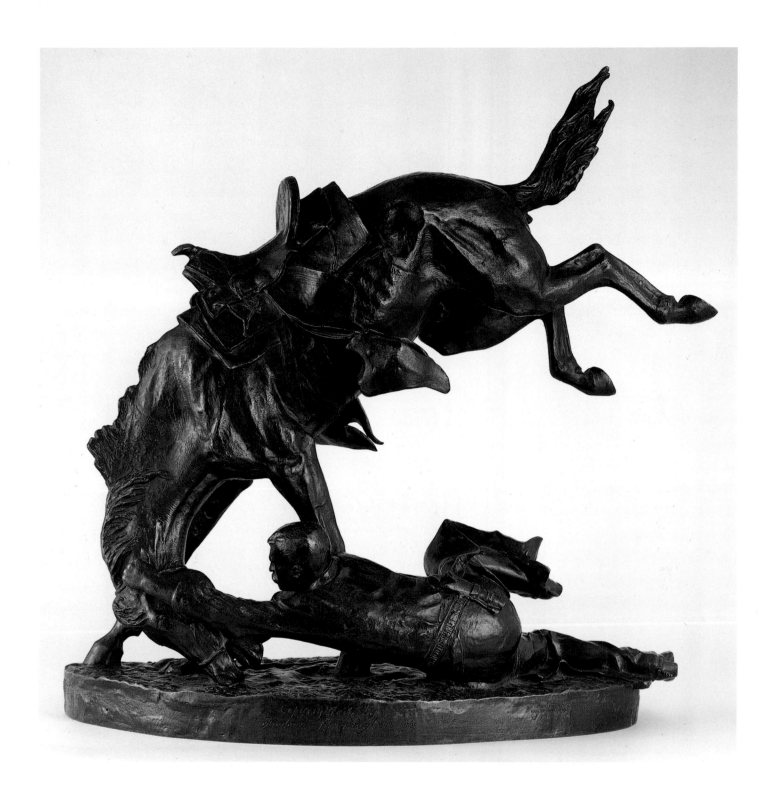

The Dead Abel (original plaster 1842; Louvre, Paris) than to forms actually observed in the American West. Like Borglum's early work, Dallin's life-size equestrian statue helped establish a new type of subject matter for turn-of-the-century American sculptors, but *The Signal of Peace,* too, is a largely static conception in which the existing vocabulary for equestrian sculpture is merely applied to a different subject matter. The truly inventive step in the area of western American bronzes was the expression of sheer physical *energy,* and the creation of energetic bronzes is Remington's achievement more than any other American artist's.

Remington may have become increasingly aware of and interested in sculpture as his career emerged, but certain events in the fall of 1894 led him to create his first model for sculpture. By coincidence, the dramatist Augustus Thomas, Remington's friend and neighbor in New Rochelle, offered the use of the back of his house to the highly successful, academically trained sculptor Frederick Wellington Ruckstull to prepare his model for an equestrian statue of General John Hartranft for Harrisburg, Pennsylvania.

Remington was so interested in Ruckstull's project that both Ruckstull and Thomas urged him to try his hand at the medium. During the three months that the senior sculptor was literally down the street, Remington had his only sustained schooling in sculpture. By the turn of the new year, Remington was infatuated with the permanence of bronze sculpture, the tactile pleasures of clay, and most especially with the opening of a new mode of expression. For this man obsessively concerned with the imminence of death and predisposed to view life in terms of decline and defeat, bronze would offer an opportunity to stop the onward rush of time. The emergent sculptor wrote in January 1895 to his friend the novelist Owen Wister: "My oils will all get old and watery…my watercolors will fade—but I am to endure in bronze…I am modeling—I find I do well—I am doing a cowboy on a bucking broncho and I am going to rattle down through all the ages, unless some Anarchist invades the old mansion and knocks it off the shelf."[2]

That first sculpture, derived from Remington's own previously published drawings and paintings of riders on horseback, consisted of a rearing horse and rider. The painted and drawn images, in turn, are related to photographs of rearing horses that he had collected (Fig. 73). These photographs, in which movement is frozen in dis-

FIGURE 73. Rearing horse. Photograph from an album in Remington's collection. Frederic Remington Art Museum, Ogdensburg, New York

crete units of time, enabled him to evoke motion authentically in his paintings and subsequently in his sculptures. He became the American sculptor most concerned with depicting the action and spirit of headlong forward motion, whose mysteries the camera's eye had first revealed in the 1870s. His success with the rearing horse in his first bronze, *The Bronco Buster* (Plate 47), soon led him to model the syncopated hooves of horses running at full gallop in *The Wounded Bunkie* (Plate 50).

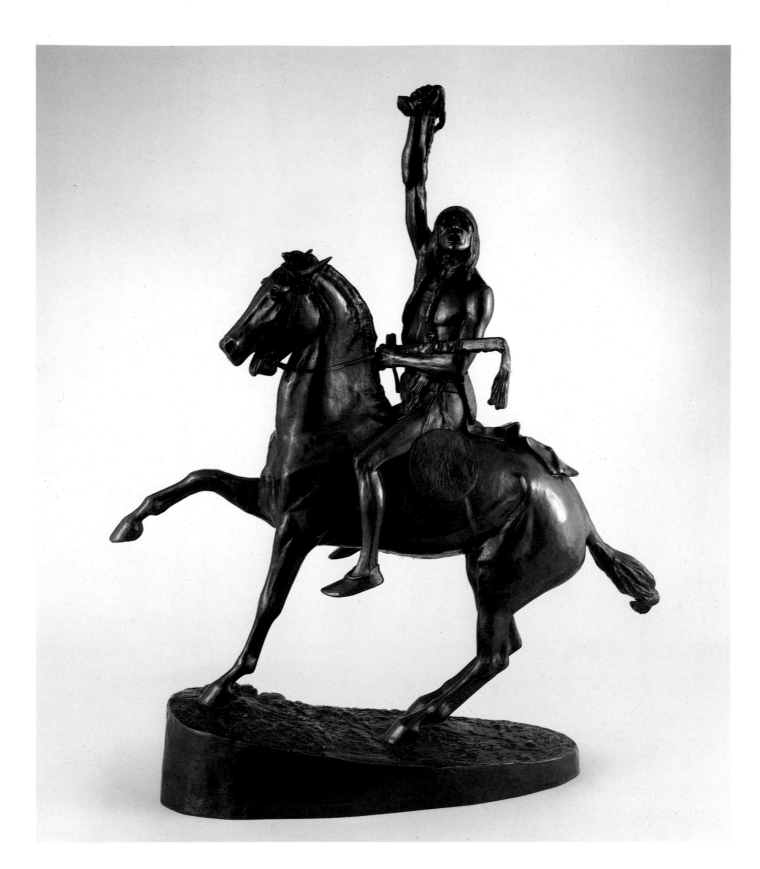

PLATE 52. *THE SCALP.* 1898.
© December 8, 1898; cast c. 1899. Bronze, h. 25⅞
in. (65.7 cm.); base 21 × 7½ in. (53.3 × 19 cm.).
Henry-Bonnard Bronze Company cast no. 10.
Amon Carter Museum, Fort Worth, Texas

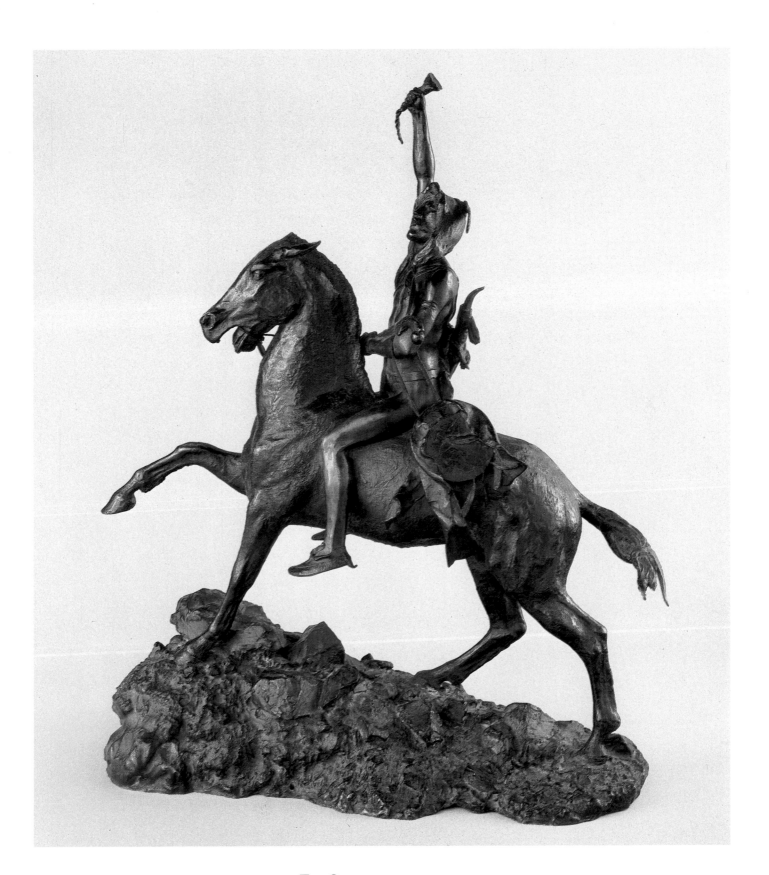

PLATE 53. *THE SCALP.* 1898.
© December 8, 1898; cast c. 1905–6. Bronze, h. 26
in. (66 cm.); base 20 × 9 in. (50.8 × 22.9 cm.). Roman
Bronze Works cast no. 2. The Lyndon Baines John-
son Library and Museum, Austin, Texas

From the first, he called his models "muds," distinguishing the muddy brown color of his modeling materials from the reflective metal surfaces of the finished work, and the word discloses the artist's pleasure in giving form to a shapeless material. A photograph of Remington calmly and confidently modeling *The Bronco Buster* disguises the fact that he worked feverishly and struggled hard to master the new medium.[3]

While he modeled his first sculpture, Remington implored Owen Wister to see it. "You just ought to see the 'great model' I am making—it's a 'lolle.'"[4] Writers who have emphasized the artist's astonishing facility with his first sculpture have overlooked Remington's own comment that making *The Bronco Buster* was "a long work attended with great difficulty on my part."[5] In fact, the creation of *The Bronco Buster* was an intensive year-long process that brought forth a masterpiece and transformed Remington into a sculptor.

By the third week in August 1895, eight to ten months in the making, the two-foot model for *The Bronco Buster* was taken to The Henry-Bonnard Bronze Company in New York to manufacture a plaster cast; this was, in turn, cut into smaller pieces from which individual piece molds of baked sand were prepared. From such sturdy sand molds (whose name is reflected in the method of casting Remington first used) the foundry produced numerous identical casts of a given model. One of Remington's notebooks lists 63 Henry-Bonnard casts of *The Bronco Buster*; notations indicate where the casts were consigned for sale (see Appendix A).

One of the corollary attractions of sculpture for Remington was financial, since income from a popular bronze continued long after the original model had been cast. Remington kept a sharp eye on his investments and understood that royalties from his sculptures were a built-in annuity for him. Unlike his illustrations, whose reproduction Remington could not control after he supplied the original to a publishing house, he could order the production of bronzes and he was paid a commission or royalty for each cast produced. Remington's *The Bronco Buster* became the most popular and, not incidentally, probably the most profitable small American bronze sculpture of the nineteenth century.

Remington's first bronze is quite planar in format and, like a painting or drawing, respects the picture plane. Remington's attention to the details of the rider's accoutrements—his holster, stirrups, quirt, and lariat—seems to derive from the precise,

descriptive concerns of illustration as well as his own fascination with such tangible emblems and relics of the changing West. But the prophetic conception of the sculpture, the selection of the moment just after the horse and rider's utmost exertion, and the sinuous, unencumbered silhouette of the two-foot statuette were beyond the aspirations of any other American sculptor of the period.

Augustus Saint-Gaudens was among those who saw the sculpture before its casting. His endorsement of the work of art in the foundry's promotional brochure appears to be the earliest reflection of the mutual respect that existed between Remington and the dean of American sculpture. Their relationship explains some of the innovative patinas on some of Remington's sculptures. Saint-Gaudens exerted a powerful influence on several other artists who have come to be called "western sculptors," including his own assistants James Earle Fraser and A. Phimister Proctor. That the most classicizing and sophisticated American sculptor of the period supported the rugged verities of Remington's western themes goes far in undermining the self-imposed and artificial category of "western sculpture." Primarily a descriptive term, it has often been incorrectly used to cut off a group of American sculptors and their work from the broader developments of American and European sculpture. Remington was not solely a "western sculptor" but an "American sculptor," and his achievements should be evaluated in a broader context than has previously been attempted.

Though as artists Remington and Saint-Gaudens may at first seem to have nothing in common, in fact, Remington was struggling with *The Bronco Buster* while Saint-Gaudens was working on several sculptures with equestrian elements: the Robert Gould Shaw Memorial (1884–97) for Boston Common and the Logan Monument (1894–97) for Grant Park, Chicago. In the latter project, Saint-Gaudens was assisted in modeling the horse by A. Phimister Proctor, who also modeled the horse in Saint-Gaudens's last and greatest equestrian statue, *General William Tecumseh Sherman* (1892–1903) (Central Park, New York City). Saint-Gaudens's monumental equestrian sculptures were more stable and earthbound than Remington's smaller, more energetic bronzes, in part because their large size and weight technically required it. But the younger sculptor was interested enough to paste photographs of the Shaw, Logan, and Sherman statues in his scrapbook of sculpture photographs, which is

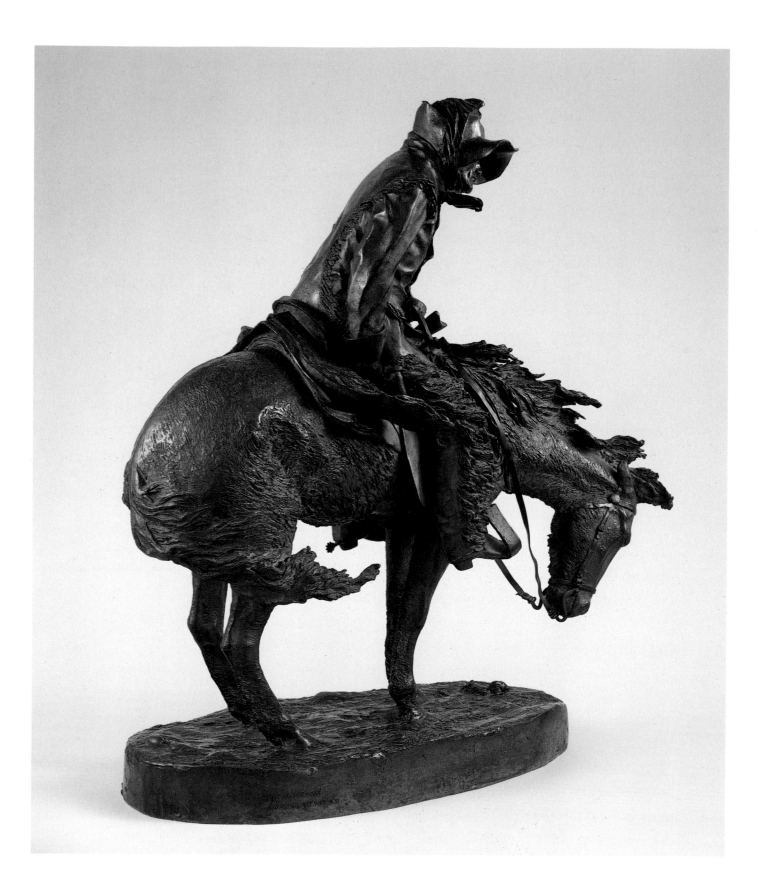

PLATE 54. *THE NORTHER.* 1900.
© July 2, 1900; cast c. 1900. Bronze, h. 22 in. (55.9
cm.); base 15¾×8 in. (40×20.3 cm.). Roman
Bronze Works (no number). Private collection

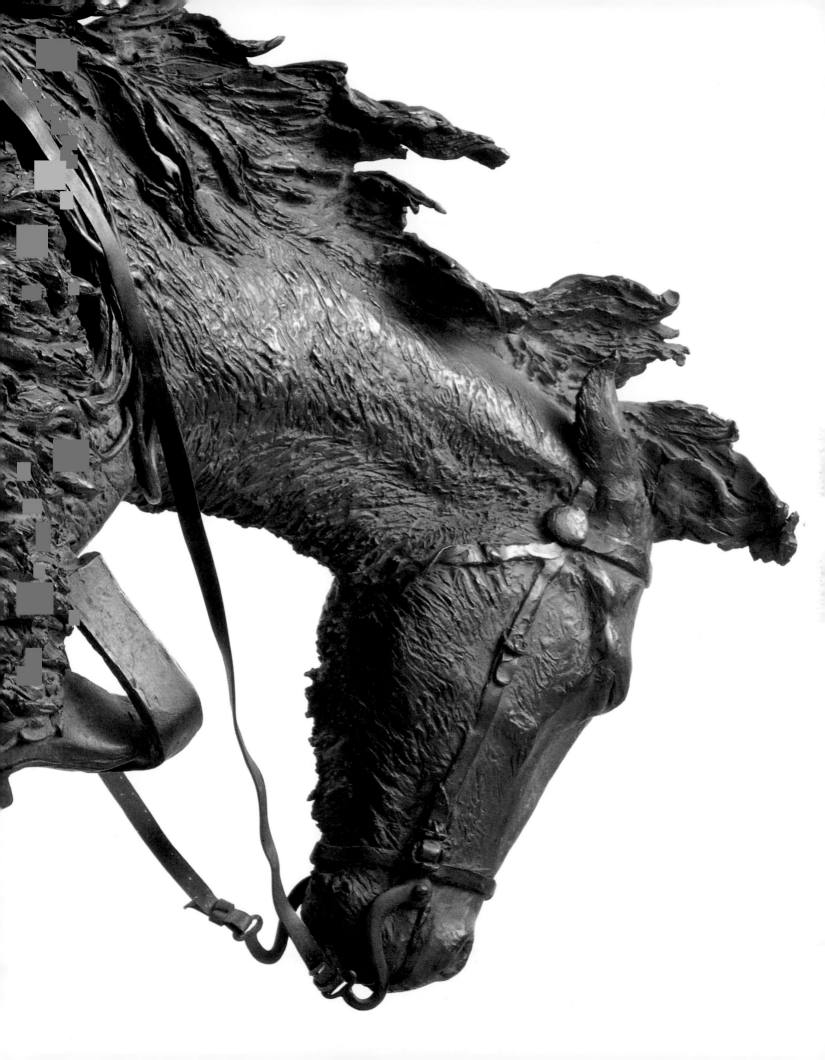

now in the Frederic Remington Art Museum's collection.[6] To what extent Remington benefited in his work from the interest of the elder sculptor is an important but difficult question because it links two artists who were previously thought to be antithetical. The available evidence suggests that Saint-Gaudens, as an artist and as a man, provided Remington with the model of an American sculptor of utter integrity. Saint-Gaudens's ability to generalize from the specific may have helped Remington find a visual language to depict heroes and symbols of the American West.

While Saint-Gaudens was the most distinguished American sculptor of Remington's acquaintance, he was by no means the only one. An early address book of Remington's lists Frederick MacMonnies at his Paris address and monument-makers J. S. Hartley and W. R. O'Donovan at New York City addresses.[7] Remington's personal correspondence includes letters from the Chicago-based *animalier* Edward Kemeys, who invited Remington to visit him, and Henry Merwin Shrady, a sculptor of a younger generation with whom Remington felt a special kinship. Shrady was strongly influenced by the textural effects and rich, plastic forms of Remington's work. His masterful *Elk Buffalo* (1901) (Frederic Remington Art Museum, Ogdensburg, New York), which Remington purchased in 1908, is an eloquent homage to Remington's sculpture. Remington also knew J. Massey Rhind and a minor sculptor from his upstate region, Sally Farnham, who was also his good friend.

Though there is no record of any direct contact between the two men, the French master Auguste Rodin's Symbolist mood and innovative mode of construction—in which elements from his seminal work *The Gates of Hell* (1880–1917) were freely combined and recombined—seem to have impressed Remington deeply. And many elements in Remington's sculptures appear and reappear in a variety of permutations. Rodin's successful career as a sculptor was not lost on Remington either. The increasingly inward mood and highly worked surfaces of Remington's later sculptures reverberate with an expressionism similar to Rodin's, although some aspects of these qualities are also reflected in most European Symbolist sculpture of the period.

Remington's second bronze, *The Wounded Bunkie* (Plate 50), comes closest in formal and technical terms to nineteenth-century French and English sporting bronzes, but the subject matter in Remington's sculpture is far more urgent. It is, in fact, a matter of life and death. The two mounted cavalrymen, bunk mates, are riding in

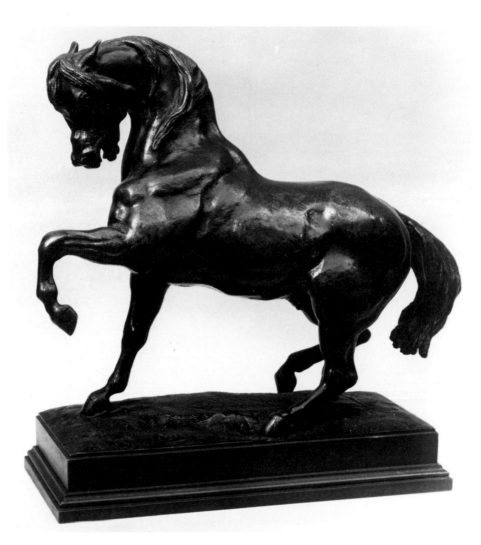

FIGURE 74. Antoine Louis Barye (French, 1796–
1875). *PRANCING HORSE.* c. 1838. Bronze, h. 11⅞ in.
(14.4 cm.). The Metropolitan Museum of Art, New
York. Rogers Fund, 1910

retreat from an unseen enemy. The officer on the far side has just been shot in the
back, and his arm jerks forward in reflex action. The uninjured officer extends his
arm in support and his horse looks over sympathetically, while the group gallops past
an emblematic skull on the earth beneath them.

The sense of danger and of drama in this work far exceeds that of *The Bronco
Buster*, and compositionally it is more sophisticated, for the entire sculpture is sup-

ported by only two of the horses' eight legs. Confronted by the direct gaze of one cavalryman and the silhouetted head of the other, the viewer is drawn to contrast the position of the human heads with the poses of the horses' heads. The effect of the overlapping forms is cinematic, as if the event were unfolding before our eyes. More decisively than *The Bronco Buster, The Wounded Bunkie* initiated a series of kinetic effects that Remington continued to refine and develop throughout his career as a sculptor. None of the later works, however, would have as clean a line or as fine a soft brown patina as this magnificent sand-cast group.

When *The Wicked Pony* (Plate 51) and *The Scalp* (first titled *The Triumph*, Plate 52), Remington's final two sculptures produced by the sand-casting method, appeared at the end of 1898, they were seen as consistent with his style. In fact, both sculptures reflect a relative slackening of sculptural intensity after the artist's achievements of 1895 and 1896. *The Scalp* may be indebted in form to Saint-Gaudens's Logan Monument of the same period. Remington's innovations were noted and appreciated at the time, but they were not deemed as significant as they now appear to be. Charles H. Caffin, who in 1903 wrote *Masters of American Sculpture* (a book that did not mention Remington), noted in the December 18, 1898, issue of *Harper's Weekly:* "There is no question of [Remington's] mental picture. It is of the most vivid and assured kind, resulting from a faculty of observation quite extraordinary in its comprehensiveness. What he has seen in his study of horses and their riders he has seen with such completeness that he can record with accuracy an action which passed before his eyes like a flash."[8]

Caffin preferred *The Scalp,* with its more conservative appearance, to *The Wicked Pony*. He found it to be technically superior and determined that the way the sculpture of the Indian built to a climax was particularly well resolved. *The Scalp,* which depicts an Indian on horseback holding a scalp in his raised hand, is close in form to Antoine Barye's *Prancing Horse,* of about 1838 (Fig. 74). Remington's horse is less stocky and has raised its head, but the energetic pose and modeling derive from Barye, the French romantic sculptor in whose work Remington found a similarly combative view of the struggle between man and forces stronger than himself. *The Scalp,* Remington's first bronze with an eccentrically shaped base and his first sculpture of an Indian, suffered from formal difficulties. The horse, with its two hind legs

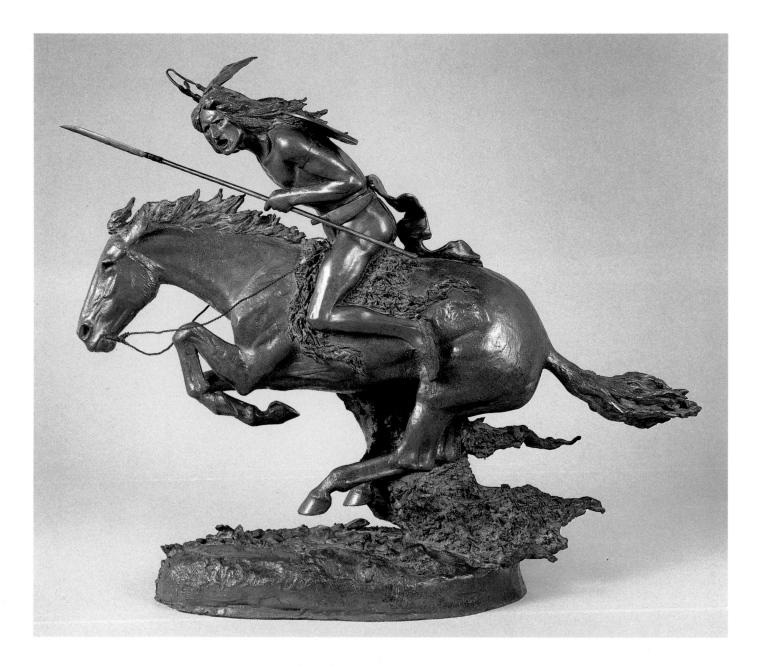

PLATE 55. *THE CHEYENNE.* 1901.
© November 21, 1901; cast c. 1902. Bronze, h. 20⅞
in. (53 cm.); base 15 × 7 in. (38.1 × 17.8 cm.). Roman
Bronze Works cast no. 3. Denver Art Museum,
Denver, Colorado. The William D. Hewit Charita-
ble Annuity Trust

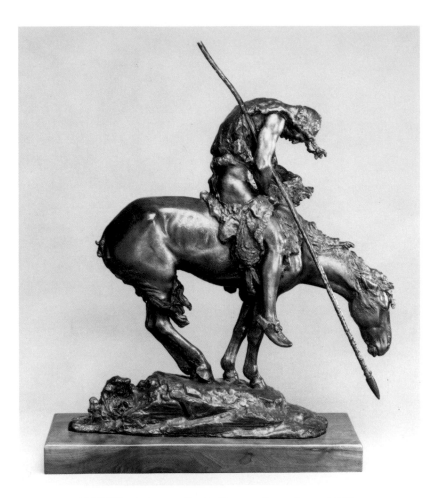

FIGURE 75. James Earle Fraser (American, 1876–1953). *END OF THE TRAIL*. 1915. Bronze, 30⅜ × 23 in. (77.2 × 58.4 cm.). The Nelson-Atkins Museum of Art, Kansas City, Missouri. Gift of Mrs. Allan B. Sunderland in memory of Allan Boulter Sunderland

together, did not stand comfortably on the inclined base, and Remington eventually reinterpreted the sculpture.

Remington conceived *The Wicked Pony* as a companion piece to *The Bronco Buster,* substituting for the victorious cowboy on a rearing horse a fallen cowboy endangered by his animal's bucking hind legs. Together the pair of sculptures describes the poles of *in extremis* situations—triumph and defeat—to which Remington would

194

turn repeatedly. However, the second sculpture lacks the heroic impact and the formal unity of the first, and relatively few casts were made.

Both *The Scalp* and *The Wicked Pony* were copyrighted in December 1898 and cast by The Henry-Bonnard Bronze Company. During the next four years the foundry made ten casts each of *The Scalp* and *The Wicked Pony,* all fourteen casts of *The Wounded Bunkie,* and more than sixty casts of *The Bronco Buster.*

The success of Henry-Bonnard in so expertly translating Remington's models into metal reflected the ability of Eugene Aucaigne, manager of the foundry, to attract skilled European workmen to New York. Though in 1898 Remington dedicated a drawing, *Porch at Tampa Bay Hotel* (Plate 15), "To my Friend Aucaigne," no real personal relationship developed between the sculptor and the bronze-founder—whom Saint-Gaudens described as "the tragic Aucaigne," in reference to the man's occasionally morose personality.[9] A fire at the foundry, coupled with the firm's tardy royalty payments,[10] prompted Remington to switch foundries shortly after he met Riccardo Bertelli, who taught him about the lost-wax method of casting.

The lost-wax method, though practiced since ancient times, had been all but superseded in the eighteenth and nineteenth centuries by the sand-casting process, with its simpler, more methodical steps. At the end of the nineteenth century, the lost-wax method was rediscovered in Europe and, through people like Bertelli and Remington, popularized in America. More labor-intensive than sand casting, the method allowed a foundry to cast richly inflected and undercut wax positives (copies in wax of an original model) in a single piece and an artist to make alterations in the positives, thus creating variations between individual bronze castings.

Remington appears to have met Bertelli in 1899, just a year before the charming Genoan established his foundry in Brooklyn under the name of Roman Bronze Works. A warm friendship developed between the two men, who shared an interest in exploiting the textural effects of lost-wax, exploring the structural and compositional limits of bronze, and indulging their mutual zest for life. By October 24, 1901, a month before *The Cheyenne* was copyrighted, Bertelli's face was already sketched in Remington's guest book, which the artist called "People I Know."[11]

The model for Remington's first edition of sculpture at Roman Bronze Works was produced in a few dramatic working sessions during the spring and summer of 1900.

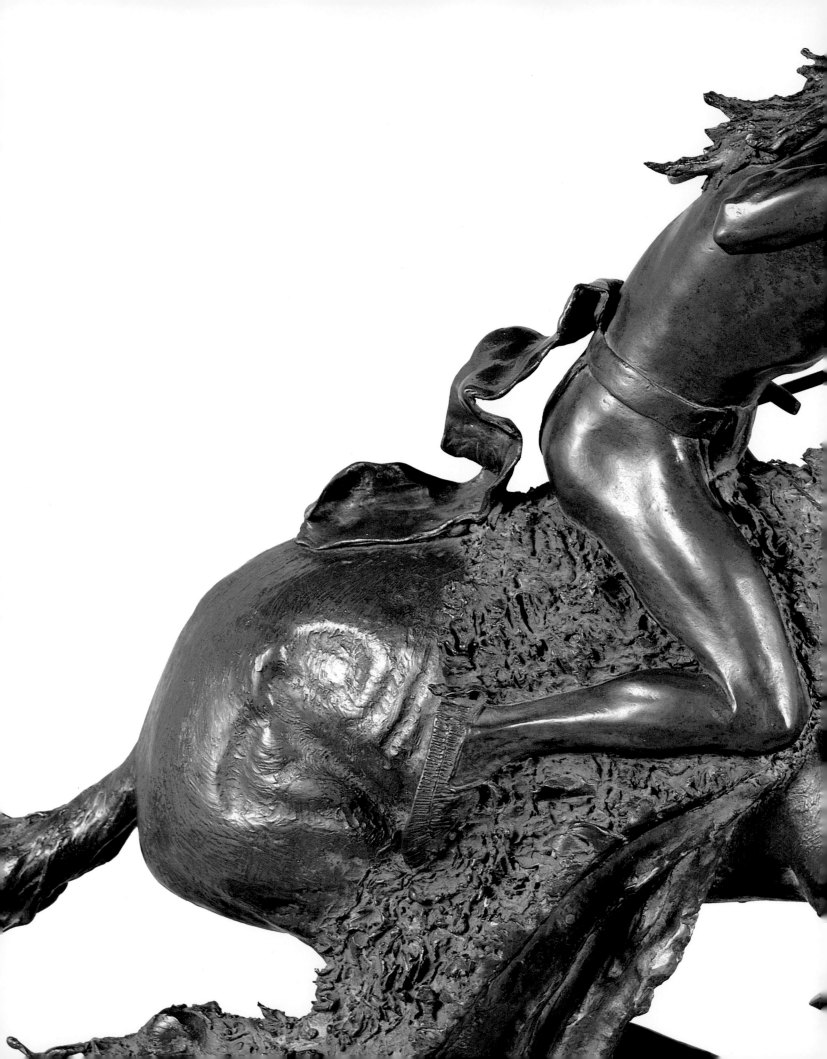

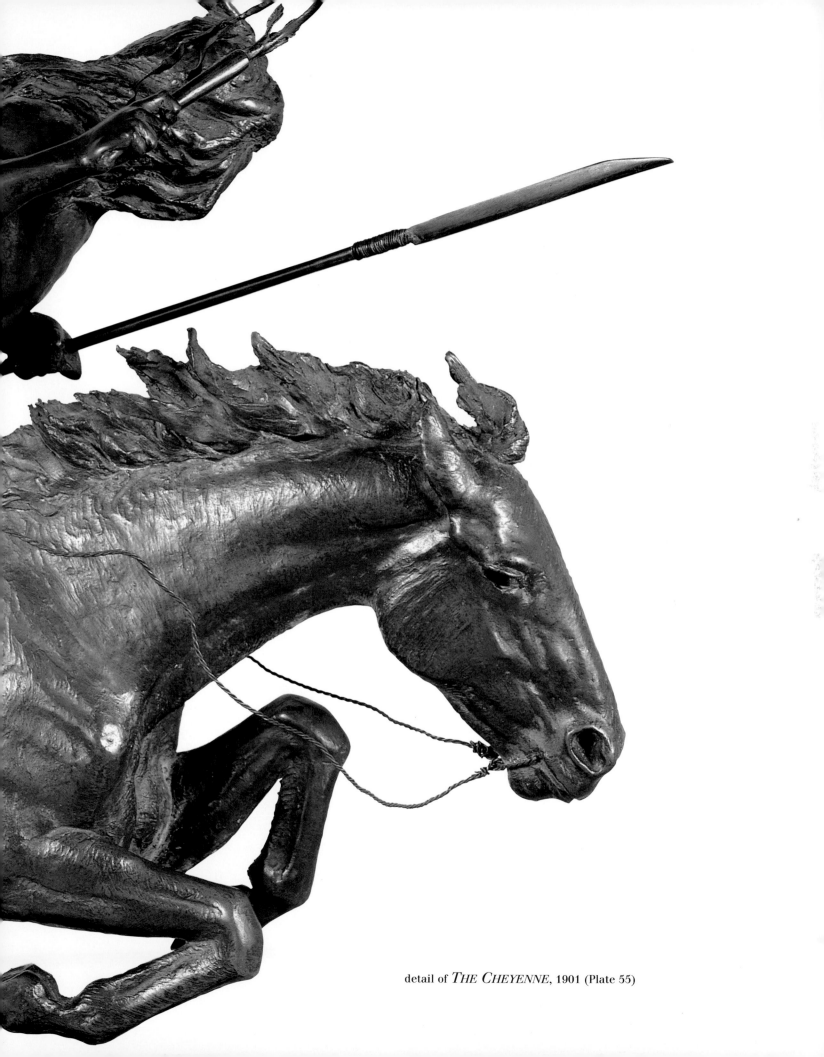

detail of *THE CHEYENNE*, 1901 (Plate 55)

The notebook he kept on his bronzes makes clear that Remington was actively at work on *The Norther,* which he initially called *The Blizzard,* on March 5 and 6 (Plate 54).[12] Only a single day was spent constructing the basic armature. The speed with which he worked reflected his intensity and excitement over discovering and exploiting the new, richer surface treatment made possible by the lost-wax method. His haste may have led him to lose half a day's work, however, when the head of the horse fell off. Another half day was given to refining the lowered head of the wind-blown horse and two days on the coat and the head.

With its range of undulating, sharply cast facets, the sculpture's surface reflects the artist's intensive efforts both on the original model in his studio and on its wax replica at the foundry. The sophisticated gold and brown patina of the finished work, three casts of which were made, was applied in the foundry and is richest in the central section, which consists of the horse's coat and the rider's chaps. It becomes less inflected on the horse's legs, the base, and the smooth gold-colored jacket of the cowboy. Both the horse, whose eyes are closed and whose tail and mane blow forward, and the rider, whose hat is tied on and whose right hand is hidden under his right leg for warmth, are turned in upon themselves. The sculpture is so sharply cast that the bits of fur under the horse's jaw appear to be frozen. Etched into the space beneath it, the line of fur creates an active outline for this most static of Remington's bronzes. The richly worked muzzle and mane of the horse's head reflect the innumerable marks of Remington's modeling tools. When seen from behind, however, the reductive linear structure and tilt of the sculpture are more apparent.

The almost unnaturally still pose, which stems from the sculptor's efforts to achieve textural effects through the lost-wax process, evokes a powerful mood of isolation and introspection. *The Norther* is a bronze whose inwardness seems analogous to European Symbolist painting and sculpture, like Gauguin's dreaming women or Rodin's *The Thinker.* Just as Remington's *The Bronco Buster* was a remarkable sculptural debut, so *The Norther* was an astonishing first achievement in lost-wax casting. The sculpture had other reverberations as well: its form served as the basis for James Earle Fraser's sculpture of a defeated Indian, *End of the Trail* (Fig. 75).

Remington's second lost-wax sculpture, *The Cheyenne* (Plate 55), further advanced the lessons he had learned working on *The Norther.* The skin of the Indian's horse is

pulled tautly over its lean, muscular frame, and its textured surface contrasts with the smooth skin of the rider and the deep, freely incised furrows of the buffalo hide. With its hooves raised off the rocky base, the mustang recalls the rear horse running at full tilt in *The Wounded Bunkie*. The two works invite comparisons that demonstrate the extraordinary intensity and rapid development of Remington as a sculptor. The horse at the rear of *The Wounded Bunkie* was reinterpreted with new textural and coloristic effects in *The Cheyenne*. The mustard-yellow patina of *The Cheyenne* recalls Remington's continuing admiration for Saint-Gaudens's unusual patinas as much as it reflects his own self-confident experimentation. Seeing the sculpture from the rear underscores the forward, almost bullet-like trajectory of the horse and rider.

Having successfully extrapolated the form of *The Cheyenne* from *The Wounded Bunkie*, Remington was encouraged to experiment with unusual supports for his sculpture. *The Cheyenne* is held aloft by a buffalo robe, and a similar *trompe l'oeil* conceit allowed him to support *The Horse Thief* (Plate 62) without any of the horse's hooves touching the ground. More than three centuries earlier, the great Italian sculptor Gianlorenzo Bernini used this device on a larger scale in his equestrian statue of Constantine in the Vatican (Scala Regia, 1654–70), and there are other analogies between the energetic forms of the Baroque period and those of Remington. Readers will remember the artist's attraction while a student at Yale to dynamic Hellenistic sculptures, and the Baroque flavor of his early bronzes also indicates that Remington was an artist eager to create physical and optical alternatives to classical stability.

Although *The Cheyenne* is among the finest and most popular of Remington's bronzes, on May 7, 1907, the sculptor destroyed the molds for it and also for the lost-wax version of *The Scalp* because, as he wrote in his diary, "They had lost all resemblance to my modeling";[13] both sculptures, however, were cast again, from fresh molds, in 1908 and then posthumously. Far fewer casts of Remington's sculpture, even of the most popular models, were produced during the artist's lifetime than has been realized—as few as twenty-one casts of *The Cheyenne* and six of *The Scalp*.

The lost-wax technique not only impelled Remington toward new sculptural formulas, it motivated him to re-create his earlier sand-cast models. Just as Remington

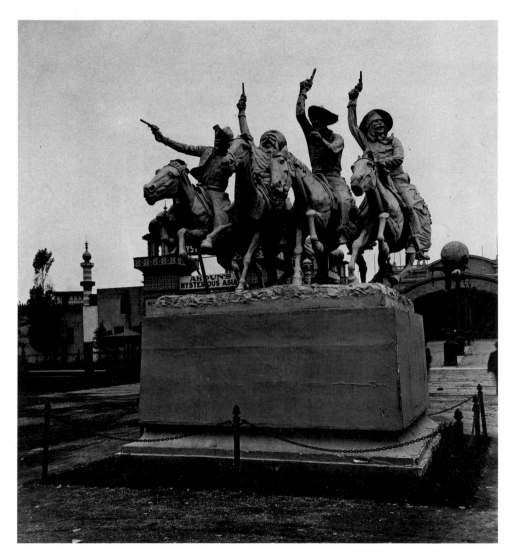

FIGURE 76. *REMINGTON'S COWBOYS.* Photograph tak-
en in 1904 at the Louisiana Purchase Exposition in
St. Louis. Courtesy Missouri Historical Society, F. J.
Koster photo, negative WF 690

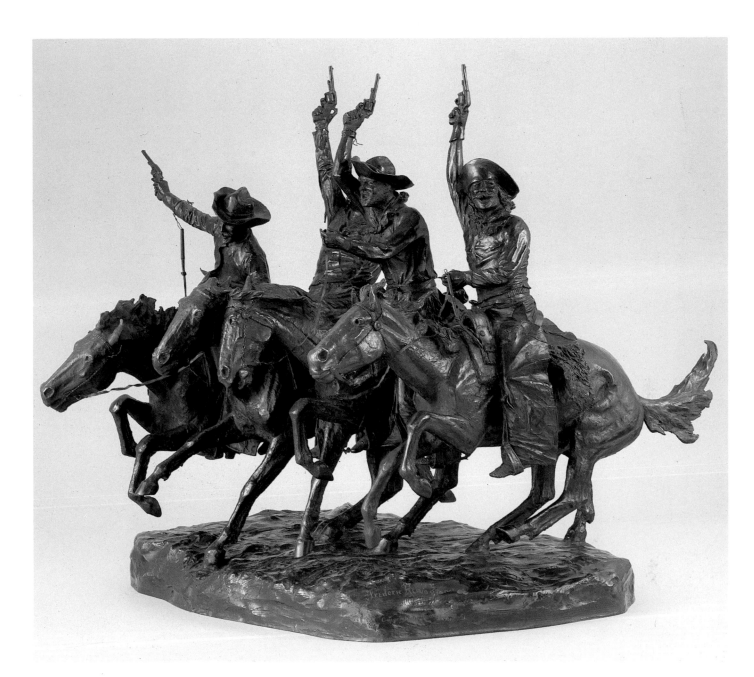

PLATE 56. *COMING THROUGH THE RYE*. 1902.
© October 8, 1902; cast c. 1902–3. Bronze, h. 28⅛
in. (72.5 cm.); base 28⅜ × 19⅞ in. (72 × 50.3 cm.).
Roman Bronze Works cast no. 2. On loan to The Art
Museum, Princeton University, Princeton, New
Jersey. Promised Gift of Laurance S. Rockefeller

(overleaf) detail of *COMING THROUGH THE RYE*,
1902 (Plate 56)

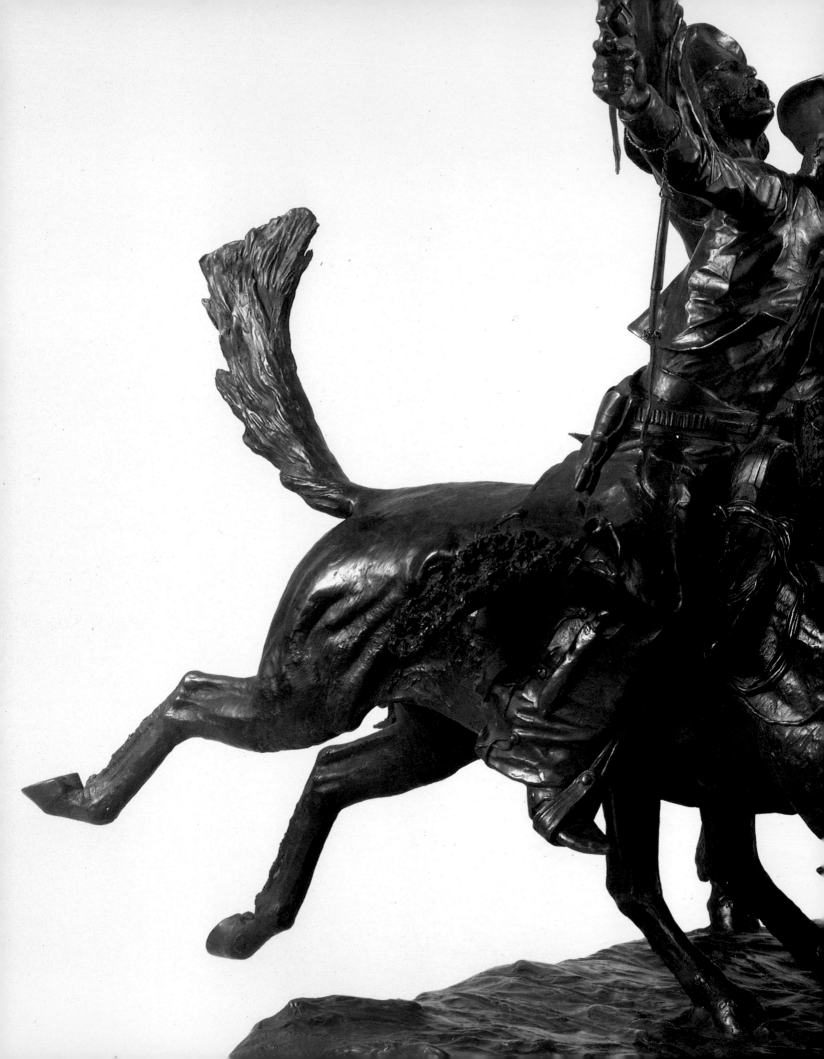

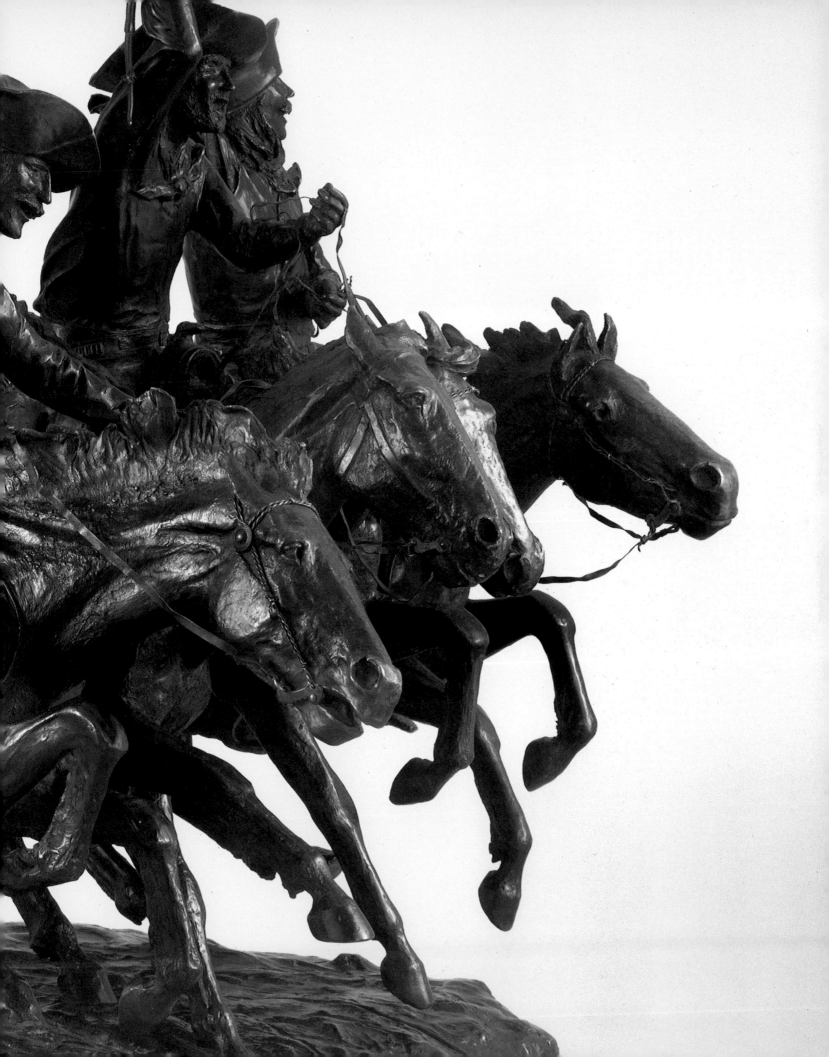

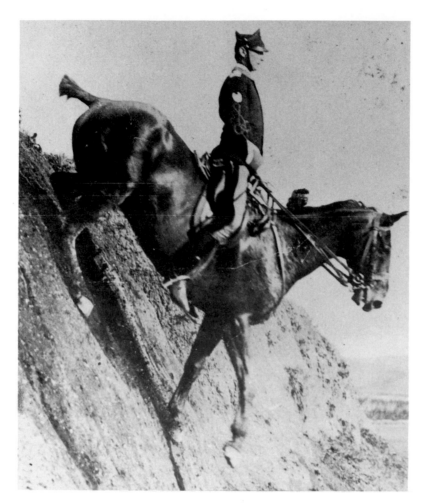

FIGURE 77. European military officer on horse-
back. Photograph from an album in Remington's
collection. Courtesy Frederic Remington Art Muse-
um, Ogdensburg, New York

PLATE 57. *THE MOUNTAIN MAN*. 1903.
© July 10, 1903; cast 1906. Bronze, h. 28 in. (71.1
cm.); base 11 × 10½ in. (27.9 × 26.7 cm.). Roman
Bronze Works cast no. 5. Collection North Ameri-
can Life and Casualty, Minneapolis, Minnesota

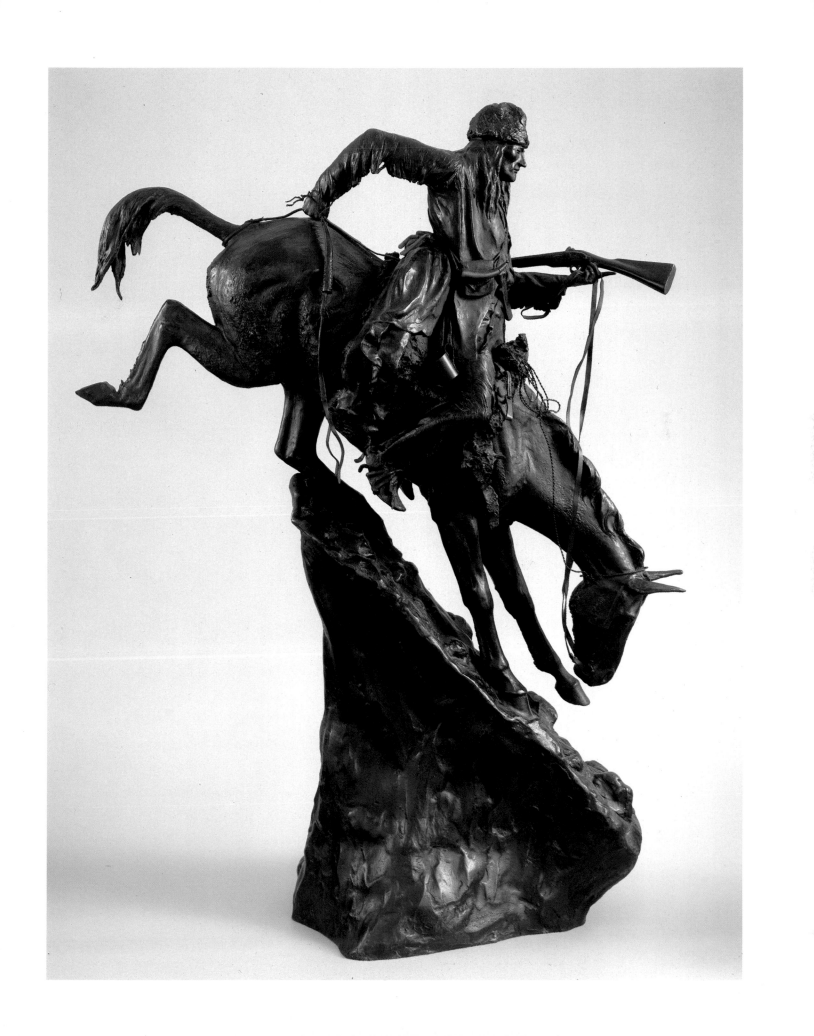

used *The Cheyenne* to reinterpret *The Wounded Bunkie* in the syntax of the lost-wax technique, so he transformed and reinterpreted the sand-cast version of *The Scalp* about 1905–6 (Plate 53). In that lost-wax revision, Remington changed the original smooth and gently sloping base into forbidding, richly textured rocks, and he remodeled the awkward pose of horse and rider into a more powerful one.

Not long after he switched from Henry-Bonnard to Roman Bronze Works, Remington produced a lost-wax version of his previously sand-cast *The Bronco Buster*. While in *The Cheyenne* and *The Scalp* Remington reinterpreted an earlier sculpture via the lost-wax method in a discrete period of time, the artist's process of refining *The Bronco Buster* was continual. In its earliest incarnation, the lost-wax version remains close to the sand-cast version, though several preliminary changes indicate the direction the artist would take. The mane of the horse is slightly perforated and its flowing hair is graphically suggested by light incisions in the wax. A more aggressive change in the model was made in 1905 or 1906, when the artist applied woolly chaps to the rider (Plate 48).

By March 1902, Remington was at work on his most complicated multifigured sculpture, which nine months later, in December 1902, would be copyrighted as *Coming Through the Rye* (Plate 56). Finished about a year after *The Cheyenne, Coming Through the Rye* represented a substantial expansion in the artist's vision. Unlike his earlier sculptures, which had their primary viewpoint along the flank of a horse, *Coming Through the Rye* has its axis pivoted forty-five degrees, as the cowboys gallop toward the viewer. While the riders are most clearly read from the front, the overlapping movement of the four horses' legs is best understood from the side. The most satisfying viewpoint is probably diagonally across the front and side views.

In the late 1880s the artist drew *Cow-boys Coming to Town for Christmas* (see Fig. 43). This conception formed the basis for *Coming Through the Rye* thirteen years later. An association between these riders and the biblical Four Horsemen of the Apocalypse could not have been lost on Remington, an artist for whom the specter of death was always present. Remington took this medieval theme decidedly into the secular realm, however, underscoring his own belief that life's enjoyments provide the best antidote against the knowledge of life's inevitable end. His excessive pleasure in food and drink, coupled with a morbid fear of death, is reflected in the cow-

boys' moment of raucous pleasure before time or circumstance can disallow it.

Coming Through the Rye was a challenge for Remington. He worked long hours at the foundry on his model, rather than at his studio in New Rochelle, because he wanted technical advice on how to raise as many of the horses' hooves off the base as possible while adequately supporting the bronze. The format is highly unusual—four independent horsemen riding so closely together that the four major components almost form a single unit.

Despite the considerable technical achievement of *Coming Through the Rye* and its subsequent fame, the sculpture is not without its awkwardnesses. The poses of several of the horsemen appear somewhat stiff, and their expressions, in this extroverted sculpture, border on caricature. But, like *The Bronco Buster,* the sculpture has become an icon, and its emblematic role transcends its flaws. Etched into popular consciousness in a way that is rare in the annals of American sculpture, it has been widely accepted as an image of the untrammeled life of the West.

By April 1903, plans were proceeding to enlarge *Coming Through the Rye* for display at the Louisiana Purchase Exposition in St. Louis the following year. The idea may have been first broached by Frederick Ruckstull, who was initially responsible for the public sculpture at the fair, and then followed up by his successor Karl Bitter, who devised the exposition's theme of "The Winning of the West." Remington simply sent a model of the sculpture to the studio in Hoboken, New Jersey, that had been built to produce the fair's temporary sculpture, and apparently was not personally involved in the enlargement. When the artist received photographs of the work installed in St. Louis, he commented to Bertelli that "the thing is pretty rotten."[14] The mixture of plaster and straw, called "staff," from which the public sculpture at the fair was made, could not support weight as bronze could, so the outermost horse, which rides free in the original version of *Coming Through the Rye,* had to be supported by a metal rod (Fig. 76). This, as well as the crude surface modeling of the enlargement, must have disappointed the artist. Nevertheless, the sculpture was subsequently sent to Portland, Oregon, where it was part of the Lewis and Clark Exposition of 1905. The unsatisfactory experience taught Remington the importance of close artistic supervision, as the rich surface texture of his only permanent outdoor sculpture, *The Cowboy* (see Fig. 82), demonstrates.

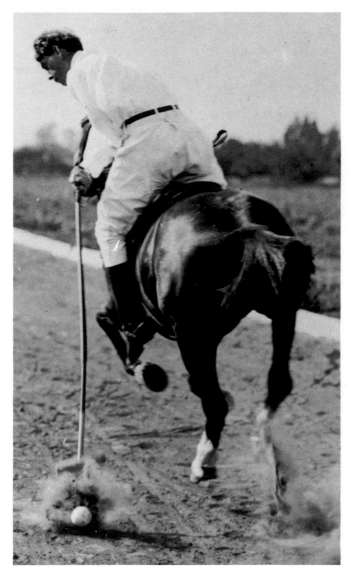

FIGURE 78. Man playing polo. c. 1904. Photograph from an album in Remington's collection. Courtesy Frederic Remington Art Museum, Ogdensburg, New York

PLATE 58. *POLO.* 1904.
© July 21, 1904; cast 1906. Bronze, h. 21¾ in. (55.1 cm.); base 19½ × 14½ in. (49.4 × 36.8 cm.). Roman Bronze Works (no number). Frederic Remington Art Museum, Ogdensburg, New York

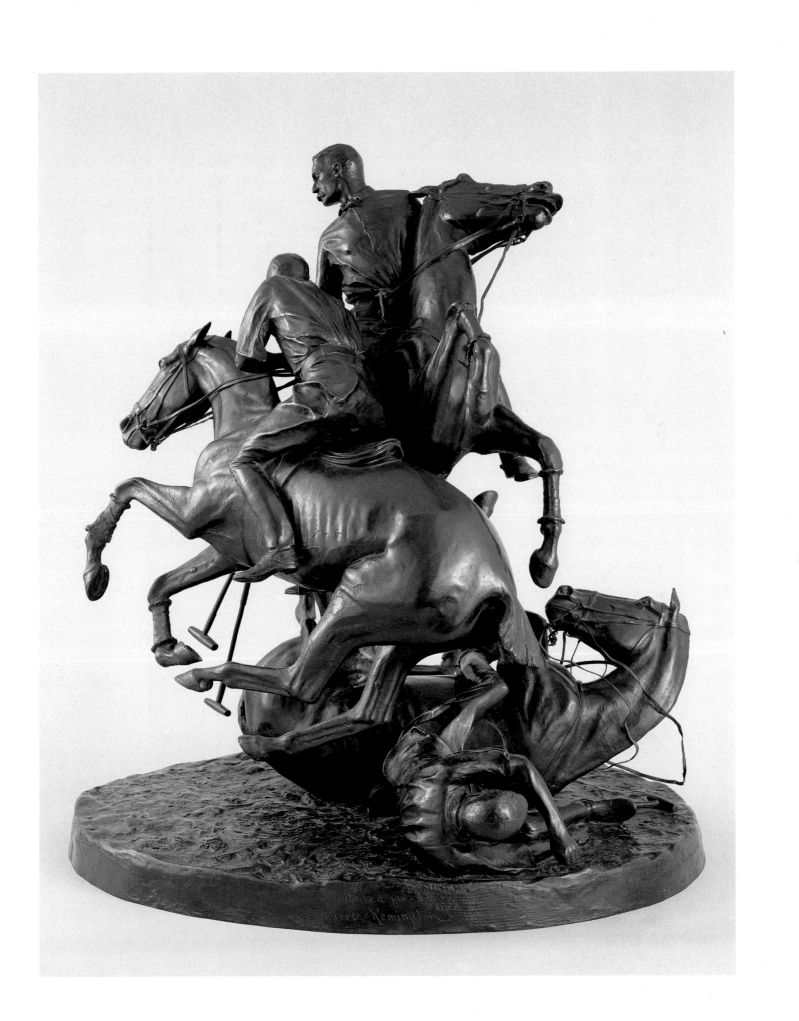

In *Coming Through the Rye* Remington expanded his handling of sculpture laterally through space; the tall and narrow format of *The Mountain Man* enabled him to integrate his sculpture vertically. The overall direction of *The Bronco Buster*, *The Wicked Pony*, and *The Rattlesnake* is downward, and the movement of *The Cheyenne*, *The Wounded Bunkie*, and *The Scalp* is lateral. In *The Mountain Man* (Plate 57), Remington took the generally downward movement of *The Bronco Buster* and, by combining the narrative element with the base, reduced it to an irresistibly singular direction. The unusual pose of the fur trapper and his mule, carefully threading their way down a steeply inclined hill, is related to a number of photographs in the Frederic Remington Art Museum of formally attired European military officers on curried horses coming down an earthen embankment. Remington may have been intrigued by the unusual stance of the horse in the photograph reproduced in Figure 77 and seen in it an opportunity to transfer movement to sculpture. If he did indeed adapt the pose of the sculpture from a photograph, then he used it to his own romantic end, transforming a modern cavalry officer into an American frontiersman of a vanished age.

The earliest version of the sculpture, in which the horse's right hind leg is extended and the rider's right hand reaches back to hold the tail strap, is more dynamic than the second version. Remington refashioned these elements in October 1905, two years after the sculpture was originally copyrighted. Perhaps he made this change to bring the sculpture more closely in line with the photograph; or he may have preferred a more compact sculptural format. One might be tempted to say that the numerous changes and revisions that Remington effected on his bronzes show an inability to invent a definitive pose. Yet it seems more accurate to state that Remington's sculpture, more than that of almost any other turn-of-the-century American or European artist except Rodin, was a serial art of permutation and adjustment in which, as in Rodin's *The Gates of Hell*, there was no clear beginning or end but rather a lengthy set of responses and counterresponses.

Shortly after completing the four-figure group of *Coming Through the Rye*, Remington in 1904 created his smallest sculpture. Only ten inches high, *The Sergeant* (Plate 64) appears to be a miniaturized portrait bust. Both it and its later pendant, *The*

Savage (Plate 63), are as close as Remington would come to portrait sculpture, yet both represent types rather than portraits. The curious format of *The Sergeant* may have been inspired by a small plaster sculpture by J. S. Hartley, dated 1883 and inscribed "Ye Ancient Mariner." It was in Remington's collection and appears in photographs on the mantel of his studio. Like Remington's sculpture, Hartley's bust rises from a small square plinth decorated with inscribed lines. Remington returned to this general format for *The Savage* in 1908. More broadly scaled than *The Sergeant,* it is almost a caricature in its treatment of an open-mouthed Indian. The two works sum up in small scale the primary human protagonists in Remington's sculpture: the stoic cowboy-soldier and the passionate Indian. We know from Remington's diary that he reworked the Indian's head to keep it from having too ingratiating an appearance.[15]

Late in 1904 Remington modeled *The Rattlesnake,* one of his most daringly cantilevered sculptures (Plate 59). In format it is a more sculptural, less planar version of *The Bronco Buster.* Indeed, one can chart Remington's development as a sculptor by his reinterpretations of his first model, to which he habitually returned for inspiration and sustenance. The narrative incident, a horse shying away from a threatening rattlesnake, allowed Remington to reformulate his theme of rearing horse and rider. The cowboy's woolly chaps reflect a formal link between his new sculpture and his first sculpture, for at about the same time he was creating the model for *The Rattlesnake* he applied textured chaps to several casts of *The Bronco Buster.*

Three years later, in January 1908, when he was in the midst of casting *The Cowboy* for Fairmont Park, Remington requested a plaster cast of *The Rattlesnake* from Roman Bronze Works in order to remodel it.[16] He devised a more compact, sculptural version by enlarging it, turning the horse inward, and curling it under itself (Plate 60). Though changes in the position of the horse seemed related to some he had made in *The Mountain Man,* the shift to a larger scale may have been inspired by his work on the large horse for Fairmont Park and his growing confidence as a sculptor and fluency as a modeler. When he finished reworking the new model on February 18, he wrote in his diary, "It is a great improvement on the other. I hope no one ever sees them together."[17] Remington continued working on the bronze on February 19 and 20, after having seen some additional defects, then noted with satisfaction in his

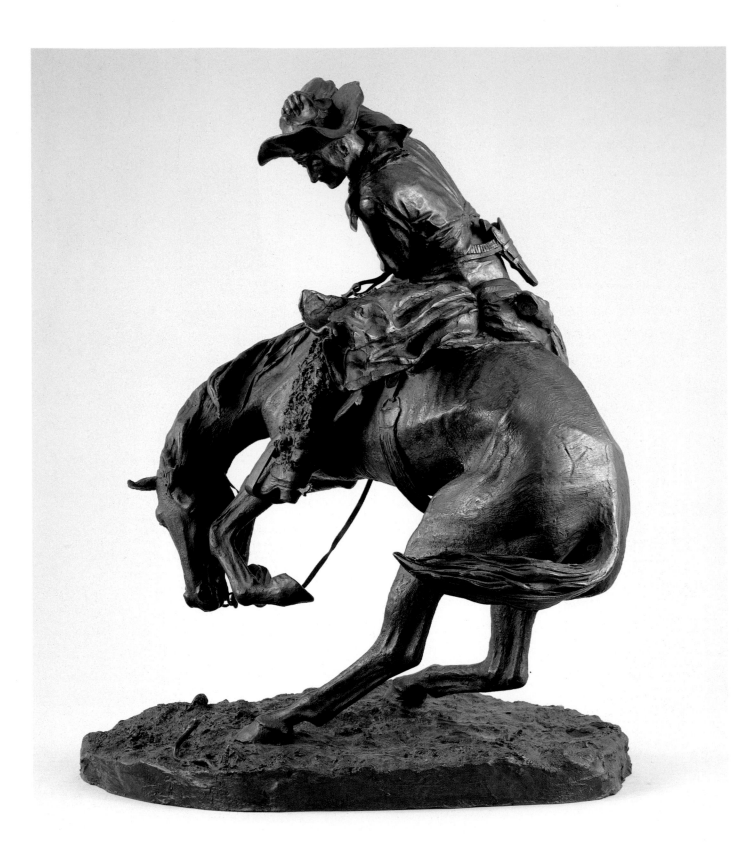

PLATE 59. *THE RATTLESNAKE*. 1905.
© January 18, 1905; cast c. 1906. Bronze, h. 20¼ in.
(51.4 cm.); base 16 × 14 in. (40.6 × 35.6 cm.). Roman
Bronze Works cast no. 7. Collection Mr. and Mrs.
William D. Hewit

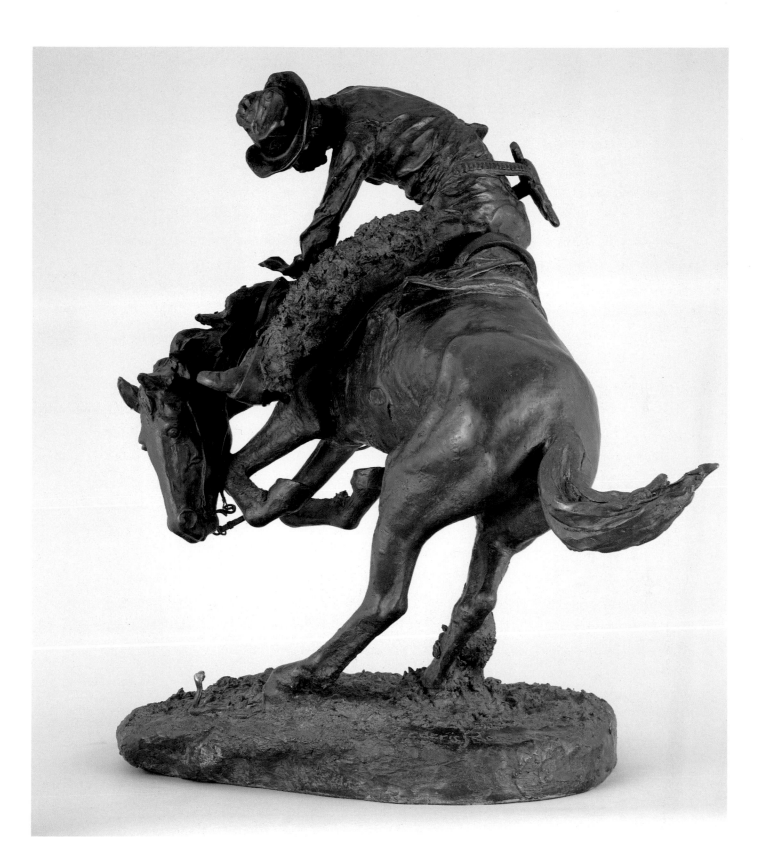

PLATE 60. *THE RATTLESNAKE*. 1905.
© January 18, 1905; cast c. 1909. Bronze, h. 22 in.
(55.9 cm.); base 15¾ × 10½ in. (40 × 26.7 cm.). Roman Bronze Works cast no. 17. Buffalo Bill Historical Center, Cody, Wyoming

diary, "It has taken me much longer to model than I had any idea of but is a good job and a good bronze."[18]

Remington's tenth year as a sculptor, 1905, was an important one for him. It marked the purchase by an important museum, the Corcoran Gallery of Art in Washington, D.C., of casts of *The Mountain Man* and *Coming Through the Rye,* and it occasioned his first commission for a permanent outdoor sculpture. Two years later The Metropolitan Museum of Art in New York purchased four sculptures: *The Bronco Buster, The Old Dragoons of 1850, The Mountain Man,* and *The Cheyenne.* Surprisingly, these six casts were the only museum acquisitions of Remington's sculpture made during his lifetime, preceding the first museum acquisition of any of his paintings by three years.

It was also in 1905 that Remington worked on a model for a 36-inch-wide bronze that came to be known as *The Old Dragoons of 1850* (Fig. 69). In subject matter, it looked back fifty years to the era of pitched battles between Indians and soldiers: two dragoons and two Indians are fighting with raised swords and spears, while a riderless horse leads the group. The sculpture suffers from some of the stiffness noted in the upraised arms and facial features of *Coming Through the Rye,* but the image of a riderless horse fleeing from the fray of battle is poetic. In this work Remington sought a new formal vocabulary in order to move beyond the confines of his earlier multifigured sculpture. So doing, he pressed five horses along a horizontal axis in a manner reminiscent of Gutzon Borglum's *Mares of Diomedes* (The Metropolitan Museum of Art, New York), a bronze of 1903 that in turn echoes some of the works of Antoine Barye. Four years later, Remington's *The Stampede* (Plate 66) more articulately resolved the sculptural problems raised in *Dragoons.*

Growing confidence in his abilities as a sculptor led Remington to move, as in *Dragoons,* beyond the original formal concerns of his work and to experiment with new subjects. His first attempt, titled *Polo* (Plate 58), was a logical extension of his interest in the furious combat of men on horseback. The new sculpture, consisting of two upright ponies and riders and one fallen pony and rider, substituted a form of recreational combat for military subjects. Photographs of polo players in Remington's collection indicate that he used them as an aid in preparing the sculpture (Fig. 78). Remington's comment in a letter of 1904 suggests discomfort with his sculpture

214

and perhaps a lack of commitment to the new subject: "I go tomorrow to work my last will on my 'Polo' group and I hope the dear d—— public will like Frederic in his new costume. The ponies and the 'fellows by Jove' are slick—so smoothe that a fly would sprain his ankle if he lit on them—but I'll soon be back to my less curried people who are more to my mind."[19] The slick, smooth surface of the sculpture is atypical among the lost-wax castings; indeed its surface seems to mark a return to the taut membranes of Remington's earlier sand-cast sculptures. Not since the galloping horses of *The Wounded Bunkie* had Remington modeled veins popping through the muscled surfaces of the horses' straining hides. The violence of the encounter is emphasized by the horses' hooves that press into the soft underbelly of another horse. While the evenly surfaced forms look back to the sand-cast sculptures, the composition—three interknit horses and riders—moves beyond the clear silhouettes of those earlier bronzes in search of a more densely packed sculpture. Despite its similarity to English and French sporting bronzes, the sculpture was never a popular success, and only two casts are known today.

Remington's second bronze without a western theme is known in larger editions and is more eccentric than *Polo.* Copyrighted in 1906 as *Paleolithic Man (Prehistoric Man)* (Fig. 79), it consists of a hairy, simian creature who, at the edge of a cavelike opening, holds a club in one hand and a clam in the other. For this theme Remington seems formally indebted to the French *animalier* Emmanuel Frémiet's *Gorilla Carrying Off a Woman* (Fig. 80). The ultimate extension of Remington's search back in time for prototypes of heroic, self-reliant men, the small sculpture is a witty comment on the ultimate forebears of many of the characters who appear in his paintings and sculptures—the original example of the "man with the bark on" that he admired. *Paleolithic Man,* however, is more successful as an index to Remington's views than as a sculpture. *Polo,* of 1905, and *Paleolithic Man,* of 1906, mark the opposite poles (contemporary and prehistoric) of Remington's efforts, whether successful or not, to broaden his vision.

While many people have noted strong similarities in subject matter and composition between Remington's paintings and his sculpture, no one has attempted to characterize the nature of the interrelationships. Sculpture, a later development in the artist's career, flowed naturally out of his existing body of work. First and foremost,

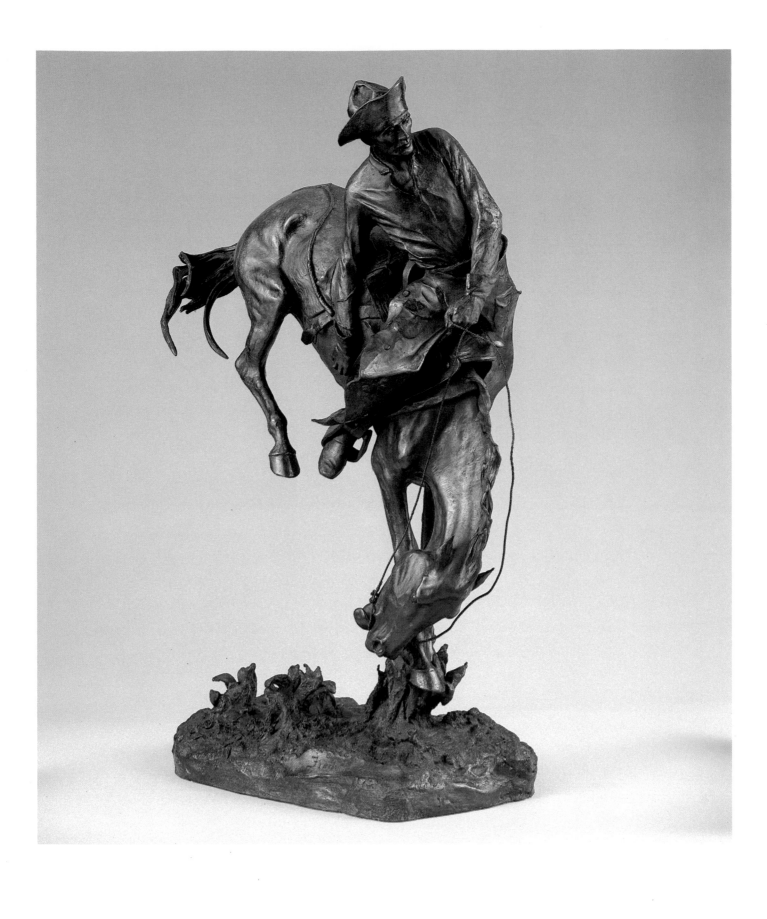

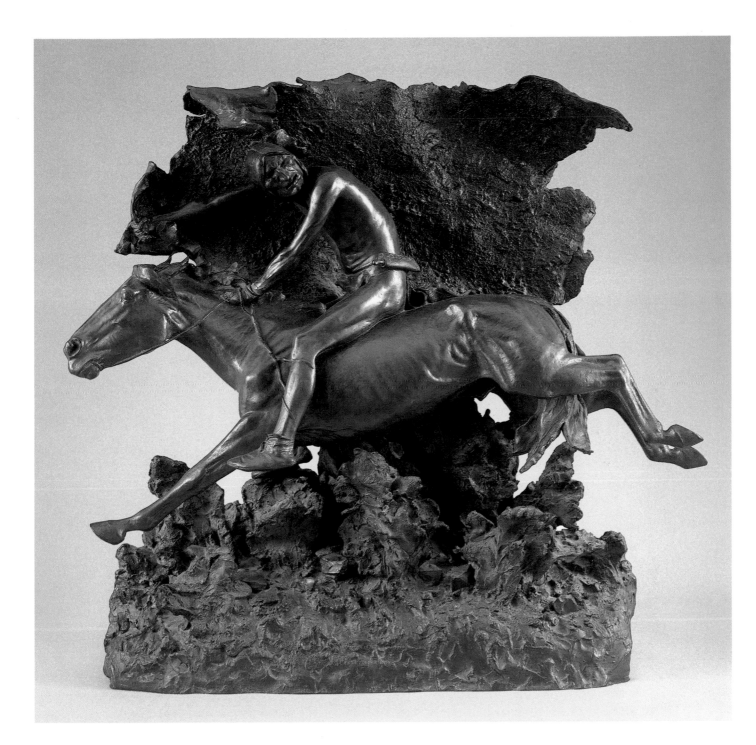

(left) PLATE 61. *THE OUTLAW*. 1906.
© May 3, 1906; cast c. 1905–6. Bronze, h. 22¾ in.
(57.8 cm.); base 13¾ × 8¼ in. (34.9 × 21 cm.). Roman Bronze Works cast no. 3. Collection Mr. and Mrs. William D. Hewit

PLATE 62. *THE HORSE THIEF*. 1907.
© May 22, 1907; cast c. 1907–9. Bronze, h. 26½ in.
(67.3 cm.); base 23¾ × 8 in. (60.3 × 20.3 cm.). Roman Bronze Works (no number). The Thomas Gilcrease Institute of American History and Art, Tulsa, Oklahoma

FIGURE 79. Frederic Remington. *PALEOLITHIC MAN*.
1906. Bronze, h. 15½ in. (39.4 cm.). The
Thomas Gilcrease Institute of American History
and Art, Tulsa, Oklahoma

Remington appears to have followed his artistic instincts, and sometimes this meant reaching back to an earlier drawing or sculpture as an aid in extracting or realizing a new idea. The first bronze in particular borrowed motifs from earlier work in another medium. For example, his early masterpiece from 1889, *A Dash for the Timber* (Plate 1), can be seen as a general prototype for Remington's sculptures of men on horseback riding closely and furiously forward: multifigured groups like *Coming Through the Rye*. In this painting, too, can be found forms later adapted for such sculptures of single horses and riders as *The Cheyenne* and *Trooper of the Plains* (see Fig. 83). *A Dash for the Timber* also contains what would become the formulation of

218

The Wounded Bunkie. One comrade leans over to aid another who has been mortally wounded. The wounded rider's head is arched back and his hands are limp. In the sculpture Remington reformulated the placement of the horses' hooves, directed the gaze of the soldier outward, and made more dramatic the gesture of the wounded man's hands. So pleased was Remington with the emphatically outstretched hand that he borrowed the pose two years later for the painting *Charge of the Rough Riders at San Juan Hill* (Plate 16). Thus, a configuration that made an appearance in *A Dash for the Timber* in 1889 was extracted for a sculpture seven years later and found a further echo in a painting two years after that.

FIGURE 80. Emmanuel Frémiet. *GORILLA CARRYING OFF A WOMAN.* 1887. Bronze, h. 17½ in. (44.5 cm.). Musée des Beaux-Arts, Nantes

detail of *THE OUTLAW*, 1906 (Plate 61)

Five years after completing *The Wounded Bunkie,* Remington turned back to it for the dynamic format of the galloping horse and rider in *The Cheyenne.* The change from soldier to Indian, from a multifigured sand casting to a richly textured lost-wax cast of a single form succeeds in camouflaging this formal relationship. Eight years later, Remington reused the format in a painting titled *The Stampede* (Fig. 81) as well as in the sculpture that same year titled *Trooper of the Plains.* To summarize: the soldier on horseback in *The Wounded Bunkie* became an Indian in *The Cheyenne,* then appeared as a cowboy in *The Stampede* (Plate 66), and finally returned to the form of his soldier in *Trooper of the Plains* and its related painting, *Cutting Out Pony Herds* (1908) (Museum of Western Art, Denver). These borrowings do not lower the quality of the artist's work, but rather enrich its fabric, providing insight into the syncretic and serial operations of his mind.

In similar fashion, the cowboy in *The Norther* was transformed into a lone Indian in the painting *The Herd Boy* (1905) (The Museum of Fine Arts, Houston). Another transposition from sculpture into painting took place in 1908, when Remington reused the sculpted image of *The Buffalo Horse,* a unique bronze of 1907 thirty-six inches high (Plate 65), in a painting titled *Episode of a Buffalo Hunt* (Plate 39). The sculpture allowed Remington physically to articulate, and the painting allowed him to interpret in two dimensions, the unlikely collision of a buffalo with a horse and rider. In each of these instances, the transfer from one medium into a different one amounted to a significant reinterpretation of the subject as a whole.

The fertile dialogue between Remington's paintings and his sculptures was more than an exchange of poses. Remington developed painting techniques to create encrusted surfaces on his lost-wax bronzes. After a wax positive had been prepared from his plaster model, the artist had the opportunity to make final changes and adjustments at the foundry. Using a brush dipped in hot wax he literally painted surface textures on the wax positive, which was subsequently cast in bronze. The fibrous surfaces of Remington's lost-wax bronzes relate closely to the weblike skins of his late paintings, just as the sharp edges of the earlier sand-cast bronzes paralleled the crisp and regular surface treatment of his early painting style. As the artist's painting and sculptural styles became looser, more textural, and more broadly scaled, he increasingly sought to evoke tactile effects in both media. Remington's

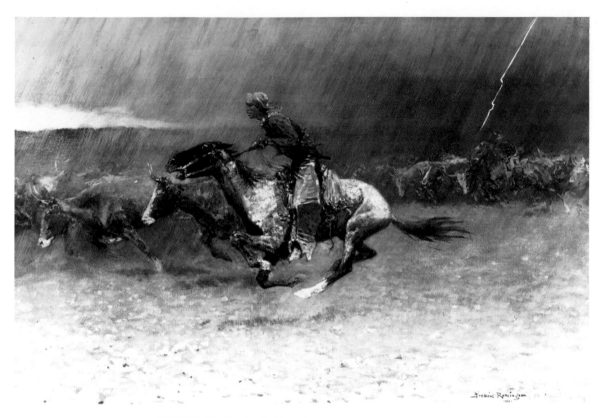

FIGURE 81. Frederic Remington. *THE STAMPEDE*.
1909. Oil on canvas, 27 × 40 in. (68.6 × 101.6 cm.).
The Thomas Gilcrease Institute of American History and Art, Tulsa, Oklahoma

movement from sand casting to lost-wax casting not only paralleled the development of his painting style but, in a broader sense, paralleled the movement by the American Impressionists and Tonalists toward a flatter mode of painting. In the arena of American sculpture, Remington's development relates to the sculpture of Augustus Saint-Gaudens, whose increasingly rich surface treatment is evident in the 1907 relief portrait of his wife (Saint-Gaudens National Historic Site, Cornish, New Hampshire). Given Remington's interest in energetic, moody, surface-oriented sculpture, it is fair to view him as a sculptor with decidedly expressionistic tendencies who died before those inclinations were fully developed.

Another question related to the interrelationships between the artist's works in different media is whether he made specific preparatory or working drawings for his sculpture. Few American sculptors did so. As we have seen, Remington's *Cow-boys Coming to Town for Christmas,* of 1889, served as a prototype for *Coming Through the Rye* in 1902, but it would be difficult to consider it a preparatory drawing. In fact, since so much of Remington's early work was as a draftsman, it may be argued that he had, in a sense, drawn studies years before he ever turned to sculpture. These early images were so deeply ingrained in his mind that preparatory drawings were for him redundant. What few drawings of his sculptures do exist are quick sketches in letters to friends or to Riccardo Bertelli at Roman Bronze Works, and these should be understood as notations regarding works already in progress.

Remington's most sustained and strenuous work of sculpture was *The Cowboy* (Fig. 82) for Fairmont Park, Philadelphia, the only large monument he conceived as such from the beginning. The initial proposal, made in May 1905 by the Fairmont Park Art Association to Remington, offered payment of $500 for a model. Initially, the artist had proposed to the committee a sculpture of either a single cowboy or a cowboy with a pack horse. Not until the spring of 1906 was the contract for a single figure on horseback formalized with the art association and work begun.

Inspired and challenged by the *Cowboy* commission, Remington built on the back of his house in New Rochelle in 1907 a new and larger studio especially equipped for large sculpture. The studio included a track that allowed the artist to roll his model indoors and outdoors. But the new studio may not have been large enough: by the time the model was enlarged in plaster, it measured 12 by 25 feet, virtually filling the 17-by-25-foot studio. In January 1907, Remington wrote to the committee: "I am out of the woods with my working model of the cowboy. I had a lot of hard going but finally made the horse and rider do what I expected of them."[20] Not used to working on such a large scale, Remington wrote to his friend John Howard in words that might have described his furious efforts at modeling *The Bronco Buster* in 1894–95: "I have not had such easy sledding with the *working model* of the cowboy as I hoped, but g—— d—— him I'll *do* him yet."[21] As the artist explained to the Fairmont Park Commission in a letter of December 12, 1907, "I am trying to give you a Remington broncho and am not following the well-known receipt for making a horse."[22]

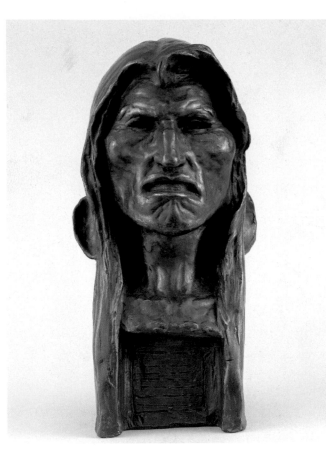

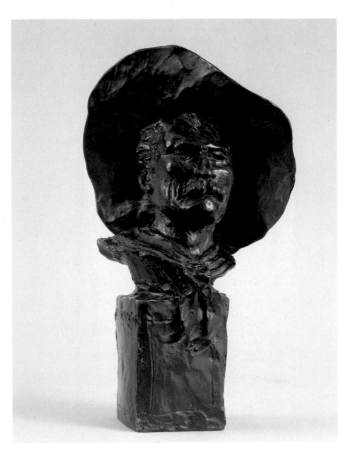

PLATE 63. *THE SAVAGE*. 1908.
© December 14, 1908; cast c. 1914. Bronze, h. 10¾ in. (27.5 cm.); base 4¼ × 4⅛ in. (10.8 × 10.6 cm.). Roman Bronze Works cast no. 5. Frederic Remington Art Museum, Ogdensburg, New York

PLATE 64. *THE SERGEANT.* 1904.
© July 30, 1904; cast c. 1905. Bronze, h. 10¼ in. (25.9 cm.); base 2⅝ × 2⅝ in. (6.7 × 6.7 cm.). Roman Bronze Works cast no. 13. Private collection

PLATE 65. *THE BUFFALO HORSE.* 1907.
© December 12, 1907; cast between 1907 and 1914. Bronze, h. 36 in. (91.4 cm.); base 21 × 11 in. (53.3 × 27.9 cm.). Roman Bronze Works (no number). The Thomas Gilcrease Institute of American History and Art, Tulsa, Oklahoma

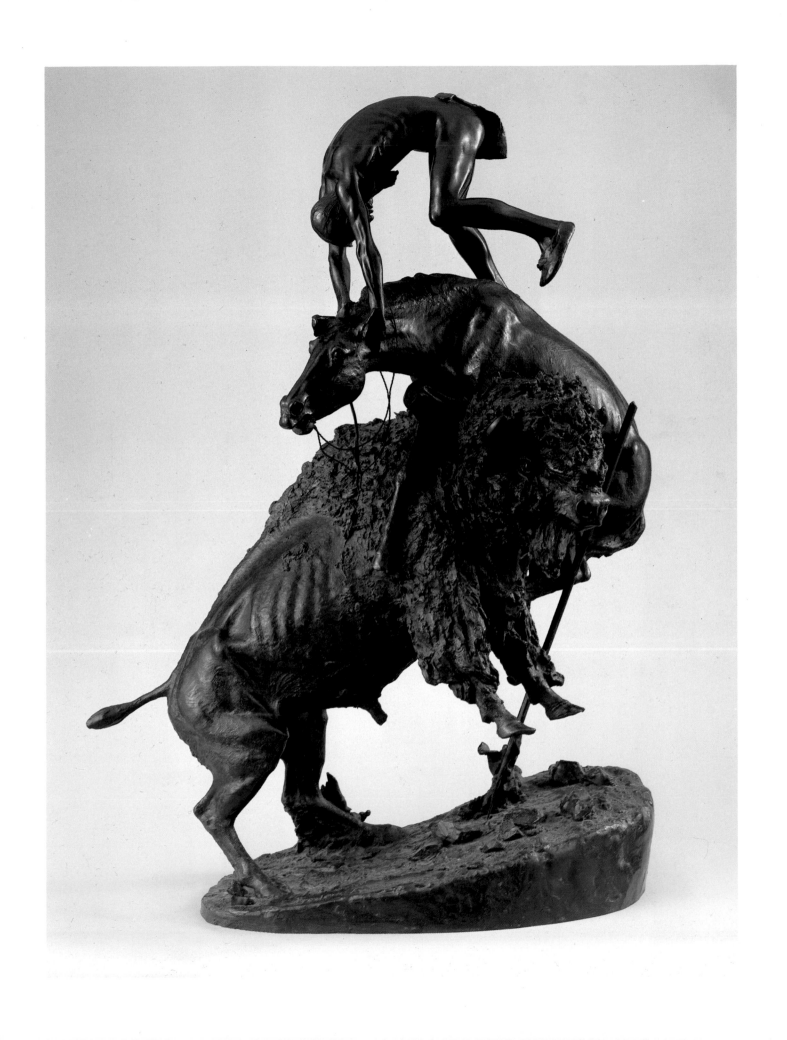

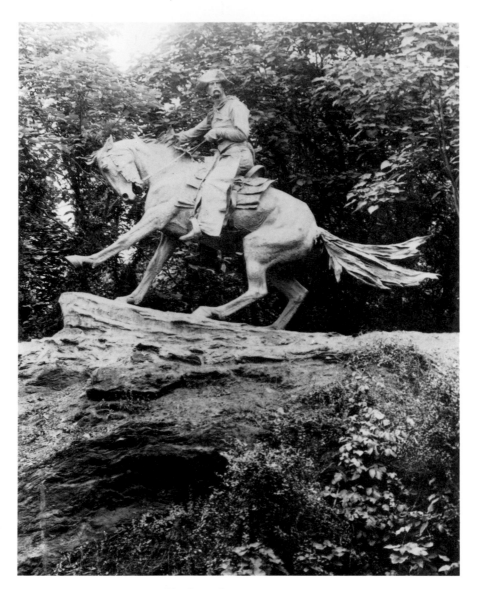

FIGURE 82. Frederic Remington. *THE COWBOY.* 1908.
Bronze, h. 12 ft. (36.58 m.). Fairmont Park Art Asso-
ciation, Philadelphia

Conceived as standing on a rocky ledge, the sculpture has a primary viewpoint from beneath and along the horse's flank. The extended left foreleg of the animal and the fact that the cowboy is a type rather than a portrait of an illustrious individual broke with the rather narrow conventions of nineteenth-century equestrian sculpture. If it was "modern" in its defiance of tradition, the sculpture also looks backward to a bygone era. As the sculptor wrote, it represents "a good type of the old Texas cowboys who came up over the trails with cattle in the early eighties on a small Spanish horse—the saddle, hat and other accouterments are of that day and must not be confused with later things. These were the Plainsmen who traveled by the stars."[23]

While he was working on *The Cowboy*, Remington modeled *The Horse Thief* (Plate 62), a sculpture that incorporated an expanded variant of the support system of *The Cheyenne*. It may not have been a coincidence that in May 1907, the same month that Remington copyrighted *The Horse Thief*, he destroyed at the foundry the molds of two earlier sculptures of Indians on horseback, *The Cheyenne* and *The Scalp*.[24] *The Horse Thief* is Remington's only relief sculpture. So involved was he in realizing the textural effects of the Indian's flowing buffalo robe and the deeply undercut forms of the undergrowth that the horse and rider seem merely appended to the setting. The animal's stiff foreleg seems inspired by the leg of the horse in *The Cowboy*.

One of the few photographs we have of Remington working on his sculpture shows him modeling *The Buffalo Horse*. (Probably taken in November or December 1907, the photograph is the only known documentation of the model for the Fairmont Park *Cowboy*, which can be seen on a shelf at the rear of the room.) The sculpture (Plate 65), which depicts the collision of an Indian on horseback and a buffalo, is supported by the Indian's spear. The rider, thrown from his horse by the impact of the collision, somersaults over the two animals. The sculpture, a *tour de force* of bronze casting, reflects Remington's increasing self-confidence, prompted in part by his work on the large equestrian *Cowboy*.

The *Cowboy* commission opened the door to a new field for Remington: monumental sculpture. In February 1908, the large plaster of *The Cowboy* was taken to Roman Bronze Works so the wax positive could be made prior to final casting. Remington worked vigorously over the entire surface of the huge wax cast, retouching and, in effect, painting its surface with hot wax. The finished wax positive was then

PLATE 66. *THE STAMPEDE*. 1909.
© April 13, 1910; cast c. 1919. Bronze, h. 23¾ in.
(58.9 cm.); base 46¼ × 16¼ in. (117.5 × 41.3 cm.).
Roman Bronze Works cast no. 3. Frederic Reming-
ton Art Museum, Ogdensburg, New York

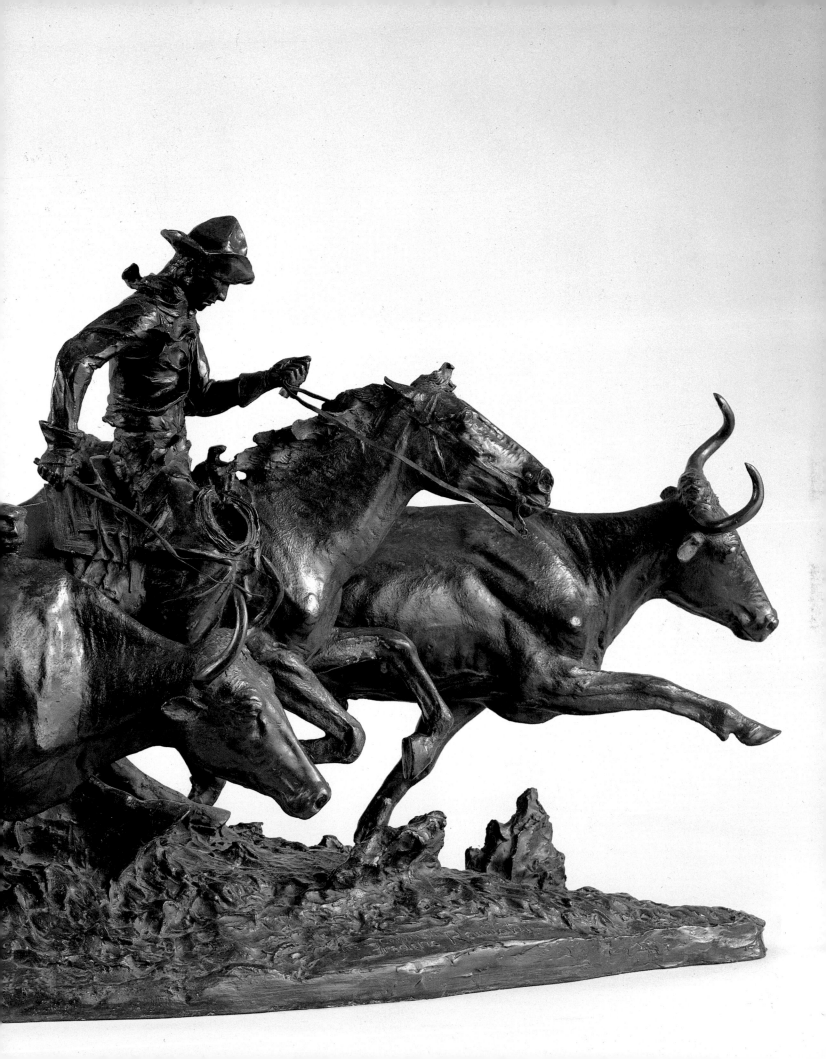

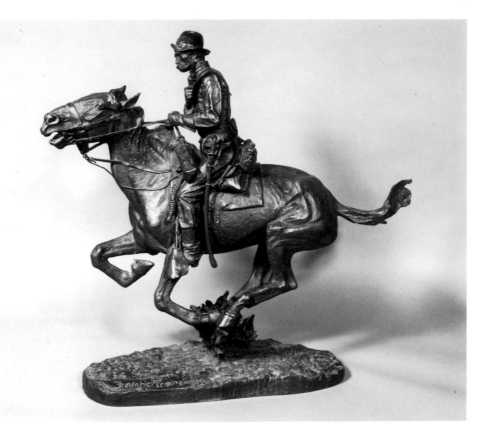

FIGURE 83. Frederic Remington. *TROOPER OF THE PLAINS*. 1909. Bronze, 25⅝ in. (65.1 cm.). The Cleveland Museum of Art. Gift of Pauline W. Horner in memory of her parents, Mr. and Mrs. Myron H. Wilson, Jr.

placed in the furnace to melt before the molten bronze was poured in to fill the empty cavity. The sculptor was pleased as the form of the horse and rider changed from plaster to wax to bronze, and he wrote, "The casting has been wholly successful and there is a lot more character in it than in the plaster which is what one can do with 'lost wax.'"[25] He went on to add how much further one could go in achieving a rich surface than with the piece molds of sand casting: "In the old piece mould the plaster ends it but in wax one can go on as far as he likes. I went over every inch of the wax."[26]

Even though Remington was commissioned to do *The Cowboy* for a public park, he nonetheless copyrighted it to protect himself against the unwarranted sale of repro-

ductions. Although he did not think that it was a bronze for "a statuette," he wanted to be cautious, particularly since some bronze manufacturers like Gorham were eager to sell his sculptures.

Some of Remington's enthusiasm for his sculpture was dampened seven months before the installation of *The Cowboy,* in June 1909, by the unveiling of Gutzon Borglum's equestrian statue of General Sheridan in Washington, D.C. Borglum's sculpture gained the distinction of being the first lost-wax-cast equestrian statue made in America, but it was not its casting (by Gorham) that irked Remington. Rather, it was the stiff-legged pose of the horse's left foreleg and the similarly down-turned tilt of the horse's head. Borglum had viewed Remington's model for Fairmont Park, and Remington felt that Borglum borrowed the motif of the horse's extended left foreleg, which Remington had considered a primary innovation in his own sculpture.

Remington considered several other large sculpture projects. He made a small model for an equestrian *Kit Carson* (unlocated) for the city of Denver; ultimately the American expatriate sculptor Frederick MacMonnies was selected for the commission. Early in 1908, he also investigated the possibility of making a portrait statue of General Custer and, perhaps, a large sculpture of an Indian for New York Harbor. He also expressed his wish to do at least two more large sculptures: "I hope now some one will let me do an Indian and a Plains cavalryman and then I will be ready for Glory."[27] He may have been thinking of the Plains cavalryman when, late in 1908, he modeled *Trooper of the Plains* (Fig. 83), his first sculpture since completing *The Cowboy.* However, the unusual support—a clump of sagebrush similar to the one that carries the weight of horse and rider in *The Outlaw* (Plate 61)—would have been difficult to use on an expanded scale.

Defying the traditional means of supporting sculpture is a consistent theme in Remington's work, and it came to be one of the clarion calls of modernist sculpture in the twentieth century. It was the apparently insoluble problem of supporting sculptures so as to make them appear free from their bases that he continually sought to solve. Possibly in response to this challenge, Remington formulated more innovative bases than any other American sculptor of his time, incorporating their shapes in *The Mountain Man* and *The Scalp* as important elements in the narrative drama of the works of art.

Remington's last two works characterize his expanding sculptural vision. The large version of *The Bronco Buster* (Plate 49) and *The Stampede* (Plate 66), both of 1909, are thirty-two inches and forty-six inches in their greatest dimension, respectively—the largest formats that Remington used for his indoor bronzes. The large *Bronco Buster* indicates the tenacity of Remington's vision and his will continually to refine and expand upon a subject. To make this "new" version of his first sculpture, Remington crafted a fresh model from the two-foot version. He extended the hand of the cowboy, raised the flaps that hold the stirrups, and modeled the horse in a looser and broader style than either the original, smaller, sand-cast version or the previous lost-wax casts. Sometimes referred to as "heroic," the large version of *The Bronco Buster* has a monumental quality and a breadth of vision not found in the smaller prototype.

Whereas *The Bronco Buster* was finished before his death, *The Stampede* was completed posthumously, by Remington's friend the sculptor Sally Farnham. With its densely packed and onward-moving elements, Remington's last sculpture relates to several of Barye's works as well as to Gutzon Borglum's *Mares of Diomedes,* of 1903. The lone rider in *The Stampede* is being pushed along by the herd of cattle. Remington was pushed along, too, by his energy, his drive, and the remarkably sharp focus of his vision. His inventiveness, along with his need to return to and refine his images, set him apart from every other American sculptor of his time. His sculptural vision and accomplishments—limited perhaps by the small scale in which he worked, by prejudices about their subject matter, and by the artist's early death—may now be seen to place him among the most brilliant turn-of-the-century American artists.

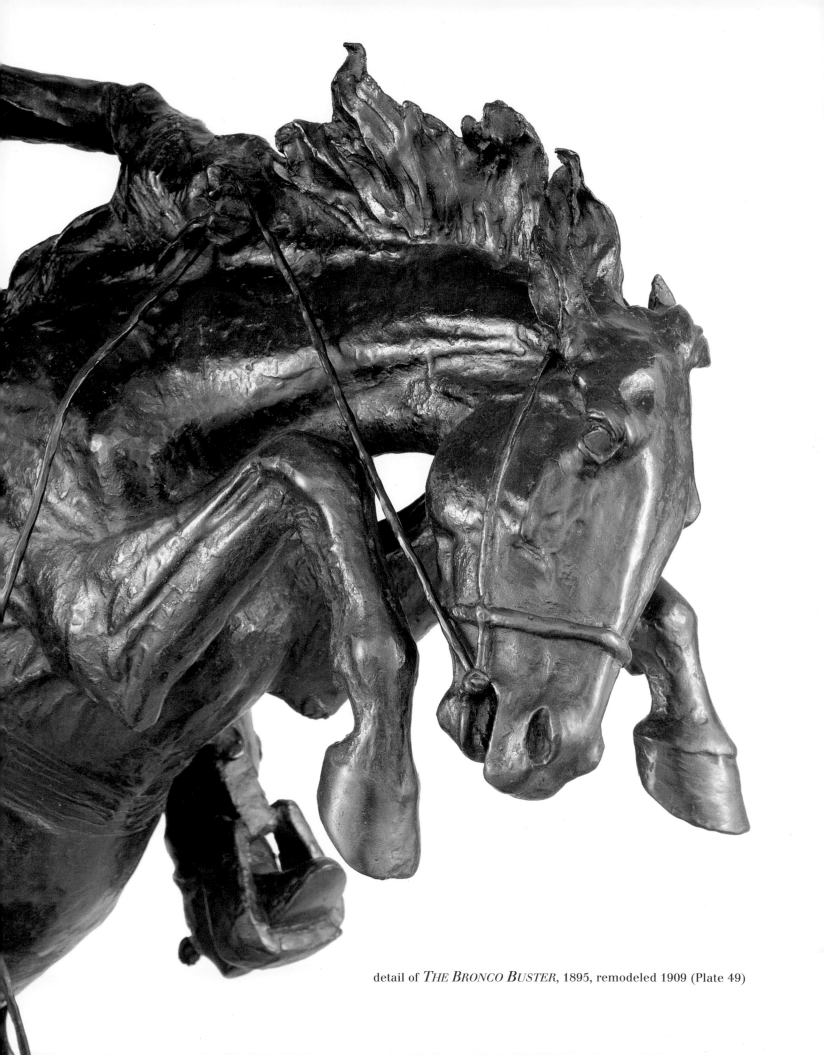

detail of *THE BRONCO BUSTER*, 1895, remodeled 1909 (Plate 49)

REMINGTON
THE WRITER

By John Seelye

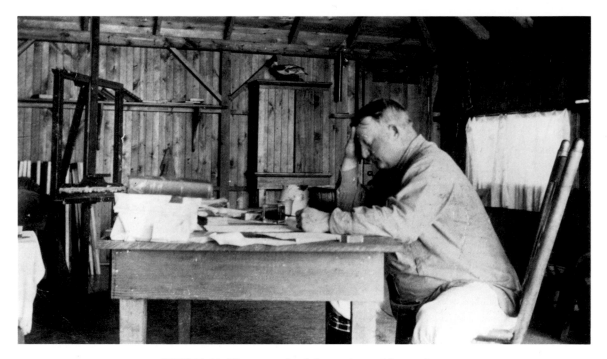

FIGURE 84. Photograph of the artist writing, taken
at the height of his career, about 1900. Frederic
Remington Art Museum, Ogdensburg, New York

Painters can write and writers paint, or John Ruskin and John La Farge lived in vain, but as both the English and the American artist-author bear witness, such creative ambidexterity is more often the exception than the rule. How much greater an exception is Frederic Remington, in that the sheer reach of his accomplishments in the graphic and plastic arts is matched by an amazing versatility in prose. Remington began his artistic career as a commercial illustrator, improved his gifts until he became a painter of the first rank, then moved on to master the difficulties of sculpting in bronze. He also pursued a three-stage authorial career: he was first a reporter, then a short-story writer, and finally a novelist. Remington's reputation as an artist perhaps has suffered because he began as an illustrator, and his stature as a writer has most definitely been dwarfed by his work with paint and clay. Though it is doubtful he would ever have been considered the equal of contemporaries Frank Norris and Stephen Crane, Remington's fiction might well have enjoyed more attention had he not been regarded as a great painter who played around with prose. More important, his reputation as a writer might have been greater had he developed that talent at the expense of his other gifts.

As with his painting, Remington's skill as a writer emerged during the years when he was chiefly known as an illustrator. Peggy and Harold Samuels have shown that there was at the start an intimate connection between his pictures and his writing and that Remington apparently became an author in order to create an additional market for his drawings.[1] Though his first accounts of his experiences riding with detachments of the United States Cavalry in search of Indians were reportorial, Remington's writing became increasingly ambitious. By the time of his death, he had to his credit a number of short stories and two novels, *John Ermine of the Yellowstone* (1902) and *The Way of an Indian* (published in 1906 but completed in 1900). Another book, *Sun-Down Leflare* (1899), is made up of five loosely connected stories about the titular hero and narrator, a French half-breed.

Each of Remington's books of fiction is quite different from the others and is different also from much that was being published at the time, though his oeuvre clearly is of a piece with the work of contemporary innovators like Norris and Crane and anticipates certain characteristic elements in the stories of Jack London. It is with Owen Wister, however, his friend and collaborator, that Remington is best com-

pared, for as Ben Merchant Vorpahl has shown us, Remington's most ambitious work of extended fiction, *John Ermine,* was written as a response to Wister's best-selling book, *The Virginian.*[2] Whereas Wister in that novel betrayed the integrity of his western vision, introducing a strong vein of sentimentality in order to gain wider readership, Remington expressly rejected sentimental formulas in his book, which, like its hero, perversely pursued a self-destructive course. At the same time, it would be wrong to regard Remington as a writer whose inspiration came chiefly from a need to refute another man's work. *John Ermine* is consistent in its theme and tragic outlook with his other fiction, which also was inspired by Remington's direct contact with the inhabitants and landscape of the American West.

As a reporter, Remington of necessity sought out (or occasionally blundered into) zones of conflict: with his friend Richard Harding Davis, he was an early American war correspondent, hired by William Randolph Hearst, whose ambition it was to exacerbate United States–Cuban relations in order to produce sensational copy. And in his fiction Remington also favored episodes of violent action, written in the great tradition of James Fenimore Cooper. Ironically, most of Remington's journalism was concerned with the everyday life of western cavalrymen, who sought more martial contact with Indians than they ever found, yet who often found it, as the sad record attests, when it was least expected. If Remington was a lover of war, his was mostly an unrequited affair insofar as the western scene was concerned. Even in Cuba, he was either a distant witness to an important battle or else absent entirely, mired down with the vast congeries of men and equipment that follow sluggishly in the wake of actual combat. Where Remington's paintings tend to promote a heroic image of the West, his journalistic drawings emphasize the daily routines of cavalrymen and cowboys. The same difference may be found between his fiction and his reporting, but the distinction is hardly so sharp in his prose as it is in his pictures. Common themes and emphases abound.

Richard Harding Davis provides a useful comparison. An author who spun out facile stories of adventure in exotic locales, Davis was both a symbol of his times and something of an anachronism—a living embodiment of the "strenuous age" and a Byronic figure. Unlike Remington, Davis as a war correspondent always seemed to be in the place where the action was, and his stories of combat were just the sort of

thing Hearst was looking for—exciting, romantic, and lively, the war as seen from officers' country. By chance and inclination, Remington saw and reported a different version of warfare, an account much like that in Stephen Crane's *The Red Badge of Courage,* which, as it happened, appeared on the eve of the Spanish-American War. For Crane and Remington, war consists of a lot of waiting, followed by a convulsive period of waste. Crane "saw" the Civil War through the eyes of a raw recruit, a lowly foot soldier, who never seems to grasp the larger, tactical picture, though he most certainly comes to understand a few of the harder truths of life—and death. Remington likewise slogged his way along with men in the ranks, while regularly enjoying the comforts of officers' quarters. Though Remington did what he could to advance the political ambitions of General Nelson Miles, he more typically celebrated men of much lower rank, like Lieutenant Powhatan Henry Clarke or the fictional sergeants in "When a Document Is Official" and "A Sergeant of the Orphan Troop," two of his best short stories.

Though as a war correspondent he enjoyed a privileged position, Remington evinces sympathy and admiration for the Pony Soldiers of the cavalry, most especially when they were forced to fight as infantry in Cuba; and despite his clearly racist private views, some of his finest writing concerns the "buffalo soldiers," black cavalrymen who were important in frontier warfare. Though he tended to celebrate the exploits of heroic sergeants and lieutenants as required by romantic formulas, Remington's commitment to realism continually drew his eye rearward, to take in the dogged courage of enlisted men who followed their leaders' direction. "I did not do much or occupy a commanding position," claims Remington's fictional soldier Joshua Goodenough, in recounting to his son the battles of the French and Indian War, "but I served faithfully in what I had to do."[3] Joshua's given name evokes the great general of ancient Israel, but it is his surname that defines him: he is a "good-enough Joshua," belonging to the heroic rank and file upon whose loyal services the general of armies must depend. Remington's ideal was always the "good soldier," without any irony attached to that phrase.

On a tactical height in Cuba overlooking "the flat jungle, San Juan hills, Santiago, and Caney, the whole vast country to the mountains which walled in the whole scene," Remington listened to "the experts talk" as they surveyed the maplike terrain

FIGURE 85. Frederic Remington. *THE BIGGEST THING IN SHAFTER'S ARMY WAS MY PACK*. Reproduced in *Harper's Monthly*, November 1898, p. 963

below: "I thought to myself this is not my art—neither the science of troop movement nor the whole landscape. My art requires me to go down in the road where the human beings are who do these things which science dictates, in the landscape which to me is overshadowed by their presence."[4] This declaration is in part a rhetorical stance, for like Richard Henry Dana in the forecastle Remington knew he could always go back home; but like Dana and journalists such as Stephen Crane who explored the "depths" of slum life for their stories, Remington was sincere in his

sympathies with the common man. In order to emphasize the hardships endured by his cavalrymen daily, Remington employed another strategy, invariably casting himself as a reluctant and often inept participant in military expeditions from the Arizona Territory to Cuba. There are often facts to substantiate the posture, but the pose is remarkably consistent.

In "A Scout with the Buffalo-Soldiers," Remington is yanked from comfortable quarters at Fort Grant and experiences the rigors of two weeks on horseback in the rugged mountains of the desert terrain, his "labored movements" on the first morning in camp revealing "the sad evidence of the effeminacy of the studio."[5] Though Remington proved equal to the challenge of the Arizona expedition, his experience convinced him "that soldiers, like other men, find more hard work than glory in their calling."[6] In "With the Fifth Corps," Remington described his ordeal covering the Santiago campaign in a self-deprecating vein suggested by a small sketch of himself with which the piece opened (Fig. 85). The picture shows Remington from the rear, the adipose correspondent in baggy pants, pith helmet, and the pack he advertised as "the biggest thing in Shafter's Army," though it is definitely dwarfed by what Remington carried below.

Though Remington was willing to play the fool, it is wrong to portray him, as his biographers Peggy and Harold Samuels have done, as a modern Falstaff, larding the ground with his sweat and preferring the joys of the mess table to the dangers of combat. "With the Fifth Corps" is classic reportage, and one of the reasons it succeeds is that Remington understood the importance of strategies other than military, placing himself in a position to serve as intermediary between the professional soldiers with whom he traveled and the sedentary reader in his easy chair back home. There may be something of the Falstaff in this ludicrous self-portrait, but then there is a bit of Falstaff in us all. Here again Stephen Crane serves as a useful analogy, for like Remington he extrapolated his youthful experience as a football player to the battlefield; but where Crane's Henry Fleming eventually emerges as something of a quarterback, carrying the battle flag at the head of his troop, Remington in the field remained the varsity rusher he had played at Yale, absorbing the brunt of the action but never taking the ball (Fig. 86). His famous painting of the storming of San Juan Hill (Plate 16) focuses on the "great game" of warfare, but his actual experience of

the event was far different, for he caught only a fleeting glimpse of the Rough Riders' main (and not very meaningful) achievement, as "With the Fifth Corps" reveals.

As a result of these rhetorical strategies, Remington conveys the feel of horse-borne military life with a skill unmatched by any contemporary writer. Owen Wister gave literary life to the cowboy (and many of Wister's stories also concern the exploits of horse soldiers), but only Remington did realistic justice to the cavalryman, filling in with prose description and vivid characterization the spaces left between his graphic depictions, in books like *Done in the Open* (1902) and *Men With the Bark On* (1900). Remington's famous paintings of western cavalry in action likewise emphasize melodramatic encounters, last stands, and galloping attacks on Indian warriors that Remington himself never witnessed. Such events are the stuff great art and myth are made of, but they were, as Remington's reporting reveals, quite rare in everyday western life. His magazine illustrations and the stories written to accompany them give us a much more realistic sense of what it was like to serve in the cavalry in the 1880s and 1890s.

In similar fashion, although in reverse emphasis, Remington's western fiction provides a counterpart to his journalism, being like his paintings a "long travel" from the dull and dusty facts of life as lived by the Pony Soldiers. Even in *John Ermine of the Yellowstone*, written in part to refute Wister's sentimental version of western life, the cavalry provides merely a *mise-en-scène*, a relatively static backdrop to an action that has little to do with arduous scouting expeditions in pursuit of the vanishing Indian. As in his western paintings, Remington in his most ambitious western novel gave melodramatic shape to frontier life, drawing on the great tradition of Cooper and, close to home, Bret Harte and Joaquin Miller. Not even Stephen Crane and Jack London were immune to this artistic convention of sustaining a skin of verisimilitude over the bones of melodramatic contrasts and heightened action. As Frank Norris observed, the new realism—"naturalism"—was in many ways the old romanticism in a different package.

But if Remington's novels resembled his western paintings in their mythic exaggeration, they differed remarkably when it came to themes, stressing not the heroic life of the cavalryman but the tragic lot of his antagonist, the Indian. It is the vanishing red man, that elusive quarry, who is the chief subject of Remington's novels, as if

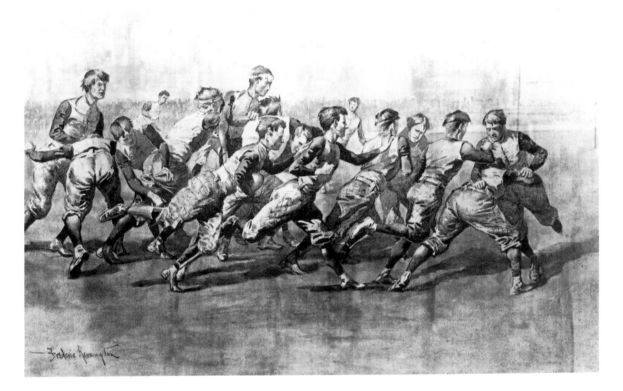

FIGURE 86. Frederic Remington. *A RUN BEHIND INTER-FERENCE*. Reproduced in *Harper's Weekly*, December 2, 1893, p. 1152. Frederic Remington Art Museum, Ogdensburg, New York

he wished to compensate for the absence by which the Indian's role is defined in his western reportage. In his short story "Massai's Crooked Trail," Remington rendered a semifictional portrait of a renegade Indian known only by the bloody path he leaves behind him, a tale that is a quintessential expression of Remington's own frustrating experience hunting for Geronimo with the cavalry. But in his three novel-length fictions, *Sun-Down Leflare, The Way of an Indian,* and *John Ermine of the Yellow-stone,* Remington dealt at length with the encounter between the races, creating what amounts to a trilogy, each book concentrating on a different aspect of the conflict between red man and white, as seen chiefly from the Indians' side of the lines. Since Remington seems never to have been able to transfer this tragic vision to can-

vas, his three long fictions must be considered an independent unit, not merely a supplement to his artistic efforts.

True, Indians do loom large on his heroic canvases, as suitable epic antagonists for his cavalrymen, fiercely stoic warriors whose way of life reflects the harshness of the western landscape. But however sharp their outlines against the desert and sky, they remain little more than a scenic generality, conveying mystery, perhaps, but little hint of the tragedy that envelops their lives. By contrast, *The Way of an Indian* is a stark chronicle of fated decline figured in the life and death of one red man, a fierce leader of his people who is eventually, inevitably, destroyed by the forces of civilization, portrayed as distant wagon trains and sudden, violent raids by cavalrymen. In that novel, the proportions of Remington's heroic paintings are reversed. In his attempt to enter a way of life with which he was only remotely familiar, Remington was forced to depend for his sources on such secondary, popular accounts as Colonel Richard I. Dodge's *Our Wild Indians*, and, as we might expect, Remington's fiction reflects Dodge's cavalryman's view of the Indian as a savage adversary. But the result is remarkably sympathetic, albeit limited, in its treatment of Indian life.

Because of Remington's emphasis on the harsh, even cruel, aspects of Indian character, his *Way of an Indian* may be considered an antidote to *Hiawatha*, much as his illustrations for Longfellow's book seem out of keeping with the essentially domestic, sentimental, and quasi-Christian emphases of the Fireside Poet. Remington's view of the Indian is much more in tune with Francis Parkman's *Oregon Trail*, the illustrations for which marked a high point in the painter's career. Both writers realized that the Indian maintained a relationship with his natural surroundings that was different from and a mystery to the white man, a mystic bond that centered on the "medicine" each male Indian carried with him after his initiation into manhood. Like Parkman, Remington also saw the difference between red man and white as a tragic gulf, and the tragedy was invariably the Indian's. Though emphasizing the ferocity of the red man's heritage, and obsessed like earlier writers with the doom already guaranteed by the historical record, Remington in his novels put forth not only a sympathetic version of Indian life, but perhaps the most complex we have by a white man who was a contemporary witness to the red man's final decline and fall.

We may esteem Remington's war reporting for its graphic qualities of realism, but

Remington's novels have quite another value, for there he attempted to express for his age the enigma that had been central to Cooper's Leatherstocking Tales: the meaning of the frontier when it was reduced to the inevitable extermination of the Indian and his way of life. Cooper will always remain the more important writer—if only for the primacy of his vision—but while Cooper was held captive by Rousseau and Romanticism, Remington wrote in the new naturalistic tradition, and though his Indians may be admirable in their unflinching courage, "noble" is not a word that comes to mind. Remington's Indian heroes are part and parcel of the dynamics of their destruction, participating in a deterministic process that does not accommodate Apollonian postures. Each of Remington's three novel-length books concentrates on a different aspect of that process, but is not limited to a strictly tragic view—Sun-Down is clearly a comic conception. The result is a trilogy whose scope matches, if it does not challenge, the epic range of Cooper's five great novels. If Remington was truly, as Theodore Roosevelt claimed, "the American Kipling" (a title Roosevelt also bestowed on Owen Wister), it is because of the completeness of his frontier diagram, a reach never essayed by Wister.

In *The Way of an Indian,* Remington recounts the fate of one prototypical Indian, White Otter, a Chis-chis-chash brave whose life span coincides with the coming of the white man to the foothills of the Rockies and the eventual extermination of his tribe. In the second book, Remington gives us a series of adventures told in characteristic patois by the French half-breed Sun-Down Leflare, who figures chiefly as a long-suffering victim-hero and as a bearer of the white man's errands, sustained by a deep vein of aborigine stoicism and considerable Gallic humor (Fig. 87). Finally, in his most ambitious work of fiction, Remington tells the story of John Ermine, a white man raised among Indians who attempts to live among whites, with tragic results. When we realize that Remington wrote these three books in the brief period of five years, during the time he was emerging as a sculptor in bronze and continuing to pursue his dual career as a painter and an illustrator, we owe this enormously talented man an added measure of respect. It is with Remington's accomplishment as a novelist, however, that we ought to concern ourselves here, not so much perhaps in aesthetic matters as in thematic concerns, the range of subject matter by means of which he filled out his vast repertoire of western tropes and topics. Remington must

be given high marks for creative dexterity in his book-length works, for all three are experiments of a kind, each told in a distinct manner, with structure and style clearly chosen to enhance its thematic burden.

In *The Way of an Indian*, for example, Remington tells a relatively straightforward story, arranged chronologically, commencing with the childhood of his hero, his emergence into manhood, and his victories in battle and consequent ascendancy as a chief over his people, then moving on to his old age and eventual defeat and death. The style he chose is clearly calculated to evoke the simple yet strenuous life he was describing, with a few faint touches of the archaic.

> Thus during the days did White Otter eat and sleep, or lie under the cottonwoods by the creek with his chum, the boy Red Arrow—lying together on the same robe and dreaming as boys will, and talking also, as is the wont of youth, about the things which make a man. They both had their medicine—they were good hunters, whom the camp soldiers allowed to accompany the parties in the buffalo-surround. They both had a few ponies, which they had stolen from the Absaroke hunters the preceding autumn, and which had given them a certain boyish distinction in the camp. But their eager minds yearned for the time to come when they should do the deed which would allow them to pass from the boy to the warrior stage, before which the Indian is in embryo.[7]

By way of telling images Remington develops an important subtheme. White Otter is a "boy" waiting to become a man, but his way of life seems closer to that of animals than that of humans: a "mud-turtle on a log" when at rest, the Indian assumes a "torpor" as the means by which he "stores up energy, which must sooner or later find expression in the most extended physical effort," at which times of action he becomes a "human wolf." For Remington, as for Parkman, the Indian is in such deep sympathy with animal life as sometimes to blur distinctions, and unlike Kipling's Mowgli, little White Otter seems at times more wolf than man. His tribe worships as a totem "the Pipe-Bearing Wolf," to whom the young warrior on the eve of his first scalp-hunting expedition offers up a ritual sacrifice. "It was more than mere extension of interest with them: it was more than ambition's atavistic blood-thirst made holy by the approval of the Good God they knew."[8]

FIGURE 87. Frederic Remington. *SUN-DOWN LEFLARE, WASHED AND DRESSED UP*. Illustration for *Sun-Down Leflare* (1899). Frederic Remington Art Museum, Ogdensburg, New York

FIGURE 88. Photograph by Remington of "Ol' Laraeux" (L'Hereux), the model for Sun-Down Leflare. Frederic Remington Art Museum, Ogdensburg, New York

Of a similar sort is the mummified bat Remington's warrior carries in his medicine bag, his private totem that gives him his new name, the Bat, as his later exploits as a warrior will earn him the title Fire Eater. It is this medicine on which the Indian chief relies for wisdom and strength as he does combat with rival tribes and, increasingly, with the Yellow Eyes, the white men who, first arriving as traders and trappers, come finally as "walking-soldiers, pony-soldiers, [with] big guns on wheels and more wagons than [we] can count. Many of their scalps shall dry in our lodges, but brother, we cannot kill them all."[9] Eventually it is the white soldiers who kill all the Chis-chis-chash, during a night attack in winter that leaves their old chief alone in the snow, clutching the corpse of his infant son, his precious medicine left behind and now lost in the wreckage of his village.

Medicine also provides a strong motif in the stories told by Sun-Down Leflare, tales told to amuse or instruct an auditor-interlocutor who is clearly intended to be taken as Remington himself. Besides soliciting stories from the half-breed, the interlocutor at times must interrupt to keep him from heading off on one of his innumerable tangents, for whereas the civilized white man wants the facts, Sun-Down, the semi-savage, believes that the truth is less easily expressed, regarding it as a matter of amplification, not direct explication. Though half-white, Sun-Down is more than half red, and he despairs of ever making certain Indian matters clear to his interrogator, as becomes evident in the following catechism concerning Sun-Down's medicine, in which he believes even while professing to be a Roman Catholic.

"What is your medicine, Sun-Down?"

"Ah, you nevair min' what my medicine ees. You white man; what you know, bout medicine? I see you 'fraid dat fores' fire out dair een dose mountain. You ask de question how does canyon run. Well you not be so 'fraid you 'ave de medicine. De medicine she tak care dose fire.

"White man she leeve een de house; she walk een de road; she nevair go half-mile out of hees one plass; un I guess all de medicine he care 'bout he geet een hees pocket.

"I see dese soldier stan' up, geet keel, geet freeze all up; don' 'pear care much. He die pretty easy, un de pries' he all time talk 'bout die, un dey don't care much 'bout leeve. All time deese die: eet mak me seeck. Enjun she wan' leeve, un, by gar, she look out pretty sharp 'bout eet too.

"Maybeso white man she don't need medicine. White man she don't 'pear know enough see speeret: Humph! white man can't see wagon-track on de grass; don't know how he see wagon-track on de cloud. Enjun he go all ober de snow; he lie een de dark; he leeve wid de win'; de tunder—well, he leeve all time out on de grass—night-time—day-time—all de time."[10]

Having served as a scout for cavalry, Sun-Down now works as a guide for white hunters—he was modeled upon a real person (Fig. 88)—but in telling his stories he is a guide also into the mysteries of Indianness, most especially the stubborn will to survive under terrible adversity, which Sun-Down always attributes to his medicine. For White Otter, the eventual loss of his medicine triggers his tragedy, but in the Sun-Down stories, as with the narrator's rambling style, the matter of medicine is often used for humorous effect. In one such story, involving a theft of horses from a Crow camp, Sun-Down evinces great powers of vision that assist in the raid, and as a result gains a reputation as a medicine man: "Dey all say I was see bes' jus' at sun-down, un dey was always call me de sun-down medicine."[11] But on closer inquiry, the interlocutor discovers that Sun-Down's great powers of vision are the result of "a new pair of de fiel'-glass what I was buy from a white man."

"So, you old fraud, it was not your medicine, but the field-glasses?" and I jeered him.

"Ah, dam white man, she nevair understan' de medicine. De medicine not 'ave anything to do wid de fiel'-glass; but how you know what happen to me een dat canyon on dat black night? How you know dat? Eef eet not for my medicine, maybeso I not be here. I see dose speeret—dey was come all roun' me—but my medicine she strong, un dey not touch me."

"Have a drink, Sun-Down," I said, and we again forgathered. The wild man smacked his lips.

"I say, Sun-Down, I have always treated you well; I want you to tell me just what that medicine is like over there in your tepee."

"Ah, dat medicine, well, she ees leetle bagful of de bird claw, de wolf tooth, t'ree arrow-head, un two bullet what 'ave go troo my body."

"Is that all?"

"Ah, you white man!"[12]

Such interviews remind a reader familiar with the writings of Thoreau of the attempts by the Concord philosopher to wrest the secrets of Indian life from Joe Polis, his guide through the wilds of Maine—attempts that were imperfect at best. But whereas Thoreau remained dissatisfied and frustrated, Remington seems content to regard the gulf between white and red men as uncrossable, even by such a man as Leflare, who should represent a racial bridge of understanding. The half-breed's name signals his fate—"Leflare," a possible corruption of "la fleur," and "Sun-Down," connoting the closing of day, both symbolic of the *carpe diem* theme. Like the setting sun, the half-breed's fate is associated with the West, and when he dies a way of life will disappear. Though he has a child, a "leetle baby," it is cared for by "a white woman up at agency," the mother having "run off on de dam railroad.... You s'pose I put dat baby een a dam Enjun tepee?"[13]

By deciding to surrender his child to civilized nurture, Sun-Down turns against his Indian heritage, in effect cooperating with the disruptive forces symbolized by the railroad. In *Way of an Indian,* similarly, it is "the talking-wires and the firewagon" (telegraph and locomotive) that signal the end of the Chis-chis-chash by bringing the white hunters who "slew the buffalo of the Indians by millions."[14] Though half-white, Sun-Down Leflare will share the fate of his red brothers.

A man who is only half-white remains red to his bones, and even a white man raised as an Indian is marked for life as a white savage: "All same," as Sun-Down says, "Enjun." Thus, the comic stories of the half-breed's adventures are followed by the tragic story of John Ermine, who is "Little Weasel" to his adoptive red parents but is given a more acceptable name when he crosses over: "Ermine" suggests both his whiteness and his innate nobility. But it is "John" that defines, being generic for a half-civilized Indian, as in "John Mohegan," the name assigned in Cooper's *The Pioneers* to the aged, drunken Chingachgook by the whites he lived among. In his last and most ambitious novel, Remington brought his tragic diagram to a close, for the European heritage of his young hero does not save him from the common fate of the Indians who have reared him. From Uncas, the "Last of the Mohicans," to John Ermine is a line unbroken, reminding us also of the repetitious cycles of history, for the American Indians were not the first primitive people to fall before the remorseless advance of civilized empire. In an early passage in *John Ermine,* Remington de-

scribes the young white boy and an Indian companion, speeding along "beside the herd of many-colored ponies. To look at the white boy, with his vermillioned skin, and long, braided [blond] hair, one would expect to hear the craunch and grind of a procession of the war-cars of ancient Gaul coming over the nearest hill. He would have been the true part of any such sight."[15] Remington's first oil painting, done while he was still a student, showed a Gallic warrior chained in a dungeon and guarded by a Roman legionnaire, an image that casts a subliminal shadow over much of his subsequent painting and prose. John Ermine is thus a "chained Gaul," pinioned by historical necessity, a victim like Billy Budd of mechanisms beyond his understanding or control.

The story of the hapless British tar, which Herman Melville was writing during Remington's years of western wandering, has been seen by R.W.B. Lewis as an illustration of his thesis concerning the American Adam, "the New World's representative hero and his representative adventure ... the birth of the innocent, the foray into the unknown world, the collision with that world, 'the fortunate fall,' the wisdom and the maturity which suffering produces."[16] We may debate Lewis's conclusion that Billy's death is redemptive, but less debatable is his declaration that a *British* sailor's death on a *British* man-of-war is an "action ... grounded in the pressures and counterpressures not of any world but the New World."[17] How much closer to such an action is the story of John Ermine, like Billy an "upright barbarian" who falls victim to the quintessential American collision between the forces of animate nature and civilization, figured as the frontier? If Billy is a type of Christ, so also, as his initials suggest, is Remington's John Ermine, an American Jesus Emmanuel, who calls out to his Indian god just prior to his death, "O Sak-a-war-te ... have you deserted me?"[18] In John Ermine we have an American counterpart to Melville's British sailor, a "handsome cavalryman" who becomes a calvary man at the last, sacrificed in the cross fire between opposing cultures.

In *John Ermine,* Remington returned to a relatively straightforward narrative, but with a plot of considerable complexity, made up of several conflicts and a pattern of fate quite literary in its design. It begins with a scene, self-consciously signaling Remington's debt to Bret Harte, in which a western mining camp is thrown into a turmoil upon the discovery that a white infant is being reared in a nearby Crow village. The

miners rescue the child but are then bewildered by their responsibility, and when the Indian mother forestalls the miraculous and sentimental transformation found in Harte's "The Luck of Roaring Camp" by stealing back the infant, the miners seem relieved. Though comic in treatment, the opening episode puts a seal on the ensuing action, demonstrating that the baby, though born white, can find no place in white society, and further suggesting that no sentimental solution to the problem can be found.

The white child is not completely at one with his adoptive people either. Growing to adolescence among the Absaroke, White Weasel becomes (like Mowgli) a "natural" leader because of the ascendancy granted him by his northern European heredity, but as a "white crow" the boy is an anomaly and something of a freak. Because of his superiority, the blue-eyed boy is assigned the responsibility of watching over the tribe's horses, and he narrowly escapes death one night when wolves attack the herd. He owes his life to the horses, which formed a protective ring around him, and most especially to a great white stallion, which lost its life in saving him. Remington here opposes the wolf, an important Indian totemic animal (as in *Way of an Indian*), with the horse—an animal intimately associated by him with the coming of civilization to the New World—most particularly a stallion distinguished by a color identifying him further with the white man. During this ordeal, little White Weasel has a mystical experience, sensing the nearness to him of the Great Spirit, who commands the boy always to carry a hoof of the white stallion with him as his medicine, an experience that testifies to the definitive—and ultimately fatal—influence of his pagan upbringing.

Soon after, White Weasel is taken by his adoptive father to visit a reclusive white man, a hunchback who has retreated into the solitude of the mountains because of his deformity. Called Crooked Bear, the old prospector is credited by the Absaroke with great powers of Indian medicine, but when he decides to adopt the white boy, it is white man's knowledge he imparts: lessons in English, mathematics, astronomy, and the Christian religion. The boy grows to young manhood, and after the news of Custer's death at Little Big Horn reaches the hermit's cave, the old man urges John Ermine (as he is now called) to go work for his true people, fighting the Sioux as a cavalry scout. In company with a young half-breed, Wolf-Voice, John Ermine rides

KATHERINE

FIGURE 89. Frederic Remington. *A SIDE-WHEELER.*
Headpiece for *John Ermine of the Yellowstone*
(1902). Frederic Remington Art Museum, Ogdens-
burg, New York

out in search of what he assumes will be a promising future, but Remington de-
scribes his departure in terms suggesting that both the half-breed and the "white
crow" will be participants in their own extermination:

> These two figures, crawling, sliding, turning, and twisting through the sunlight
> on the rugged mountains, were grotesque but harmonious. America will never
> produce their like again. Her wheels will turn and her chimneys smoke, and the
> things she makes will be carried round the world in ships, but she never can
> make two figures which will bear even a remote resemblance to Wolf-Voice and
> John Ermine. The wheels and chimneys and the white men have crowded them
> off the earth.... Their gaunt, hammer-headed, grass-bellied, cat-hammed roach-
> backed ponies went with them when they took their departure; the ravens fly
> high above their intruding successors, and the wolves which sneaked at their
> friendly heels only lift their suspicious eyes above a rock on a far-off hill to follow
> the white man's movements. Neither of the two mentioned people realized that
> the purpose of the present errand was to aid in bringing about the change which
> meant their passing.[19]

Of the two, Wolf-Voice has the simpler errand: he wishes to become rich by work-
ing for the white man. He plays Sancho Panza to the quixotic John Ermine, whose
desire to rejoin the white race is soon complicated by a photograph he finds, dropped
along the trail by a troop of cavalry that has passed by. It portrays an apparently

FIGURE 90. Frederic Remington. *JOHN ERMINE*. Illustration for *John Ermine of the Yellowstone* (1902). Frederic Remington Art Museum, Ogdensburg, New York

FIGURE 91. Frederic Remington. *HE BORE THE LIMP FORM TO THE SANDS*. Headpiece for *John Ermine of the Yellowstone* (1902). Frederic Remington Art Museum, Ogdensburg, New York

angelic figure: "Before the persistent gaze of Ermine the face of a young woman unravelled itself from a wonderful head-gear and an unknown frock. The eyes looked into his with a long, steady, and hypnotic gaze. The gentle face of the image fascinated the lad."[20] From this moment John Ermine's fate is sealed, an unlikely coincidence triggering his inevitable doom. He places the photograph in his medicine bag to keep company with his horse's hoof, reading the message as yet another divine proof of the Great Spirit's favor.

The girl in the picture is Katherine Searles, the flirtatious daughter of Major Searles, and the photograph was lost by young Lieutenant Butler, who had met Katherine in the East, and who will frequently act as her escort following the young woman's arrival in the "canvas town" that is General Crook's camp and her father's home. By the time Katherine arrives, John has been serving the army as a scout for a season, and has survived the rough hazing of the soldiers—who call him a "sorrel Injun"—and a near-fatal encounter with Sioux, from which he has predictably emerged as a hero. But much of the ensuing action concentrates on the romance between Ermine and Katherine, a one-sided affair in which the scout is led by her flirtatiousness to believe that she returns his love, most particularly after an episode in which he saves her life following a fall from a horse (Fig. 91).

Katherine's eventual rejection—"Oh, my good man, I cannot make the dreams of casual people come true, not such serious dreams as yours"—fires John Ermine's Indian nature.[21] Though he is tempted to resolve his dilemma in the Indian way—that is, simply kidnap, rape, and keep Katherine with him in the mountains—he eventually decides on a different plan: to murder his rival, Lieutenant Butler, whom he had earlier wounded in a struggle for possession of the photograph.

> Hope had long since departed—he could not steal the girl; he realized the impossibility of eluding pursuit; he only wanted to carry Butler with him away from her. All the patient training of Crooked-Bear, all the humanizing influence of white association, all softening moods of the pensive face in the photograph, were blown from the fugitive as though carried on a wind; he was a shellfish-eating cave-dweller, with a Springfield, a knife, and a revolver.[22]

No longer thinking in English, "and muttering to himself in Absaroke," Ermine enters the army camp in search of Indian revenge, but having paused for a moment

253

before Katherine's lighted window, he is himself killed, shot by an Indian whom he earlier had insulted by pushing him away from Katherine as he escorted her about the camp. The Indian had merely wanted to shake hands—the white man's gesture of amity—but his sudden approach frightened the girl. Ermine had understood the Indian's intention, as well as the consequences of his response, but inspired by his infatuation, he violated cultural courtesies and sealed his own fate.

The chapter describing the heroine's arrival in camp is decorated by a symbolic headpiece, a small picture of a steamboat with the chapter title "Katherine" printed below it (Fig. 89). The steamboat is the camp's only connection with the world of white men, and as such is equivalent to the "white man's medicine"—the railroad and the "talking wire"—those instruments of civilization that signal the doom of Fire Eater and the fate of Sun-Down Leflare. "Can you make John Ermine what he was before the steamboat came here?" the scout demands of Katherine Searles, connecting her advent with his desperate plight.[23] As in the stories of Bret Harte and in Wister's *The Virginian,* the arrival of women in the West signals the advent of civilization, a feminine force that John Ermine is incapable of handling and which finally destroys him.

As Ben Merchant Vorpahl has demonstrated, Remington's tragic resolution of the meeting between West and East was intended to refute Owen Wister's sentimental resolution of a similar situation—the successful courtship of a Vermont school-teacher by an unlettered cowboy from Virginia.[24] Henry James, praising his friend's novel, could not entirely endorse the plot, feeling that the noble-hearted Virginian should have had a higher fate than marriage to "the little Vermont person": "I wouldn't have let him live and be happy; I should have made him perish in his flower & in some splendid sombre way."[25] Edwin Cady has seen James's remark as a key to the meaning of Wister's novel, and Vorpahl has applied it likewise to *John Ermine.* From Cooper's Leatherstocking Tales to James's own *The American,* the literary tradition in this country has been to place a fatal barrier between American Adams and their much more worldly and sophisticated Eves: Natty Bumppo is rejected by Mabel Dunham and Christopher Newman by Claire de Cintre. So Remington, in being true to what he saw as the tragic reality of the West—integral to the fate of the Indian— was also being true to the great American tradition.

FIGURE 92. Ermine getting the drop on Captain
Lewis. A scene from the stage production of *John
Ermine of the Yellowstone*. 1903. Frederic Reming-
ton Art Museum, Ogdensburg, New York

FIGURE 93. Louis Shipman, who rewrote
Remington's *John Ermine of the Yellowstone* for
the stage. c. 1902. Frederic Remington Art
Museum, Ogdensburg, New York

FIGURE 94. James K. Hackett in the title role of
John Ermine of the Yellowstone. 1903. Frederic
Remington Art Museum, Ogdensburg, New York

And yet, when in 1903 the American dramatist Louis Shipman (Fig. 93) undertook to make the story of John Ermine into a stage play, Remington willingly cooperated in changing the plot so as to achieve a happy, Wisterian resolution (Figs. 92, 94). Following the disastrous opening performance of a version that kept the tragic ending, Remington and Shipman recast the action and gave the public a sentimental melodrama, a story in which John Ermine and Katherine Searles are able to marry, not so much overcoming as ignoring their great cultural differences. One reviewer, having put the most positive light possible on the play, went on to admit that a happy union between an educated woman and a semibarbarian was hardly likely, yet the demands of the popular stage overrode Remington's deepest convictions about the West.

Clearly, considerations of popularity and wealth are powerful literary motives. Even as Remington was abandoning anecdotal painting for "serious" art, he was willing to assist in the sentimentalization of his most ambitious novel, suggesting perhaps that he may have regarded fiction as a lower form of expression. That there should be two ends to *John Ermine*—the realistic yet highly colored denouement of the novel and the romantic finale of the play—is true to Remington's enigmatic and protean character, bearing on the continued popularity of this artist who was far more complex in his meanings than many of his admirers even now realize. We have yet, I think, to fathom the mystery of Frederic Remington, but familiarity with his fiction does give us further access into the shadowy recesses of his soul. *John Ermine of the Yellowstone,* most particularly, is a work whose symbolic reach far exceeds the melodramatic plot that sustains it, much as Remington's scenes of cowpunchers and cavalrymen and Indians whose skulls show through their faces are grand opera of a sort, the kind of Wagnerian *Götterdämmerung* Wister also saw in the West, but which he was never able as a novelist to convey.

FIGURE 95. This photograph taken of Remington in cowboy costume during his western sojourn of 1883 suggests the projection of self that resulted in his ideal western hero, John Ermine of the Yellowstone. Frederic Remington Art Museum, Ogdensburg, New York

NOTES

In the Context of His Artistic Generation

The author is grateful to Libby Russell McClintock, intern, and Carrie Rebora and Mishoe Brennecke, research assistants, for their help in compiling the material required for this essay. Lawrence Campbell of the Art Students League; Louis D. Liskin of the Salmagundi Club; Betsy Fahlman of Old Dominion University, Norfolk, Virginia; Abigail Booth Gerdts of the National Academy of Design, New York; and Ronald G. Pisano and his assistant Beverly Rood all provided unpublished information. Nancy Gillette, assistant in the Department of American Paintings and Sculpture at The Metropolitan Museum of Art, provided essential support.

1. "Mr. Roosevelt on Remington," clipping, no source indicated, manuscript inscribed August 29, 1910, Frederic Remington Art Museum, Ogdensburg, New York (hereafter cited as FRAM).

2. "Janitor Brother Tells How Chance Aided W. M. Chase," *Indianapolis Star*, March 25, 1917, clipping in Indiana Clipping Files, Indiana State Library, Indianapolis.

3. Frederic Remington (hereafter cited as FR) to Poultney Bigelow, August 9, 1897, Owen D. Young Library, St. Lawrence University, Canton, New York; quoted in Allen P. Splete and Marilyn D. Splete, *Frederic Remington: Selected Letters* (New York: Abbeville Press, forthcoming) (hereafter cited as *Selected Letters*).

4. John F. Weir (hereafter cited as JFW) to Julian A. Weir, February 25, 1875, quoted in Dorothy Weir Young, *The Life and Letters of J. Alden Weir* (New Haven, Conn.: Yale University Press, 1960), p. 63.

5. See *Catalogue of the Officers and Students of Yale College, with a Statement of the Course of Instruction in the Various Departments* (New Haven, 1878 and 1879) for the academic years 1878–79 (pp. 71–74) and 1879–80 (pp. 72–76). For all the information given here on the Yale School of Fine Arts, I am deeply indebted to Betsy Fahlman, who is writing a book about JFW, the director of that institution for forty-four years.

6. *Catalogue... of Yale College... 1879–80*, p. 72.

7. Executive Committee of the Society of the Alumni, *Yale College in 1879* (June 1879), p. 13.

8. Poultney Bigelow, *Seventy Summers*, 2 vols. (New York: Longmans, Green & Co.; London: E. Arnold & Co., 1925), vol. 1, p. 301.

9. Eva Remington (hereafter cited as ER) to JFW, June 10, 1910, John Ferguson Weir Papers, Yale University Library, New Haven, Connecticut.

10. JFW, "Art Study at Home and Abroad," *Harper's New Monthly Magazine*, vol. 66 (May 1883), pp. 946–51 (quotations on pages 951, 948).

11. [Edmund C. Stedman], "Forging of the Shaft," *New York Evening Post*, May 7, 1868, p. 2. Stedman was referring to JFW's first version of this picture, painted in 1867–68 and destroyed in 1869.

12. Niemeyer's instruction of Saint-Gaudens is mentioned in biographies of Niemeyer—for example, *Dictionary of American Biography* (1934, s.v.)—and in his obituary in the *New York Times*: "Prof. J. H. Niemeyer, Artist, dies at 93," December 8, 1892, p. 21. No mention of Niemeyer's instruction of Saint-Gaudens appears in major monographs on the sculptor. For a description of the sculpture course at Yale, see *Catalogue... of Yale College... 1879–80*, p. 74. For an illustration of Niemeyer's sculpture, see: *National Academy Notes and Complete Catalogue, Sixty-first Spring Exhibition, National Academy of Design New York*, ed. Charles M. Kurtz (New York, 1886), p. 135. This piece was hardly well received; it was called "a performance only excusable on the general ground that every man is sure to try another field than the one in which he excels" ("The Spring Academy," *New York Times*, April 17, 1886, p. 3).

13. Albert Boime, "The Teaching of Fine Arts and the

Avant-Garde in France During the Second Half of the Nineteenth Century," *Arts Magazine*, vol. 60 (December 1985), p. 47.

14. "New York Art Schools," *Art Amateur*, vol. 12 (December 1884), p. 13. For a description of the school, program, and staff during FR's enrollment, see "Art Gossip," *Art Age*, vol. 3 (June 1886), p. 176.

15. *Circulars of 1885–86: Art Students' League of New York: 38 West 14th Street...Season of 1885–1886* (1885), p. 8.

16. Ibid., p. 12.

17. FR to Mr. Sparhawk, November 26, [1890], Fairmont Park Art Association, Philadelphia; quoted in *Selected Letters*.

18. M. G. van Rensselaer, *Book of American Figure Painters* (Philadelphia: J. B. Lippincott, 1886), unpaged introduction.

19. FR to A. S. Brolley, [probably November 1909], private collection; quoted in *Selected Letters*.

20. FR to Mr. McCormack, [1890], McCracken Collection, Owen D. Young Library, St. Lawrence University, Canton, New York; quoted in *Selected Letters*.

21. Clarence Cook, "National Academy of Design," *The Studio* (New York), n.s. vol. 3 (June 1888), p. 112.

22. George W. Sheldon, *Recent Ideals of American Art* (New York and London: D. Appleton and Co., 1888–89), p. 37.

23. Fr[iedrich] Pecht, "A German Critic on American Art," *Art Amateur*, vol. 11 (September 1884), pp. 76–77 (translated and reprinted review of an exhibition of American art held in Munich).

24. Julian Ralph, "Frederic Remington," *Harper's Weekly*, vol. 39 (July 20, 1895), p. 688.

25. Gerald M. Ackerman, "Thomas Eakins and His Parisian Masters Gérôme and Bonnat," *Gazette des Beaux-Arts*, vol. 73 (April 1969), pp. 243–44, 255. For a more recent study of Eakins and Gérôme, see H. Barbara Weinberg, *The American Pupils of Jean-Léon Gérôme* (Fort Worth: Amon Carter Museum, 1984), pp. 35–47. Ackerman (p. 244) also likens *Cowboys in the Bad Lands* to Gérôme's *Prayer in the Desert*.

26. Weinberg, *American Pupils of Gérôme*, pp. 65–67 (quotation on page 65).

27. Clarence Cook, "The Society of American Artists," *The Studio* (New York), n.s. vol. 2 (June 1887), p. 216.

28. "The National Academy of Design: Ideal and Genre Pictures," *New York Times*, May 6, 1888, p. 5.

29. Cook, "National Academy of Design," p. 112.

30. FR to Marcia Sackrider, December 12, [1879], McCracken Collection, Owen D. Young Library, St. Lawrence University, Canton, New York; quoted in *Selected Letters*.

31. FR notebook, FRAM (accession no. 71.812.8).

32. S[usan] N. C[arter], "Paintings at the Centennial Exhibition," *Art Journal* (New York), n.s. vol. 2 (September 1876), p. 284.

33. The Editor [A. T. Rice], "The Progress of Painting in America," *North American Review*, vol. 124 (May 1877), pp. 458–59.

34. "An Artist of the Plains," *New York Evening Post*, December 3, 1908, p. 9.

35. "Notes," *Craftsman*, vol. 15 (January 1909), pp. 501–2.

36. FR diary, August 27, 1909, FRAM.

37. Ibid., January 25, 1908. FR speaks negatively of some of his early work in diary entries for November 23 and December 22, 1908, and mentions burning paintings on January 3 and 25, and December 19, 1908.

38. FR address book, FRAM (accession no. 71.807).

39. "The Autumn Academy Exhibition," *New-York Daily Tribune*, November 16, 1889, p. 7.

40. "Paintings at the Academy," *New York Times*, November 26, 1889, p. 5.

41. "The Autumn Exhibition. Creditable Gathering of New Pictures," *New-York Daily Tribune*, March 29, 1895, p. 7; "Art Exhibitions: The Opening of the Academy of Design," *New-York Daily Tribune*, April 1, 1899, p. 8.

42. Minutes, National Academy of Design, May 13, 1891, Archives, National Academy of Design, New York.

43. The Academy's nomination ledger that covers the period 1889–1900 shows that FR was nominated on March 10, 1897, by Frederick Vinton; on May 12, 1897, by Vinton and JFW; and on December 13, 1899, by George Henry Hall. Archives, National Academy of Design, New York.

44. Minutes, "Report of Committee for Counting Nominations," Annual Meeting, National Academy of Design, May 9, 1906; FR diary, March 16 and May 10, 1908; March 16, 1909, FRAM.

45. "The American Art Galleries: The Work of Ten American Artists," *New-York Daily Tribune*, April 8, 1908, p. 10.

46. An improvement in FR's technical ability is noted, however, in "Exhibition of Pictures by American Painters," *New York Evening Post*, April 9, 1890, p. 9.

47. "American Paintings," *New York Times*, April 10, 1890, p. 4.

48. Ralph, "Remington," p. 688.

49. "Frederic Remington's Exhibition of Paintings," *Harper's Weekly*, vol. 37 (January 7, 1893), p. 7.

50. "The Chronicle of Arts. Exhibitions and Other Topics," *New-York Daily Tribune*, January 8, 1893, p. 14; "Remington as Painter," *New York Times*, January 1, 1893, p. 17.

51. "Chronicle of Arts."

52. "American Art: New Paintings by Mr. Remington and Mr. Dewey," *New-York Daily Tribune*, December 6, 1908, part 2, p. 2.

53. FR to John Howard, January 27, 1909, Owen D. Young Library, St. Lawrence University, Canton, New York, quoted in Peter Hassrick, *Frederic Remington: The Late Years* (Denver: Denver Art Museum, 1981), p. 7.

54. FR to Powhatan Clarke (hereafter cited as PC), [Fall 1887], Missouri Historical Society, St. Louis; FR to ER, June 22, [1888], FRAM; both quoted in *Selected Letters*. For an excellent discussion of FR's use of photography and its impact on his work, see Estelle Jussim, *Frederic Remington, the Camera & the Old West* (Fort Worth: Amon Carter Museum, 1983).

55. Jussim, *Remington*, pp. 62–64; FR to Alvin Sydenham, n.d., quoted in *Selected Letters*.

56. FR to PC, September 13, [18]90, Missouri Historical Society, St. Louis; quoted in *Selected Letters*.

57. FR notebook, FRAM (accession no. 71.812.8).

58. Clipping from *Everybody's Magazine* in FR diary, March 26, 1909, FRAM.

59. Quoted in Owen Wister (hereafter cited as OW) to FR, October 26, 1895, Library of Congress, Washington, D.C.; quoted in *Selected Letters*.

60. FR to ER, April 7, 1907, FRAM; quoted in *Selected Letters*.

61. FR diary, August 27, 1909, FRAM.

62. See Hassrick, *Remington: Late Years*.

63. H. Barbara Weinberg, "American Impressionism in Cosmopolitan Context," *Arts Magazine*, vol. 55 (November 1980), pp. 160–65.

64. FR diary, January 15, 1908, FRAM.

65. Ibid., March 17 and June 22.

66. Ibid., March 19. Remington owned E. R. and J. Pennell's book *The Life of James McNeill Whistler* (2 vols., Philadelphia: J. B. Lippincott, 1908), but this biography was apparently a gift from George Wright or Henry Smith (see FR diary, December 25, 1908, and "Books Bought," at back of 1908 diary).

67. Peter Hassrick, *Frederic Remington* (New York: Harry N. Abrams, 1972), p. 41.

68. "Paintings, Pastels and Drawings by Frederic Remington," *New York Sun*, December 11, 1901, p. 6.

69. FR diary, March 30, 1909, FRAM; January 2 and February 24, 1908, FRAM.

70. FR to OW, October 24, [1895], Library of Congress, Washington, D.C.; quoted in *Selected Letters*.

71. FR diary, December 15, 1909, FRAM.

72. FR to OW [January 1895], Library of Congress, Washington, D.C.; quoted in *Selected Letters*.

73. A. W. Drake to FR, January 17, 1899, FRAM.

74. For additional information about this monument, see David Sellin, "Cowboy," in Nicholas B. Wainwright, ed., *Sculpture of a City: Philadelphia's Treasures in Bronze and Stone* (New York: Walker Publishing Co., 1974), pp. 196–205.

75. FR to Leslie Miller, December 12, 1907, Fairmont Park Art Association, Philadelphia; quoted in *Selected Letters*.

76. FR to Leslie Miller, June 25, [1908], Fairmont Park Art Association, Philadelphia; quoted in *Selected Letters*.

77. FR diary, November 16, 1907, FRAM; February 28 and November 22, 1908, FRAM.

78. Ibid., February 20, 1908. See Michael Shapiro, *Cast and Recast: The Sculpture of Frederic Remington* (Washington, D.C.: National Museum of American Art, Smithsonian Institution, 1981), pp. 58–59.

79. FR diary, November 25, 1909, FRAM.

The Painter

1. *Exposition Universelle Internationale de 1889 à Paris: Catalogue General, Officiel…Groupe 1. Oeuvres d'art…* (Lille: Imprimerie L. Danel, 1889), p. 183.

2. *New York Herald*, March 31, 1889, p. 12.

3. See George W. Sheldon, *Hours with Art and Artists* (New York: D. Appleton and Co., 1882), p. 151.

4. Quoted in Alice P. Gunnison to Robert Taft, August 22, 1943, in the Robert Taft Papers, Kansas State Historical Society, Topeka.

5. "American Art at the Paris Exposition," *New York Daily Graphic*, February 28, 1889, p. 880.

6. "The Autumn Exhibition a Display of Much Interest," *New York Herald*, November 16, 1889.

7. Sheldon, *Hours with Art*, p. 18. For comparisons of the work of Detaille and de Neuville, see also *"Call to Arms!" Edouard Detaille and His Contemporaries* (Tampa: Tampa Museum, 1981), and Richard Muther, *The History of Modern Painting* (London: J. M. Dent & Co., 1907), vol. 2. For an informed discussion of the *peintre militaire* tradition in the early nineteenth century, see *All the Banners Wave: Art and War in the Romantic Era 1792–1851* (Providence: Brown University Department of Art, 1982).

8. Julian Ralph, "Frederic Remington," *Harper's Weekly*, vol. 39 (July 13, 1895), p. 688.

9. "Prospects of the Art Season," *Leslie's*, November 3, 1888, p. 183. Biographical information on Vereshchagin appears in Richard Whiteing, "A Russian Artist. Basil Werschagin," *Scribner's Monthly Illustrated Magazine*, September 1881, pp. 674–80.

10. Eva Remington to Henry Sackrider, December 2, 1888, Owen D. Young Library, St. Lawrence University, Canton, New York.

11. "The Frontier Trooper's Thanatopsis," *Harper's Weekly*, vol. 33 (April 13, 1889), p. 277. For further discussion on the influence of Vereshchagin on Remington (hereafter cited as FR), see Rufus F. Zogbaum, "War and the Artist," *Scribner's Magazine*, January 1915, pp. 34–35.

12. This comparison is discussed at length in Lon Taylor and Ingrid Maar, *The American Cowboy* (Washington, D.C.: Library of Congress, 1983), pp. 98–99. See also Robert Taft, *Artists and Illustrators of the Old West* (New York: Charles Scribner's Sons, 1953), pp. 183–88 and 353–54. The Zogbaum illustration appeared in *Harper's Weekly*, vol. 30 (October 16, 1886), pp. 668–69, and FR's in *Harper's Weekly*, vol. 33 (December 21, 1889), pp. 1016–17.

13. *Kansas City Star*, January 23, 1891, p. 5.

14. Theodore Roosevelt, "Who Should Go West?" *Harper's Weekly*, vol. 30 (January 2, 1886), p. 7.

15. FR to "Fitch," November 13, 1888, Milwaukee Art Center, Milwaukee, Wisconsin.

16. George William Sheldon, *Recent Ideals in American Art* (New York: D. Appleton and Co. [1889]), p. 115.

17. See FR, "On the Indian Reservations," *Century Illustrated Magazine*, no. 38 (July 1889), p. 396.

18. Ibid. FR's journal from that trip evidences the same frustration. On page 7 of his journal FR notes "San Carlos Apaches—won't let me draw them." Five pages later he recorded, "photographed to my heart's content and the Indians never seem to notice the camera." FR's journals are in the collection of the Frederic Remington Art Museum, Ogdensburg, New York (hereafter cited as FRAM).

19. Joseph Pennell, *Pen Drawing and Pen Draughtsmen* (London: T. Fisher Unwin, 1921), p. 239. Mahonri H. Young summarized these opinions in his biography of FR (s.v.) in *Dictionary of American Biography* (1935): "He was famous for his horses in action; at the time he began his work Eadweard Muybridge had just published his book of photographs, *The Horse in Motion*, and shortly afterward the snap-shot camera was invented. Remington took advantage of these devices, sometimes to the detriment of his drawings; malformations are recorded, owing to the distortions of the lens, and often truth of movement is defeated because of the stopage of action."

20. Estelle Jussim, *Frederic Remington, the Camera & the Old West* (Fort Worth: Amon Carter Museum, 1983), p. 64.

21. See, for example, F. Hopkinson Smith, *American Illustrators* (New York: Charles Scribner's Sons, 1893), pp. 23–24, and Perrington Maxwell, "Frederic Remington—Most Typical of American Artists," *Pearson's Magazine*, October 1907, p. 403.

22. Jussim, *Frederic Remington, the Camera*, p. 3.

23. Quoted in Maxwell, "Frederic Remington," p. 403.

24. FR to Mrs. Sage, April 22, 1892, photostat, Joseph McCarrell Collection, Amon Carter Museum, Forth Worth, Texas.

25. FR to Powhatan Clarke, October 14, 1891, Missouri Historical Society, St. Louis.

26. *Dismounted*, completed in 1890, was illustrated in E. S. Godfrey, "Custer's Last Battle," *Century Illustrated Magazine*, no. 3 (January 1892), and now hangs in the Sterling and Francine Clark Art Institute, Williamstown, Massachusetts. It was FR's entry in the autumn exhibition of the National Academy of Design.

27. "New Pictures at the Academy," *Philadelphia Inquirer*, January 21, 1892, p. 5.

28. My thanks to Rick Stewart and Barbara Wiskow for their close inspection of the original painting to confirm the fact that *The Trooper* is the original central figure remaining from the larger canvas.

29. David C. Huntington, "American Art Between World's Fairs 1876–1893," in *The Quest for Unity* (Detroit: Detroit Institute of Arts, 1983), p. 26.

30. "Remington's Fame Was Won Quickly," *New York Herald*, January 14, 1894, p. 13.

31. FR diary, 1888, p. 4., FRAM.

32. The painting was completed at Roosevelt's request to illustrate Roosevelt's story "The Cavalry at Santiago," *Scribner's Magazine*, April 1899, p. 421. There has been considerable debate regarding whether or not Roosevelt was on horseback during the charge and whether his attack was on Kettle Hill rather than San Juan Hill. For further discussion, see Peggy and Harold Samuels, *Frederic Remington: A Biography* (Garden City: Doubleday, 1982), pp. 291–92.

33. I am especially grateful to Melissa Webster, Assistant Curator of Art at the Buffalo Bill Historical Center, for sharing with me her insights into Remington's nocturnes as discussed in her master's thesis, "Remington: His Art and His Nocturnes" (University of California at Davis, 1986).

34. For discussions of figure work and mood in American painting of the period, see Linda Ayres, "The American Figure: Genre Paintings and Sculpture," in *An American Perspective* (Washington, D.C.: National Gallery of Art, 1981), p. 43, and William H. Gerdts, Jr., *Revealed Masters: 19th Century American Art* (New York: American Federation of Arts, 1974), pp. 31–32.

35. Sadakichi Hartmann, *A History of American Art* (Boston: L. C. Page & Company, 1901), vol. 2, p. 114.

36. "The Art World," *New York Commercial Advertiser*, December 10, 1901.

37. Quoted in Edwin Wildman, "Frederic Remington, the Man," *Outing*, March 1903, pp. 715–16.

38. Royal Cortissoz to FR, December 2, 1904, FRAM.

39. I am grateful to Thomas R. Buecker, Curator, Fort Robinson Museum, for identifying this painting's subject as Red Cloud Buttes behind Fort Robinson.

40. "Paintings of Western Life by Frederic Remington, Indians, Cowboys, and Trappers," *New York Times*, December 23, 1906. This was a noticeable advance in one year, for the same paper had described an exhibition of paintings at Noe Gallery in February as exemplifying broader brushwork but generally being "hard wrought." See "Indians on Land and Wave. Exhibition of Paintings by Frederic Remington at the Noe Gallery," *New York Times*, February 10, 1906.

41. Maxwell, *Frederic Remington*, p. 406.

42. *New York Tribune*, December 4, 1907.

43. "Exhibitions Now On," *American Art News*, December 7, 1907, p. 6.

44. *New York Tribune*, ibid.

45. FR diary, January 15, 1908, FRAM.

46. For a full development of this thesis, see Ben Merchant Vorpahl, *Frederic Remington and the West: With the Eye of the Mind* (Austin: University of Texas Press, 1977), pp. 267–84.

47. Quoted in Betty Beck Robertson and Jane Beck Johnson, eds., "Beckoning Frontiers, Footnote to American History" (typescript in the editors' possession, 1985), pp. 83–84.

48. Augustus Thomas, "Recollections of Frederic Remington," in *Century Illustrated Magazine*, no. 86 (July 1913), p. 361.

49. Theodore E. Stebbins, Jr., extended caption for FR's painting *Evening on a Canadian Lake*, reproduced in *A New World: Masterpieces of American Painting 1760–1910* (Boston: Museum of Fine Arts, 1983), p. 277.

50. Georges-Albert Aurier's definition of the movement, quoted in Robert Rosenblum and H. W. Janson, *19th Century Art* (New York: Harry N. Abrams, 1984), p. 425.

51. FR diary, October 15 and 20, 1909, FRAM.

52. Rosenblum and Janson, *19th Century Art*, p. 450.

53. FR to A. S. Brolley [probably November 1909], private collection; quoted in Allen P. Splete and Marilyn D. Splete, *Frederic Remington: Selected Letters* (New York: Abbeville Press, forthcoming).

The Sculptor

1. I am grateful to Betsy Fahlman of Old Dominion University, Norfolk, Virginia, for sharing her research on the art school at Yale, and to George Guerney for reading a draft of this essay.

2. Frederic Remington (hereafter cited as FR) to Owen Wister, [January 1895], Owen Wister Papers, Library of Congress, Washington, D.C.; quoted in Allen P. Splete and Marilyn D. Splete, *Frederic Remington: Selected Letters* (New York: Abbeville Press, forthcoming) (hereafter cited as *Selected Letters*). In the years since FR's death, the word *bronco* has been spelled without an "h," and this usage is reflected in the spelling in this book and elsewhere of the title of several popular FR bronzes. However, the original copyright documents and other papers in the collection of the Frederic Remington Art Museum in Ogdensburg, New York (hereafter cited as FRAM), show that FR's spelling was *The Broncho Buster* (with an "h").

3. The photograph of FR modeling *The Bronco Buster* is reproduced in Charles H. Garrett, "Remington and His Work," *Success*, May 13, 1899, p. 409.

4. FR to Owen Wister, [between February 25 and 28, 1895], Owen Wister Papers, Library of Congress, Washington, D.C.; quoted in *Selected Letters*.

5. Quoted in Peggy and Harold Samuels, *Frederic Remington: A Biography* (Garden City, N.J.: Doubleday, 1982), p. 227.

6. The scrapbook includes photographs of Saint-Gaudens and Rodin on its cover. Collection FRAM.

7. Undated address book, FRAM.

8. Charles Caffin, "Frederic Remington's Statuettes: 'The Wicked Pony' and 'The Triumph,'" *Harper's Weekly*, vol. 42 (December 17, 1898), p. 1222.

9. Quoted in John H. Dryfhout, *Augustus Saint-Gaudens: The Portrait Reliefs* (Washington, D.C.: National Portrait Gallery, Smithsonian Institution, 1969), n.p.

10. FR to Julian Ralph [Summer 1900], McCracken Collection, Owen D. Young Library, St. Lawrence University, Canton, New York; quoted in *Selected Letters*.

11. The guest book is in the collection of FRAM.

12. The notebook is in the collection of FRAM.

13. FR diary, May 7, 1907, FRAM.

14. FR to Riccardo Bertelli, [1904], R. W. Norton Art Gallery, Shreveport, La.; quoted in *Selected Letters*.

15. FR diary, February 22, 1908, FRAM.

16. Ibid., January 21 and 22.

17. Ibid., February 18.

18. Ibid., February 20.

19. FR to Jack Summerhayes, [1904], Buffalo Bill Historical Center, Cody, Wyoming; quoted in *Selected Letters*.

20. FR to Leslie Miller, January 5, 1907. Fairmont Park Art Association, Philadelphia; quoted in *Selected Letters*.

21. FR to John Howard, [1907], McCracken Collection, Owen D. Young Library, St. Lawrence University, Canton, New York; quoted in *Selected Letters*.

22. FR to Leslie Miller, December 12, 1907, Fairmont Park Art Association, Philadelphia; quoted in *Selected Letters*.

23. FR to Leslie Miller, [1908], Fairmont Park Art Association, Philadelphia; quoted in *Selected Letters*.

24. FR diary, May 7, 1907, FRAM.

25. FR to Leslie Miller, [1908], Fairmont Park Art Association, Philadelphia; quoted in *Selected Letters*.

26. Ibid.

27. FR to Leslie Miller, June 25, 1908, Fairmont Park Art Association, Philadelphia; quoted in *Selected Letters*.

The Writer

1. Frederic Remington, *The Collected Writings of Frederic Remington*, ed. Peggy and Harold Samuels (Garden City, N.J.: Doubleday, 1979), pp. xv–xvi, xvii.

2. Ben Merchant Vorpahl, *My Dear Wister—The Frederic Remington–Owen Wister Letters*, foreword by Wallace Stegner (Palo Alto, Calif.: American West Publishing, 1972), pp. 302, 310–14.

3. Remington, *Collected Writings*, p. 276.

4. Ibid., p. 344.

5. Ibid., p. 26.

6. Ibid., p. 30.

7. Ibid., p. 558.

8. Ibid., p. 560.

9. Ibid., p. 587.

10. Ibid., p. 333.

11. Ibid., p. 336.

12. Ibid., pp. 336–37.

13. Ibid., p. 326.

14. Ibid., p. 586.

15. Ibid., p. 465.

16. R.W.B. Lewis, *The American Adam: Innocence, Tragedy and Tradition in the Nineteenth Century* (Chicago: University of Chicago Press, 1955), pp. 147, 153.

17. Ibid., p. 147.

18. Remington, *Collected Writings*, p. 540.

19. Ibid., p. 487.

20. Ibid., p. 489.

21. Ibid., p. 533.

22. Ibid., p. 548.

23. Ibid., p. 534.

24. Vorpahl, *My Dear Wister*, pp. 310–16.

25. Quoted in Edwin H. Cady, *The Light of Common Day: Realism in American Fiction* (Bloomington: Indiana University Press, 1971), p. 182. The quotation is also given, in part, in Vorpahl, *My Dear Wister*, p. 315.

APPENDIX A

Henry-Bonnard Bronze Company Casts of *The Bronco Buster*

The following list, dating from about 1899, was Remington's personal record of sales and consignments of Henry-Bonnard casts of *The Bronco Buster*. The first column lists the casts in order of production. To the left of some of the cast numbers, Remington made rough notes about payment. Next to numbers 22, 30–39, and 46, he wrote and then crossed out the words "not yet paid"; above numbers 34–36 and 46 he later added "paid." Next to number 40 he wrote and later crossed out the word "paid." Next to numbers 41–44, 50, and 51, he wrote the word "paid." The second column indicates the owner of a bronze; thus, Owen Wister, Remington's friend, owned cast number 5. Most of the casts were sold to jewelry stores with large bronze depart-

ments, such as Tiffany & Company, New York, and Lindsey & Company, Philadelphia. With the exception of cast number 26, which the artist retained for himself, and cast 30, the first 36 casts were apparently sold directly to their owners; casts 30 and 37–51 were consigned. For casts 37–44, 46, 50, and 51, the artist received a $75 royalty check. For casts 22 and 30–36, a full $200 was paid; presumably, casting costs and Remington's royalty were deducted from this price. This list—pages 2–5 of a ledger in the collection of the Frederic Remington Art Museum, Ogdensburg, New York—is particularly helpful in providing initial provenance information for casts of Remington's first sculpture.

Broncho Buster

	Sold	*Consigned*			*Sold*	*Consigned*	
No. 1	Tiffany & Co.			No. 32	check, Feb. 12th [?]	Lindsey & Co., Phil.	
2	Lindsey & Co.					—delivered to Tiffany & Co. Oct. 29th, 1898	paid 200
3	Tiffany & Co.			33	(check Feb. 17th)	S. Boyd & Co., Pittsburgh,	
4	Lindsey & Co.					*ordered back to be consigned to Tiffany & Co.*	paid 200
5	Owen Wister, Phil.			34	Tiffany & Co.		paid 200
6	Tiffany & Co.			35	do		paid 200
7	d[itt]o London			36	do		paid 200
8	do City			37		check	paid royalty 75
9	Lindsey & Co.			38		Feb. 17	paid royalty 75
10	do			39		1899	paid royalty 75
11	Tiffany & Co.			40		John A. Lowell, Boston	paid royalty 75
12	Lindsey & Co.			41		Tiffany & Co. check	paid royalty 75
13	Tiffany & Co.			42		" " " Feb.	paid royalty 75
14	do			43		" " " 17/99	paid royalty 75
15	Lindsey & Co.			44		" " "	paid royalty 75
16	Tiffany & Co.			45		Lindsey & Co., Philadelphia	
17	J. E. Caldwell & Co.			46		O'Brien & Co., Chicago	paid royalty 75
18	Tiffany & Co.			47		Shreve Crump, Low, Boston	
19	do			48		Fred Kuis Sons, Newark	
20	do			49		Doll & Richards, Boston	
21	do			50		Tiffany & Co.	paid royalty 75
22	do		paid 200 [dollars]	51		" " "	paid royalty 75
23	Lindsey & Co.			[52–63]			
24	do						
25	J. E. Caldwell & Co.						
26	F. Remington						
27	do for Louis Brown						
28	Tiffany & Co.						
29	Lindsey & Co.						
30		Spalding & Co. Chicago	paid 200				
31	Tiffany & Co.		paid 200				

APPENDIX B

Edition Sizes of Remington's Bronzes as of May 9, 1907

On May 9, 1907, Remington recorded on page 32 of a ledger now in the collection of the Frederic Remington Art Museum, Ogdensburg, New York, the current cast numbers of his extant bronzes. He may have been motivated to review the extent of his bronze production by his destruction, only two days earlier, of the molds for *The Scalp* and *The Cheyenne*. This list, made only two and one-half years before the sculptor's death, indicates that his editions were relatively small at that time. The end of the editions of *The Wounded Bunkie* at number 14 and of *The Norther* at 3 are recorded, as is the date of the destruction of the molds of *The Scalp* and *The Cheyenne*. Why Remington wrote the numbers 250 and 400 after the titles of entries 1 and 2 is unknown.

Bronzes			*May 9, 1907* *the next number* *on my bronzes*
1 The Broncho Buster		250	66
2 The Wounded Bunkie.			
14 copies (out of print)		400	14
3 The Scalp.			
destroyed May 7, 1907			7
4 The Cheyenne.			
20 copies and destroyed,			
May 7, 1907			20
5 The Blizzard or Norther			
(3 copies only)			3
6 The Mountain Man			10
7 The Rattlesnake			10
8 Coming thro the Rye			9
9 The Dragoons			4
10 The Seargeant. a head			19
11 Paleolithic Man			3
12 Polo. a group			2
13 The Outlaw			7
14 The Horse Thief	commission $100		
	royalty $215		
	casting $225		
15			
16			
17			

INDEX

Pages on which illustrations appear are in *italics*. Unless otherwise indicated, all artworks and books listed in this index are by Frederic Remington.